STUDIES IN THE HISTORY
OF ART AND ARCHITECTURE

General Editors

ANTHONY BLUNT FRANCIS HASKELL

CHARLES MITCHELL

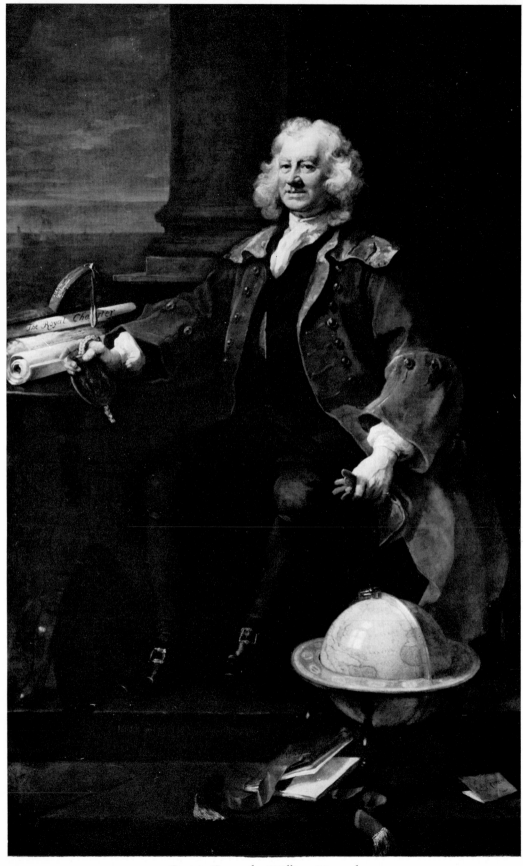

Captain Coram, by William Hogarth

THE TREASURES
OF THE
FOUNDLING
HOSPITAL

BENEDICT NICOLSON

*With a catalogue raisonné
based on a draft catalogue by*
JOHN KERSLAKE

CLARENDON PRESS · OXFORD

1972

Oxford University Press, Ely House, London W.1

GLASGOW NEW YORK TORONTO MELBOURNE WELLINGTON
CAPE TOWN IBADAN NAIROBI DAR ES SALAAM LUSAKA ADDIS ABABA
DELHI BOMBAY CALCUTTA MADRAS KARACHI LAHORE DACCA
KUALA LUMPUR SINGAPORE HONG KONG TOKYO

ISBN. 0198171862

PRINTED IN GREAT BRITAIN BY
WILLIAM CLOWES & SONS, LIMITED
LONDON, BECCLES AND COLCHESTER

PREFACE

'IN THE way it combines charitable work with the care of a notable collection of paintings and much of historical interest, the Thomas Coram Foundation for Children invites comparison with certain confraternities and similar institutions in Florence and Venice. For the quality of the collection it has no rival among comparable institutions in Britain.' Thus wrote Terence Mullaly in a recent article on the Foundation.

The Governors are very mindful of what they owe to the world of the Arts, not only for the decoration of the Foundling Hospital, but also for the money that was raised in the early days of the work for children. The Governors have always felt the need of a worthy record of their treasures and this has now been attained due to the untiring work of the late Sir Alec Martin, one of the Governors, who for so long supervised the care of the works of art and gave the benefit of his unequalled experience. Due to his efforts, we were fortunate enough to persuade Benedict Nicolson to write this book.

When describing Hogarth's portrait of our founder, Thomas Coram, Mullaly wrote, 'What Hogarth has painted with such sure sympathy, is a forthright seaman and master craftsman who, moved by the plight of unwanted children, literally left to die in the streets of London, proceeded to do something about it.' The work begun by Coram, namely the maintenance and protection of the young children of unmarried mothers, remains our primary function today. Many pass through the Foundation's hands annually, and between 200 and 300 remain in care in foster homes until they come of age. The Foundation encourages mothers to keep in touch with their children and gives them help, advice, and above all time to plan for their children's future. The value of the specialized role of the Foundation, with over 200 years of experience in the care of children, can best be judged by the fact that over eighty per cent of the

children currently admitted become, at an early age, permanent members of a family, about half of them being restored to their mothers and the other half adopted.

The Foundation is a live museum (open to the public on Monday and Friday afternoons) with all its treasures in an appropriate setting, and also a live charity devoted to the continuing care of children.

DOUGLAS SCOTT

ACKNOWLEDGEMENTS

THE genesis of this book goes back to the mid-1960s when the late Sir Alec Martin, a Governor of the Thomas Coram Foundation for Children, asked my advice on a suitable author for a volume the Foundation was planning on its art treasures. Most presumptuously I proposed myself, but he accepted my offer with alacrity, and always took an active interest in the progress of the work. He read the book in manuscript, and helped me with constructive criticism. To him I am much indebted, since I have reason to believe that no one else was in such a strong position to persuade his fellow-Governors that such a volume was desirable. We jointly approached Basil Taylor, then Director of the Paul Mellon Foundation for British Art, who agreed to collaborate with Routledge and Kegan Paul in its publication. Since then the organization of the Mellon Foundation has suffered a sea change, but this does not make me any the less grateful to Basil Taylor for the support he then gave me. It meant that, along with other obvious advantages, we could benefit from the expert services of Douglas Smith, who has produced photographs of all pictures and sculpture at the Hospital's Headquarters, 40 Brunswick Square, in cases where no adequate photographs existed. Mercifully the old negatives belonging to the Hospital, which were used to illustrate Nichols and Wray's *History of the Foundling Hospital* (1935) survive, with the result that I am able to reproduce a number of views of the exterior and interior of the building before its demolition in the late 1920s.

Another Governor of the Thomas Coram Foundation, and Treasurer from 1958 to 1970, Colonel Sir Douglas W. Scott, has been continuously encouraging and helpful, and it has been a positive pleasure to work in collaboration with him. I must record my thanks to Sir Gilbert Inglefield, a third Governor, who read my essay in manuscript. I have also been helped in the passages on Handel by an account in manuscript dealing with Handel's association with the Hospital, written shortly before his death in

1968 by Hubert Langley. The Hospital's Secretary, Frederick C. Brown, put all the records preserved at 40 Brunswick Square at my disposal, and good-humouredly dealt with my innumerable and tiresome requests.

Simon Kenrick spent several months in the early part of 1969 ploughing through the Hospital Minute Books and other documents, noting references to artistic matters. He read every entry between 1739 and 1760, and from 1760 onwards, carried out spot checks in places where I guessed relevant information was to be found. On the completion of his work he handed over to me a sheaf of notes which form the core of this book. Had it not been for his scrupulous execution of what must have been a thoroughly dull job, the book could never have been written. Although the Minute Books had already been consulted by writers on Hogarth, Coram, Handel, and others, he discovered much new material which is here published for the first time.

Finally, I must record my indebtedness to John Kerslake of the National Portrait Gallery, who allowed me to make use of his draft catalogue of the Hospital Treasures, preserved in two typescripts at the Hospital's Head-quarters and at the Portrait Gallery. Though I have brought his researches up to date (they were undertaken ten years ago) and have made alterations, they have formed the basis of my catalogue raisonné.

<div align="right">B.N.</div>

CONTENTS

List of Plates xi

I. CORAM AND HOGARTH I

II. BUILDING OF THE HOSPITAL II

III. ARTISTS ASSOCIATED WITH THE HOSPITAL
 (1746–51) 20

IV. ARTISTIC DEVELOPMENTS IN THE 1750s 32

V. THE CHAPEL AND MUSIC 39

VI. THE HOSPITAL SINCE 1760 50

CATALOGUE OF THE HOSPITAL TREASURES 57
 A. Pictures and Drawings 59
 B. Pictures Untraced in the Collection 83
 C. Sculpture 85
 D. Sculpture Untraced in the Collection 89
 E. Furniture, Silver, Decoration 90

Bibliography 92

Index 96

LIST OF PLATES

Plates 1–36 between pp. 34–5; Plates 37–99 at end. The Frontispiece and all plates from 37 onwards represent works of art at the Foundling Hospital, so their location has not been added to the captions.

FRONTISPIECE. *Captain Coram*, by William Hogarth. Signed and dated 1740. Canvas, 94 × 58 ins.

1. Royal Charter for the Incorporation of the Foundling Hospital, October 1739.

2. Entrance to the Hospital looking north towards the Chapel, with statue of Coram by W. Calder Marshall, R.A. (erected 1853). Photograph taken shortly before demolition in 1920s.

3. Receipt signed by Hogarth for 'Disbursements to 29 Sepr 1760' on behalf of three children. (Thomas Coram Foundation for Children.)

4. Receipt dated 30 December 1762 signed by Jane Hogarth for maintenance of children. (Thomas Coram Foundation for Children.)

5. First Seal of Hospital, 1739.

6. *The Foundlings*, by William Hogarth. Head piece to a Power of Attorney. Pen, ink and wash on white paper, $4\frac{3}{8} \times 8\frac{1}{4}$ ins. (Collection Mr. and Mrs. Paul Mellon.)

7. *Coat-of-Arms of the Foundling Hospital*, by William Hogarth. Signed and dated 1747. Pen on paper of irregular shape, and folded, *c*. $6\frac{1}{4} \times 7$ ins. (Collection Marquess of Exeter, Burghley House.)

8. *Infant studying Nature*, by William Hogarth. Design for a frontispiece. Pen with grey ink and grey wash over pencil, $7\frac{1}{16} \times 5\frac{13}{16}$ ins. (Sabin Galleries Ltd., London, 1969.)

9. Engraving by Drevet after Rigaud's portrait of *Samuel Bernard*. (Versailles.)

10. Plan and elevations of the Foundling Hospital. Engraving by Fourdrinier, *c*. 1749. (Dance Folio of Engravings, No. 24, Sir John Soane's Museum.)

11. *Bernard des Rieux*, by Maurice Quentin de La Tour. 1741. (Private Collection.)

12. Plan and perspective view of the Foundling Hospital. Engraving by K. Roberts after a drawing by Jeremiah Robinson, published 6 July 1749.

13. Perspective view of the Foundling Hospital. Engraving by N. Parr after a drawing by L. P. Boitard, published 1751.

14. South front of the Hospital. Photograph taken shortly before demolition in 1920s.

15. Front entrance to the Hospital overlooking Guildford Street. Photograph taken in 1920s.

16. West front of the Hospital seen from the west. Photograph taken shortly before demolition in 1920s.

17. Detail from plan of the Hospital precincts, 1912. (Thomas Coram Foundation for Children.)

18. *Theodore Jacobsen*, by William Hogarth. Signed and dated 1742. Canvas, $35\frac{3}{4} \times 27\frac{3}{4}$ ins. (Allen Art Museum, Oberlin College, Oberlin, Ohio.)

19. Elevation of a triangular house designed by Jacobsen. Engraving by Fourdrinier, *c.* 1749. (Dance Folio of Engravings, No. 10, Sir John Soane's Museum.)

20. Oak staircase in the west wing of the Hospital. Photograph taken shortly before demolition in 1920s, but the staircase survives in 40 Brunswick Square.

21. Court Room of the Hospital. Photograph taken shortly before demolition in 1920s, but the decoration survives in 40 Brunswick Square.

22. *Charity*, by John Michael Rysbrack. Incised. Painted terracotta. (Victoria and Albert Museum.)

23. *Charity*, by John Michael Rysbrack. Incised and dated 1745. Terracotta. (Herron Museum of Art, Indianapolis.)

24. *Admission of Children to the Hospital by Ballot.* Engraving by N. Parr after a drawing by S. Wale, published 9 May 1749.

25. Study for engraving of Hogarth's *Moses brought before Pharaoh's Daughter*, here attributed to Luke Sullivan. Red chalk, $15\frac{3}{4} \times 20\frac{1}{4}$ ins. (Private Collection, North Berwick.)

26. *Study after Ramsay's Dr. Richard Mead*, by Joseph Vanhaecken or Van Aken. Stamped *V.H.* Black and white and red chalk, $20\frac{3}{8} \times 12\frac{3}{4}$ ins. (National Galleries of Scotland.)

27. *Study after Hudson's John Milner*, by Joseph Vanhaecken or Van Aken. Stamped *V.H.* Black and white and red chalk, $20\frac{3}{8} \times 12\frac{3}{4}$ ins. (National Galleries of Scotland.)

28. Letter from Reynolds to the Secretary of the Foundling Hospital, Thomas Collingwood, dated 28 February 1782. (Thomas Coram Foundation for Children.)

29. Declaration by artists, dated from Turk's Head Tavern, 7 December 1760. (Thomas Coram Foundation for Children.)

30. *View of the Girls' Dining Room*, by John Sanders. Signed and dated 1773. Watercolour. (On loan to the Thomas Coram Foundation for Children from the William Salt Library, Stafford. Reproduced by permission of the William Salt Library.)

31. *View of the Chapel looking West*, by John Sanders. Signed and dated 1773. Watercolour. (On loan to the Thomas Coram Foundation for Children from the William Salt Library, Stafford. Reproduced by permission of the William Salt Library.)

32. *View of the Chapel looking West.* Lithograph by G. R. Sarjent after a drawing by himself, printed by M. K. N. Hanhart.

33. The Chapel looking east. Photograph taken shortly before demolition in 1920s.

34. Altar Rails and Altar in the Chapel. Photograph taken shortly before demolition in 1920s.

35. List of performers and singers at performance of *Messiah* in the Chapel, 2 May 1760. (Thomas Coram Foundation for Children.)

36. Collection of Foundlings' Coins and Tokens. (Thomas Coram Foundation for Children.)

37. *Massacre of the Innocents*, from the School of Raphael (?Giulio Romano). Small pieces of paper stuck on canvas, 113×109 ins.

38a, b, c. *Bacchanalian Procession*, by Giulio Campi (one drawing divided into three). Sepia wash.

39. *A Piping Shepherd Boy.* Italian School, Seventeenth Century. Canvas, $56\frac{3}{4} \times 76\frac{3}{4}$ ins.

40. *Our Lord appearing to St. Peter*. Italian School, after 1700 (?Tuscan). Canvas, 59½ × 45 ins.

41. *Woman taken in Adultery*, by Giovanni Camillo Sagrestani. Canvas, 54 × 43¼ ins.

42. *Thomas Emerson*, by Joseph Highmore. Signed and dated 1731. Canvas, 48 × 57½ ins.

43. *George Frederick Handel*, by Louis Francis Roubiliac. *c.* 1739. Terracotta with ceramic glaze.

44. Detail of head of Hogarth's *Coram* (frontispiece).

45. Detail of right hand of Hogarth's *Coram* (frontispiece).

46. *Thomas Coram*, by B(althazar?) Nebot. *c.* 1741. Canvas, 16¼ × 11½ ins.

47. *Sidetable*. Pine wood, with rectangular green Grecian marble top, supported by carved figures of a goat and two children before a tree stump. Mirror above. British School, *c.* 1740s.

48. *Mantelpiece* in Court Room, by John Devall. *c.* 1745. Incised. Rysbrack relief inset.

49. *Charity*, by John Michael Rysbrack. Incised. 1746. Marble, 30 × 47½ ins.

50. *Hagar and Ishmael*, by Joseph Highmore. ?Signed. 1746. Canvas, 68 × 76 ins.

51. *The Finding of the Infant Moses in the Bullrushes*, by Francis Hayman. 1746. Canvas, 68¼ × 80½ ins.

52. *Moses brought before Pharaoh's Daughter*, by William Hogarth. 1746. Canvas, 68 × 82 ins.

53. *Little Children brought to Christ*, by James Wills. ?Signed. 1746. Canvas, 68 × 82½ ins.

54. *The Charterhouse*, by Thomas Gainsborough. 1747-8. Canvas (tondo), 22 ins. diameter.

55. *St. George's Hospital*, by Richard Wilson. *c.* 1750. Canvas (tondo), 21 ins. diameter.

56. *The Foundling Hospital*, by Richard Wilson. *c.* 1750. Canvas (tondo), 21 ins. diameter.

57. *Chelsea Hospital*, by Edward Haytley. *c.* 1750. Canvas (tondo), 22 ins. diameter.

58. *Bethlem Hospital*, by Edward Haytley. *c.* 1750. Canvas (tondo), 22 ins. diameter.

59. *St. Thomas's Hospital*, by Samuel Wale. *c.* 1747. Canvas (tondo), 21 ins. diameter.

60. *Christ's Hospital*, by Samuel Wale. *c.* 1747. Canvas (tondo), 21 ins. diameter.

61. *Greenwich Hospital*, by Samuel Wale. With oakleaf and acorn frame. *c.* 1747. Canvas (tondo), 21 ins. diameter.

62. *Dr. Richard Mead*, by Allan Ramsay. Signed and dated 1747. Canvas, 93 × 57 ins.

63. Detail of head of Ramsay's *Mead* (Plate 62).

64. *John Milner*, by Thomas Hudson. 1746. Canvas, 93 × 57 ins.

65. *Theodore Jacobsen*, by Thomas Hudson. Canvas, 93 × 54 ins.

66. Detail of right hand in Hudson's *Jacobsen* (Plate 65).

67. Walnut longcase *Clock*, by John Ellicott. Inscribed.

68. *Caracalla*. British School, before 1754. Plaster, on painted English wood wall bracket.

69. *Marcus Aurelius*. British School, before 1754. Plaster, on painted English wood wall bracket.

70. *The March to Finchley*, by William Hogarth. 1747-9. Canvas, 39½ × 52½ ins.

71. *Adoration of the Magi*, by Andrea Casali. Signed. 1750. Canvas, 100 × 81½ ins.

72. Hogarth's Lambeth-Delft Punch-bowl.

73. Keyboard of eighteenth-century Organ, said to be the one presented to the Hospital by Handel.

74. *A Flagship before the wind under easy sail, with a cutter, a ketch, and other vessels*, by Charles Brooking. Signed. 1754. Canvas, $70\frac{1}{4} \times 123\frac{1}{4}$ ins.

75. *Landscape with Figures*, by George Lambert. 1757. Canvas, 48×48 ins.

76. *Taylor White*, by Francis Cotes. Signed and dated 1758. Pastel on paper, 30×25 ins.

77. *Francis Fauquier*, by Benjamin Wilson. *c.* 1757. Canvas, 36×28 ins.

78. *William Legge, Second Earl of Dartmouth*, by Joshua Reynolds. *c.* 1757. Canvas, $91\frac{1}{2} \times 54$ ins.

79. *George II*, by John Shackleton. *c.* 1758. Canvas, $93 \times 56\frac{1}{4}$ ins.

80. *Earl of Macclesfield*, by Benjamin Wilson. *c.* 1760. Canvas, 94×57 ins.

81. *Lord Chief Justice Wilmot*, by Nathaniel Dance (Sir Nathaniel Dance-Holland). Canvas, 83×65 ins.

82. *?William Beckwith*, attributed to Nathaniel Hone. Canvas, $25\frac{1}{2} \times 22$ ins.

83. *The Press Gang*, attributed to John Collet. Canvas, 39×49 ins.

84. *Action off the Coast of France, 13 May 1779*, by Thomas Luny. Signed and dated 1779. Canvas, $43\frac{1}{2} \times 62\frac{1}{4}$ ins.

85. *Siege of Gibraltar*, by John Singleton Copley. *c.* 1787-8. Canvas (monochrome), $39\frac{1}{2} \times 49\frac{1}{2}$ ins.

86. *Christ presenting a Little Child*, by Benjamin West. Canvas, $85 \times 73\frac{1}{2}$ ins.

87. *William Beckwith*, by R. Tomlinson. Incised and dated 1807. Marble, 25 ins. high including socle, on dark painted wood pedestal.

88. *The Ven. Archdeacon Pott*. British School, early nineteenth century. Canvas, $62 \times 46\frac{1}{2}$ ins.

89. *Christopher Stanger*, attributed to George Watson. Canvas, 30×25 ins.

90. *The Worthies of England*, by James Northcote. Signed and dated 1828. Canvas, 45×57 ins.

91. *Relief from Monument to Dr. Bell*, by Willliam Behnes. Incised and dated 1839. White plaster, *c.* 25×40 ins.

92. *Rev. J. W. Greadhall*, by Samuel James Bouverie Haydon. *c.* 1874. Plaster painted white, $27\frac{1}{2}$ ins. high including base.

93. *Queen Victoria*, by Joseph Durham. Incised and dated 1855. Plaster painted white, 32 ins. high, including socle, on plaster pedestal plinth.

94. *The Foundling restored to its Mother*, by Mrs. Emma King (née Brownlow). Signed and dated 1858. Canvas, arched top fillet, 30×40 ins.

95. *The Christening*, by Mrs. Emma King (née Brownlow). Signed and dated 1863. Canvas, arched top fillet, *c.* 30×40 ins.

96. *Foundling Girls in the Chapel*, by Mrs. (Walter) Sophia Anderson. Signed. Canvas, $26\frac{1}{2} \times 21$ ins.

97. *A Foundling Girl at Christmas Dinner*, by Mrs. Emma King (née Brownlow). Signed and dated 1877. Canvas, 35×28 ins.

98. *The Pinch of Poverty*, by Thomas-Benjamin Kennington. Signed and dated 1891. Canvas, 45×40 ins.

99. *Luther Holden*, by Sir John Everett Millais. Canvas, $49 \times 36\frac{1}{2}$ ins.

I

CORAM AND HOGARTH

STRANGELY enough great portraiture, even when it purports to be realistic, has a habit of leading one away from real life. It is a form of deception practised on the spectator. It cannot be relied on to tell one what the man, sitting there, was really like. Hogarth's famous portrait of *Captain Thomas Coram* (frontispiece) tells us more about Hogarth than about Coram, more about the history of art than about the history of benevolent institutions, and in order to find out how the originator of the Thomas Coram Foundation for Children[1] must have struck his contemporaries, we would be better advised to turn to a poor image unadorned by art, showing a stocky, kindly, shrewd little man, unsteady on his feet, blessed with a mission which nothing but death shall deter him from accomplishing: an image that an almost unknown painter Nebot—we are even uncertain of his Christian name—has bequeathed to us (Plate 46).[2]

[1] The name of the Charity was changed in 1954 from The Foundling Hospital to The Thomas Coram Foundation for Children. Since I shall be concerned throughout this study chiefly with the early history of the institution, I am proposing to retain its original name of The Foundling Hospital throughout.

[2] These are the only two contemporary portraits of Coram which are undisputed (leaving aside his appearance in Hogarth's drawing *The Foundlings*, Plate 6). My catalogue Nos. 5 and 6 are pastiches or copies after Hogarth, and therefore of no interest iconographically. A poor canvas, $29\frac{1}{2} \times 24\frac{1}{2}$ ins. in the National Portrait Gallery, said to represent Coram and attributed to Ramsay, is neither of the former nor by the latter. It is said to have been in Dr. Mead's sale, 20 March 1754 (6), second day as 'Mr. Ramsay. Capt. Coram 3 gns'. Mr. John Kerslake is of the opinion (and I agree with him) that this has no doubt been wrongly equated with the picture in the Mead Sale.

There are several nineteenth-century statuettes of Coram in the Hospital, based on the Hogarth, the prime original being the Siever (Cat. No. 104) dated 1833. A statute of Coram by W. Calder Marshall, R. A., was erected in 1853 at the entrance to the original Hospital, facing Guildhall Street (see Plate 2). A bronze of Coram by W. Macmillan, R. A., now stands outside the new premises in Brunswick Square. It was unveiled in 1963, and is inscribed as of that year. It also is based on the Hogarth—an image impossible to escape. It replaced the Calder Marshall which was damaged in the First World War.

Coram stands at the entrance to his temporary premises (not to his hospital which was not yet built), clutching in his left hand the precious Royal Charter for the Incorporation of the Hospital, and pointing with his right towards a wicker basket containing a baby dumped in his front garden, whose life he shall save as he shall save the lives of countless other forsaken children. The painting dates from 1741, two years after Coram had received the Royal Charter. He was then aged about seventy-three. His life's work was complete.

The main outlines of Coram's life are known to us. He was a Dorset man, born at Lyme Regis about 1668, who went to sea as a boy and spent his whole life among ships. He was apprenticed to a Thames-side shipwright in the 1680s. In 1693 he travelled to Boston with a cargo of merchandise, and started business in Boston as a shipwright. Brought up a staunch member of the Church of England, he had no patience with the Nonconformists so vociferous in New England. After several years Coram returned to Taunton, but was soon back in Boston where he married (1700). As far as we know, like Hogarth he never had any children of his own. This must have contributed to their joint interest in the children of others. He retired from business soon after 1719, and devoted the remainder of his life to public service, having accumulated sufficient wealth for his ordinary needs. It was at this moment, after settling at Rotherhithe, profoundly disturbed by the spectacle of poverty in the streets of London, that he conceived the scheme of founding a Hospital for Foundlings. He fought for it for twenty years, by enlisting the support of all the most influential citizens. The scheme was crowned with success when on 20 November 1739 a meeting was held at Somerset House to receive the Royal Charter for the Incorporation of the Hospital (Plate 1). The aristocracy was represented by Dukes, Viscounts, Peers, Baronets; the city by magnates, merchants, bankers; science by the greatest physician of the age, Richard Mead; art by the greatest painter, William Hogarth.[3] It was one of the noblest conceptions of an age not noted for its nobility.

[3] The fullest account of Coram's life is to be found in Nichols and Wray, 1935, pp. 7 ff., to which the reader is referred for further details. (Throughout these notes references are given by shortened titles in cases where full bibliographical references are to be found in the bibliography. Publications not given in the bibliography are cited in full here.)

The General Court Minutes of the Foundling Hospital[4] open with the solemn incantation: 'Somerset House in the Strand Tuesday the twentieth of November 1739 At a Meeting of the Governors and Guardians, held by Summons from His Grace the Duke of Bedford, the President named in His Majesty's Royal Charter. Present the Duke of Bedford President.' Then follows the list of the distinguished persons present. The Royal Charter was then read 'bearing the date the fourteenth of October 1739'. Fifty people were elected by ballot to 'direct manage and transact the Business Affairs and Effects of this Corporation . . .', and these included Coram himself, Dr. Richard Mead, and the architect of the Hospital, Theodore Jacobsen. Early meetings were held at 'Mr. Manaton's Great Room in the Strand', until early 1741 when they were resumed at the newly acquired premises in Hatton Garden. (Presumably the building in the background of Nebot's portrait represents the new premises.) There is a mystery surrounding Coram's own participation in the affairs of the Hospital after its incorporation. He was concerned with his friend Dr. Robert Nesbit, who owned the Nebot portrait and was Governor of the Hospital from the moment of its foundation, in a dispute with other Governors in the autumn of 1741. A Sub-Committee specially appointed to enquire into certain allegations—we are never allowed to know in what they consisted—concluded that Coram had been 'principally concerned in promoting and spreading the said aspersions'. He and Nesbit were not censured, but the episode led to strained relations with their colleagues, and marked the end of Coram's official connection with the Hospital. Though he lived on until 1751, the last Committee he attended was on 5 May 1742.[5] To his features in Nebot's portrait we now have to add a sharp tongue. Many years later, long after he had ceased to play an active part in Hospital affairs, an amusing description is given by Vertue (VI, pp. 150-1) under the date 1 January

[4] The Minutes have been religiously kept ever since the first meeting, and are preserved in massive volumes at the premises of the Thomas Coram Foundation for Children at 40 Brunswick Square. They are divided into General Court Minutes (here described as G.C.M.), kept continuously since the first meeting on 20 November 1739, and the Minutes of the General Committee (here described as Gen. Comm.), kept continuously since its first meeting on 29 November 1739. The General Court was held quarterly, the General Committee more frequently.

[5] Nichols and Wray, 1935, p. 23.

1750, of an evening spent as Dr. Mead's guest when Coram was present. '... Dr. Mead toasted a health to all the Governors—honest Governors of the Foundling Hospital—hoping says Coram these new chosen ones will be better than the last. who were rogues enough ... but these Governors says the Doctor you don't suspect. I expect [says Coram] little better than the former.'

Hogarth was not among those appointed to the General Committee to direct the business affairs of the Corporation, but was made Governor and Guardian from the moment of the foundation, attended the first General Court meeting, and thereafter constantly, though by no means invariably, attended, until 1760.[6] He served the Hospital in other capacities besides painter, draughtsman, and governor. His punch-bowl of Lambeth-Delft, painted with dragons and fish in blue on a white ground (Plate 72) is among the possessions of the Hospital, but it is not known whether he himself presented it. He subscribed sums of money to the Hospital,[7] and in about 1760 agreed to maintain two Foundling infants in Chiswick where he and his wife (who were childless) were then residing. The children were returned to the Hospital after his death by his widow.[8]

It is always assumed that he and Coram were close friends, and that this explains why a painter should be so closely associated with a charitable institution. But in fact we know nothing of their relationship, and can only infer (and it is a fair inference) that Hogarth's generosity towards the Foundation was inspired by friendship, but more particularly by a passion-

[6] Hogarth is recorded in G.C.M. as having been present at two meetings in 1741, one in 1743, one in 1744, two in 1746 (including the crucial meeting on 31 December when many artists were elected Governors), two in 1747, and one in 1750. He was again present at General Court meetings in 1754, 1757, 1758, 1759, and twice in 1760.

[7] G.C.M. under 25 June 1740, announcing that Hogarth had subscribed £21 to the Hospital. He paid a further subscription of £21 on 28 March 1741. (G.C.M. under 1 April.)

[8] The Hospital possesses a receipt signed by Hogarth for 'Disbursments to 29 Sep.ʳ 1760' on behalf of these children, amounting to £13. 15s. (see Plate 3), and a further receipt dated 30 December 1762 signed by Jane Hogarth, for £12. 6s. 6d. for their maintenance (see Plate 4). A letter from Jane Hogarth in the Hospital, dated from Chiswick 28 June 1765, addressed to Thomas Collingwood, Secretary of the Hospital, illus. Nichols and Wray, 1935, opp. pp. 258 and 259, suggests that the children under her 'inspection' would 'Benefit of a Run in the Country for the Summer Season', and could be returned at the end of the year. The Secretary recommends that they should be sent to a county hospital at once.

ate admiration for a man willing to dedicate his declining years to a new and marvellous idea. Humanitarianism was not exactly the rage in Coram's day, as it became later in the century; his 'unhealthy' desire to save the lives of abandoned bastards at first shocked people's sensibilities; they condemned it as a dangerous refusal to allow Nature to take its course; if wanton women felt that their offspring would prosper if dumped on the Hospital's doorstep, this would merely encourage prostitution. But it stirred the imagination of this other humanitarian, Hogarth, also a member of the new, up-and-coming middle class who had spent his youth in daily contact with poverty, starvation, and death. What more natural than that he should offer his services to this swarthy sea captain, as combative as himself? Moreover, with Hogarth idealism was always matched by a keen mercenary sense, and even in the very early days of the Hospital's history, he saw in it a chance of raising his own status as an artist. This he succeeded in doing within a few years.

The Foundling Hospital was by no means the only charitable institution he supported. He designed the admission ticket for the London Infirmary. In the mid-1730s he had painted for, and presented free of charge to, St. Bartholomew's Hospital of which he was Governor, his *Pool of Bethesda* and *Good Samaritan*, determined that the national school should stand on its own feet with the highest form of art, history painting. But this did not lead to any further commissions, and Hogarth was forced in the late 1730s to fall back on a regular source of income, his prints. Undeniably he was having a success with these, with a mass public; but he still hankered after recognition by the connoisseurs as a serious history painter. By throwing in his lot with the Foundling Hospital, he saw a second chance of establishing a reputation in this field, and seized it.[9]

Since there were no Hospital walls as yet to decorate, he had to be content at first with painting the founder's portrait, and with performing certain more menial tasks for the Hospital's benefit in which he could display his gifts as a draughtsman. He does not seem to have been involved in the

[9] See Waterhouse, 1953, p. 130; Antal, 1962, p. 146; and Paulson, 1965, I, pp. 10 ff. Antal emphasizes the 'markedly human and charitable character' of the staircase paintings at St. Bartholomew's. This attitude of mind is again reflected in the work he undertook for the Foundling Hospital.

designing of the first seal (Plate 5), but perhaps a design had been prepared before he came on to the scene: it was produced by Coram as a sample to the Committee at a meeting on 26 December 1739 'for transacting the Affairs of the Hospital', and was forthwith accepted as the seal of the Corporation.[10] No particular significance need to attached to the fact that the subject of the relief is the same as that adopted by Hayman for his history picture for the Hospital: *Pharaoh's Daughter finding Moses in the Bullrushes* (Plate 51), since obviously the first foundling in history would at once spring to Coram's mind as the most appropriate image. Hogarth did, however, produce a design for *The Foundlings* which was used as a head piece to a Power of Attorney for collecting subscriptions for the Hospital.[11] The drawing which was engraved in reverse by La Cave (Plate 6), depicts Coram holding the Royal Charter—here a more monkish figure than in the other two representations of him. Misery changes to happiness as we move from left to right towards the portals of the Hospital. A mother thinks better of murdering the child she is unable to support, drops her dagger, and kneels in tears before Coram like a penitent Magdalen, while the beadle carries her baby to salvation. Another infant lies abandoned in front of a bridge; a mother disposes of her child in a stream; while on the right a group of contented older children in their school uniforms carry the emblems of the useful trades the Hospital has taught them: trowels, spinning wheels, sickles, rakes, brooms, and the like. The scene has no basis in fact: for at that date (1739) there were no foundlings, and no premises in which to house them. But Coram had his picture of the rosy future already, which Hogarth was quick to appropriate and transmit to paper.

An entry in the Minutes of the General Committee under 25 March 1741 reads: 'Mr. Taylor White acquainted the Committee that Mr. Hogarth has Painted a Shield which was put up over the Door of this Hospital and

[10] G.C.M. under that date. It bears the inscription 'Sigillum Hospitii Infantum Expositorum Londinensis'. See the reproduction in Nichols and Wray, 1935, opp. p. 201.

[11] Paulson, 1965, I, pp. 265–6; II, Plate 265 (third state of engraving of 1739). Paulson did not know the drawing at the time but refers to it in 1967, p. 285. See also Oppé, 1948, under No. 66 where the drawing (also unknown to him) is tentatively traced through some early sales. It was exhibited at the Virginia Museum, 'William Hogarth', 1967 (34). Pen, ink and wash on white paper, $4\frac{3}{8} \times 8\frac{1}{4}$ ins. neither signed nor dated.

presented the same to this Hospital.' This was in the new premises in Hatton Garden, but the design on the shield cannot be deduced from Nebot's painting or the engraving after it, and no trace of it has been found. It is generally supposed[12] that it was an emblematic sketch similar in character to the Arms of the Hospital designed by Hogarth six years later. These Arms were presented on the authority of the Herald's College early in 1747,[13] and he designed them in the same year. His drawing for them, now in the collection of the Marquess of Exeter at Burghley (Plate 7), is inscribed 'Armes for [over "of"] the Foundling Hospital: Wm Hogarth Invt 1747'. The motto 'HELP' on the scroll, and 'Nature', 'a Lamb' and 'Britannia' are also in his own handwriting.[14] The terminal figure of the many-breasted Diana reappears in two other Hogarth drawings: *Boys peeping at Nature* (1731) in the Royal Library, and in a design for a frontispiece showing an *Infant studying Nature* (Plate 8) on the London market in 1969, intended for engraving and reversal. The Exeter drawing was engraved anonymously soon afterwards, possibly by Richard Yeo,[15] and the plate or later plates were used for various purposes, including the heading on tickets for Handel concerts held at the Hospital in the 1750s.

Far more important than any other task Hogarth undertook for the Hospital[16] was his portrait of the founder painted in 1740 (frontispiece), a

[12] By among others Brownlow, 1858, p. 57.

[13] The Petition of the Governors for Grant of Arms, dated 28 January 1746, is reproduced in Nichols and Wray, 1935, opp. p. 250, and the Grant of Arms itself, of 27 March 1747, opp. p. 252. G.C.M. under 1 April 1747 announces that Mr. Pine, Bluemantle Pursuivant of Arms, brought the Grant to the General Meeting. The theory that has been advanced, that there must have been some connection between the Hospital Arms and Handel's birthplace Halle on the grounds that they contain part of the Arms of Halle, is incorrect. Handel had nothing to do with the Hospital until three years after the Grant of Arms. It was a concidence, as Deutsch (1955, p. 688) rightly says.

[14] For further details, see Oppé, 1948, No. 66 and Plate 38. The drawing was given to the then Lord Exeter by Mrs. Hogarth in 1781. A copy presented to the Foundling Hospital by E. Bellamy is reproduced by Nichols and Wray, opp. p. 251 as the original.

[15] Paulson, 1965, I, pp. 276–7; II, Plate 276 (first state of c. 1747). Gen. Comm. under 6 May 1747: 'Mr. Hogarth acquainted the Committee that Mr. Yeo the Engraver had offered to make a Present to this Corporation of a Seal of their Arms which were lately granted them from the Herald's Office.' Thanks are conveyed to Yeo *via* Hogarth. An entry in Gen. Comm. under 7 November 1759 informs us that Yeo presented the seal of the Arms on that day. He was elected a Governor in the following year.

[16] Hogarth also painted in 1741 a portrait of one of the original Vice-Presidents (1739–47) of the Foundling Hospital, *Martin Folkes*, which he presented to the Royal Society. Folkes was President of the Royal Society from 1741 to 1753 (see Beckett, 1949, No. 133).

milestone in the history of British portraiture, which looks back to Van Dyck and forwards to Lawrence, and yet is an object more momentous than a mere stage on a journey. It marks a significant moment in British social life, when the genius of the rising middle class asserts itself with confidence and power, and permits an image to be produced unlike anything that had gone before. Even Hogarth's own earlier sitters had never asserted themselves so authoritatively. *Captain Coram* epitomizes the rise to power of a new class, just as Holbein's images had epitomized the Tudor monarchy. Its ancestors in portraiture can be traced without difficulty; yet it stands alone, unique and totally original. Portrait painters of the latter half of the eighteenth century, the Great Age, struggled in vain to get it out of their system; Hogarth himself in later years looked back on it as among his most satisfying inventions. Circumstances had combined to produce a masterpiece. On the one hand, here at last was a sitter of humble origin who like Hogarth had raised himself by imagination and hard work; a man of principle, who had fought for a cause close to Hogarth's heart and had won his way. On the other, here at last was a British painter, blessed with the gifts, and presented with the opportunity, to invent a new pictorial equivalent for a new idea. There had been decent middle-class portraits in Britain before, notably by Highmore, where realism had been used as a convenient vehicle for conveying the business acumen of sitters. But it needed an artist of genius like Hogarth to bring out the imaginative qualities as well as the good sense of this new class, by combining a modified realism (in a benevolent face, plate 44) with the dignified tradition of Baroque portraiture (in the setting).[17]

There is nothing down-to-earth about *Captain Coram*, who is represented as enjoying his new role as the triumphant philanthropist; clutching the large seal of the Corporation in one hand (Plate 45), and his glove in the other ('but as a man of action would hold it and not as a man of words'[18]); with the Royal Charter on the table beside him; and in front and in the distance, a globe showing the Atlantic Ocean, and ships on the sea, to remind us of his life's work as a shipwright plying between Boston and Rotherhithe. All

[17] See Waterhouse, 1953, p. 131; Antal, 1962, especially pp. 16, 28–9, 45–6.
[18] Waterhouse, 1965, p. 14.

around him are the trappings of the Grand Manner. We have left High-more's literalness far behind, to find ourselves transported into the world of Van Dyck's *Charles I and his Family* and its successors throughout the seventeenth century, both in Britain and abroad. Various sources for *Coram* have been noted. One is a portrait of *Sir Christopher Wren* in the Sheldonian Theatre at Oxford,[19] designed by Verrio and carried out by Kneller and Thornhill, showing the architect seated in a strikingly similar pose, pointing to a globe and holding a plan, surrounded in the Baroque manner by scientific instruments and books, with the view of the Thames at the City of London glimpsed behind a column and draped curtain. But it has not the strength of Hogarth's portrait, and we are forced to turn to the Continent of Europe to find a closer parallel, in Rigaud's *Samuel Bernard*, an eminent financier, at Versailles, no doubt familiar to Hogarth through the engraving by Drevet (Plate 9).[20] We think of *Captain Coram* as a Baroque conception. But seen beside the Rigaud, it suddenly turns into a realistic image. Along-side a Highmore it would seem fanciful. It is only by making such con-frontations as these that we learn the true place a picture occupies in the history of style.[21] Hogarth's picture takes up an intermediate position between the idea and the thing seen.

Hogarth referred to his portrait of Coram in his autobiographical *Anec-dotes of an Artist*, started after the publication of the *Analysis of Beauty* (1753) and left in draft form, unrevised, at his death.[22] These notes are sometimes

[19] Mrs. Poole, *Catalogue of Portraits . . .*, I, 1912, 133–4. A reproduction will be found in *The Sheldon-ian Theatre and the Divinity School*, Oxford, 1964, p. 13. The comparison with the Hogarth was first made by Whinney/Millar, 1957, p. 195, note 1.

[20] The comparison was first made by Antal, 1947, pp. 43–4. Antal, 1962, note 59, p. 228, points out that Hogarth in the *Analysis of Beauty* singles out Drevet as a great engraver.

[21] Antal, 1962, p. 46, draws attention to the portrait of Samuel Bernard's son *Bernard des Rieux* (here Plate 11), painted by La Tour one year after the Hogarth (1741), showing a parallel development in France away from the Baroque towards a more realistic portrayal.

Hogarth's small portrait of *Bishop Hoadley* in the Henry E. Huntington Art Gallery, published by R. R. Wark in *The Burlington Magazine*, October 1957, p. 326, is extraordinarily similar to the *Coram* in the sense that a bourgeois face is inset into extravagant Baroque surroundings. Waterhouse, 1965, p. 14, thinks that the *Hoadley* represents a half-way stage between the Rigaud and the *Coram*, but we cannot be sure which (the *Hoadley* or the *Coram*) came first. They appear to be about contemporary.

[22] Ed. Burke, 1955, pp. 212–13, 218; folios 14, 14b, 34b, 35, of the manuscript of the *Analysis of Beauty*.

hard to interpret, but the general sense can be extracted from his hectic and cantankerous jottings. When I wrote that, placed between Rigaud and Highmore, Hogarth's *Coram* occupied an intermediate position, this is borne out by his own statement, that in his portraiture 'the life must not be strictly followed'. He complains that his portraits were said to be 'at the same time by some Nature itself by others exicrable', but in spite of the criticisms: ' . . . is it not strange that one of the first portraits as big as the life of Captain Coram in the foundling hospital should stand the test of twenty years as the best Portrait in the place notwithstanding all the first portrait Painters in the Kingdom had exerted their talents to vie with it . . .'. Later follows a more difficult passage:

. . . The portr[ait] of Cap Coram in the foundlings was given as a specimen which and still stand in competition with with effort that has been made since by every painter that has since emulated it and this which lowers the difficulty of this branch was done without the practis of having done thounsand which ever other face painter has before he arives at doing as well. and it has been left to the Judgement of the Public these twenty years whether and of the efforts are equall or not. . . .

He seems to be saying[23] that he cannot be such a bungler as his detractors maintain, if *Coram* can stand the test of twenty years, and generally be thought the best portrait in the place. He had in mind the works of Ramsay, Highmore, Hudson, Reynolds, Cotes, and others—that is to say the leading portrait painters of the day. In spite of this keen competition, Hogarth's boast does not seem to us at all exaggerated.

[23] This is the meaning given to his words by Ireland, *Supplement to Hogarth Illustrated*, 1798, pp. 48–9. Ireland tidied up Hogarth's inconsequential jottings for publication, but on the whole faithfully retained the meaning of the sentiments expressed.

II

BUILDING OF THE HOSPITAL

A T a meeting of the General Court on 31 October 1740 it was decided that the Committee would be empowered to purchase two pasture fields belonging to the Earl of Salisbury containing thirty-four acres of land on the north side of Ormond Street between Lamb's Conduit and Southampton Row, for a site for the Hospital. Two months later, the Earl having announced that he wished to dispose of the whole of the land he had in this area, it was resolved to purchase fifty-six acres for £7,000.[1] At precisely this moment the lease of the house in Hatton Garden was taken out, which remained as premises for meetings until one wing of the Hospital was finished (1745).

In May 1742 it was decided that the plan of the Hospital must be large enough to contain 400 children, besides officers and servants, and that rooms sufficient to contain 200 children should be immediately erected. In June of that year four plans for the new Hospital were considered, submitted by the architects Sampson, Dance, James, and Jacobsen. Sampson's was turned down because it was too small, and Dance's because it was 'too expensive and stands on too much ground'. Jacobsen's plan for a brick house was finally preferred to James's on every count: welfare, finance, and convenience. It provided 'such Rooms as for the present will serve for your General Court, Committees, Officers & Servants and also necessary Offices'. It was resolved that 'the General Committee be desired to carry into immediate Execution Mr. Jacobsen's Plan' (30 June 1742). It was proposed

[1] G.C.M. under 31 December 1740. Some delay was caused by negotiations. It was not until 15 July 1741 that the General Committee agreed to the purchase of the Earl's land, and not until 30 December that year that five Hospital representatives were empowered to draw £6,500 for this purpose.

for the time being only to erect one wing. The foundation stone of the Hospital was laid by John Milner, Vice-President, on 16 September 1742, and by October 1745 the Western wing of the Hospital was ready.[2] This proved inconvenient, since it meant that the boys and girls were together. In order to separate them, plans were made to proceed with the building of the east wing. 800,000 more bricks were ordered on 29 November 1749 'towards finishing the New Wing Offices, and one side of the Pavillion and Collonnade . . .'. By May 1753 both wings of the Hospital were inhabited.[3]

The children were first admitted to premises in Hatton Garden in 1741, and afterwards to the newly erected building in Lamb's Conduit Fields, but infants were placed out to nurse with foster-mothers in country districts. They were generally returned to the Hospital at about the age of five, where they remained until they were apprenticed, the boys often going into the Armed Forces, the girls into domestic service. At first the Hospital was financed by private charity, but its funds proved insufficient to meet the costs. Too many babies were dumped on the doorstep and a balloting system had to be devised. The embarrassing success of the enterprise induced the House of Commons in 1756 to make large grants. These were discontinued after 1771. From then onwards the Hospital was maintained by public subscription and from rents from the property it owned, and ever since the site was sold in 1926, from revenue received from its sale.

The engraving showing the plan and elevations of the Hospital here reproduced (Plate 10) dates from before 1751, may even be as early as the

[2] Full details are given in Gen. Comm. Minutes from 1742 onwards of the work to be carried out. It is hard to assess how valuable this information is to historians, but the reader who requires further details is referred to the entries under 22 July, 9 September, 28 September, 27 October, 8 December 1742, and 22 February, 6 June, 20 June, 12 September, 24 October 1744. Craftsmen, etc., employed under Jacobsen are named. Contract for internal carpentry and joinery goes to Lancelot Dowbiggen and William Spier. The glaziers are Thomas and John Lovett. The ironwork (including railings) is entrusted to a Mr. Alexander. Dowbiggen and Spier are mentioned again as supplying beds for the Hospital in Gen. Comm. under 17 July 1745.

[3] Gen. Comm. under 30 May 1753. Nichols and Wray, 1935, p. 44, state that the eastern wing, together with the Treasurer's house, 'appears to have been ready for habitation in 1752'. This is probably correct, but I have not traced the source for their statement.

late 1740s,[4] and so is of some historical interest. It represents at the top the south front towards Guildford Street; in the centre a plan of the ground floor of the complete building including the parts still unconstructed; and at the bottom an elevation of the already existing west front—the same view of it as that selected by Richard Wilson in his tondo of the Hospital (Plate 56). On the north side of the Courtyard, in the centre, unconnected to the wings except by arcades, was to be the Chapel (still under construction). Arcades were to extend the whole length of the series of the narrower ground-floor rooms on the Courtyard side of both west and east wings. The largest rooms on the west wing were the dining room and the General Court Room, linked by a vestibule. The Secretary's office was at the south-west corner. The main rooms in the east wing were to be two large school rooms, again divided by a vestibule.

The plan and perspective view of the Hospital reproduced in Plate 12,[5] published in 1749 and therefore about contemporary with the first, give us the additional information that the south front was or was intended to be enclosed from wing to wing by a low wall and railings, and that different ideas for the interior construction of the Chapel were being debated. A third engraving of 1751 (Plate 13) shows the same front from a greater distance.[6] Some slightly later engravings are also known;[7] while crowding the corridors of the new offices at 40 Brunswick Square are views of the Hospital dating from the later eighteenth and early nineteenth centuries, which need not detain us.

These plans can be supplemented by photographs of the Hospital taken shortly before its demolition in the late 1920s. It will be seen that the

[4] Its date can be deduced from the fact that Jacobsen holds it in his hand in his portrait by Hudson (Plate 66), which was certainly the property of the Hospital by 1751, and which may have been ready or almost ready as early as 1747 (see catalogue No. 44). This engraving by Fourdrinier is reproduced from the copperplate in the Dance Folio of Engravings, No. 24, Sir John Soane's Museum.

[5] Engraved by K. Roberts after a drawing by Jeremiah Robinson, published 6 July 1749.

[6] Engraved by N. Parr after a drawing by L. P. Boitard, published 1751.

[7] Two are reproduced in *Country Life*, 1920, p. 540, Figs. 15 and 16. Figure 15 of 1756 shows that the low wall and railings linking the wings were abandoned, and replaced by a more imposing semi-circular wall with gates further south—doubtless at a time when it was feared that the Hospital would be besieged by visitors and needed to be defended. Figure 16 is too far removed from reality to be of great interest topographically, being a perspective view with emblematic figures.

exterior did not radically change in the interval, although new class rooms, as well as an infirmary and a swimming bath, were added in later times to the north, and extensions were made to Jacobsen's main block both west and east of the Chapel. Plate 14 shows a south front with which we are already quite familiar, except that the Chapel has now been joined to the wings on either side. Plate 15 is reproduced chiefly for sentimental reasons, since it shows beyond the entrance with the mid-nineteenth-century statue of Coram, a beautiful row of houses in Guildford Street, which were damaged in the Second World War and have all gone from the corner of Guildford Place eastwards. Plate 16 shows the west front, unchanged on the southernmost side since the mid-eighteenth century, but with the addition of later buildings to the north never part of Jacobsen's original design. Internally, on the other hand, the Hospital underwent extensive alterations over the centuries, as can be seen from part of a plan of 1912 reproduced in Plate 17.[8] I shall turn to the interior decoration later.

The new *Ospedale degli Innocenti* overlooking Guildford Street cannot rival the elegance of its Florentine predecessor. But then Brunelleschi had inherited a highly refined Gothic on which to graft his classicism, whereas Jacobsen (who was in any case not an architect of comparable genius) was developing his sobriety from the extravagant High Baroque, just as Hogarth was developing his from Thornhill and Rigaud. His building had to be on a far more massive scale, to cope with a social situation in London in the mid-eighteenth century, undreamed of by the Florentines. Nevertheless, the unfair comparison with Brunelleschi must not lead us to underrate Jacobsen's achievement. As has been pointed out, his building 'although it had not the same decisive influence on the architecture of his day as Brunelleschi's, was also the invention of a rational mind—monumental, imposing, simple and solid, really utilitarian and yet not lacking in grace'.[9]

8 Nichols and Wray, 1935, reproduce some further photographs of the exterior in their book: two of the eastern colonnade which is still standing (opp. pp. 58 and 59); another of the Front Entrance, Guildford Street (opp. p. 115); and views of the Chapel Piazza and Cloister (opp. pp. 206 and 209). A model of the Foundling Hospital, 10 ft. to 1-inch scale, by John B. Thorp is on view on the ground floor of 40 Brunswick Square. It was made in 1927 after the sale of the Hospital and purchased that year (see 1965 catalogue, No. 7).

9 Antal, 1962, p. 222, note 76.

We have to imagine it standing in the country in the middle of Lamb's
Conduit Fields, with the cattle grazing around it. We have only to study the
plans to appreciate its simplicity, and convenience: the free use of open
space for the children to play in; the great dormitories extending almost
the entire length of the two wings, one side for the girls, the other for the
boys; the rooms on the ground floor, some simple, some ornate, where the
children worked and ate and the officers held their deliberations.

Theodore Jacobsen [10] was of German extraction, a business man and not
(at any rate at first) a professional architect, who carried on a successful
business in the London Steelyard on behalf of Hanseatic merchants. One
would suppose from the sympathetic portrait of him at Oberlin (Plate 18)
painted by Hogarth in 1742—the very year that his design for the Hospital
was accepted—that the two men were friends. All we know for certain is
that he was the only practising artist besides Hogarth who was a Governor
and Guardian of the Hospital from the moment of its foundation (they were
joined by Zincke in 1740), and that like Hogarth he had Coram's humani-
tarian ideals very much at heart, since he offered his services gratuitously as
the Hospital's architect. His generosity may well have influenced his fellow
Governors in his favour. In 1751 he drew up designs for another charitable
institution, the Royal Naval Hospital for Sick Sailors at Gosport (Hants). A
third and considerably earlier building is a triangular house shown on the
plan he holds in Hogarth's portrait (Plate 18).[11] This has not been identified,
but an engraving of about 1749 (Plate 19)[12] is captioned 'The Section of the
Design of a Triangular House by Theodore Jacobsen Esq[r] . . .', and is
clearly the same. The portrait is said to have belonged to the descendants of
Sir Jacob Bouverie, the Earls of Radnor, and this—combined with the fact
that an inscription on the reverse reads: 'portrait Jacobsen the Architect

[10] The fullest account of Jacobsen is that of Colvin, 1954, *ad vocem*, from which much of the informa-
tion here is taken, though it omits some significant details.

[11] The portrait is catalogued in *Oberlin Bulletin*, 1959, pp. 67–8. Signed and dated lower right
'W. Hogarth Pinx. 1742'. Canvas, $35\frac{3}{4} \times 27\frac{3}{4}$ ins. See also the catalogues 'An American University
Collection . . .', Iveagh Bequest, Kenwood, 1962 (24), and 'William Hogarth', Virginia Museum,
1967 (25), for further details.

[12] By Fourdrinier; here reproduced from the copperplate in the Dance Folio of Engravings, No. 10,
Sir John Soane's Museum.

with a plan of Longford Castle, Wilts. by W. Hogarth, 1742'—has led to
the supposition that Jacobsen's triangular house was a project for the
remodelling of Longford, but the plan is not that of Longford, and Jacob-
sen's name has not been traced in the building accounts preserved there.[13]
The only other house known to have been designed by Jacobsen was his
own, near Dorking, where Vertue dined one evening in August 1747.[14]
He died in 1772.

In about 1749 or slightly earlier[15] Thomas Hudson presented to the
Foundling Hospital his portrait of the architect (Plate 65). His cross-legged
pose which thereafter became popular is so close to that of *Sir John Sutton*
in Rysbrack's contemporary monument to him in Sherbourne (Glos.)[16]
that one can hardly believe that the two images were created independently
of each other. Jacobsen is shown standing in a landscape, leaning on a
plinth with a stone relief in the manner of Rysbrack (cf. Plate 23), rep-
resenting an appropriate subject, *Charity*. In his right hand (Plate 66) he
holds the plan of the Hospital engraved by Fourdrinier (Plate 10),[17] promi-
nently displaying the west front, already complete and teeming with
foundlings. Hudson is the most prosaic of English portrait painters in mid-
century, and no one could detect poetry in this face and body. Nevertheless,
it is one of his most accomplished creations; solid and well constructed if not
inspired; a decent piece of craftsmanship in the tradition of Highmore, if
not a leap into the future.

Jacobsen's principles of simplicity and utility in his façades was carried
over into the interior decoration of the Hospital as far as the rooms designed
for the children were concerned. The Boys' dormitory and the Boys'

[13] See letter from Christopher Hussey in *Country Life*, 1942, p. 621. It is, however, possible that
Bouverie, who was Vice-President of the Foundling Hospital in 1740–1 and certainly knew Jacobsen,
employed the architect in an advisory capacity at Longford, and supported his design for the Hospital
building.

[14] See Vertue, V, 1938, p. 155.

[15] The portrait is generally dated 1746 (by Waterhouse, 1953, p. 150 and 1965, p. 15, and by others),
but I have not traced the evidence on which this early date is based.

[16] Illus. Whinney, 1964, Plate 95A. Inscribed and dated 1749. Both this and the *Jacobsen* go
back to the Scheemakers of *Shakespeare* in Westminster Abbey (Whinney, 1964, plate 75) of
1740.

[17] See above, note 4.

dining hall in the west wing[18] were of the utmost austerity. So also was the oak staircase in the west wing (Plate 20),[19] which was preserved when the Hospital was demolished, and re-erected in the new premises at 40 Brunswick Square. The rooms where the Governors and Guardians held their deliberations were, in contrast, of great sumptuousness. Most splendid of all was the Court Room (Plate 21) on the ground floor of the west wing, faithfully dismantled after the demolition, stored, and erected in Brunswick Square in 1937 when the new offices were built. The atmosphere of the mid-eighteenth century can nowhere be better captured in the whole of London than in this room. The ceiling, the plaster enrichments on the wall, the mantelpiece, the doors and architraves are intact, so far as one knows exactly as they were originally.

The ceiling of the Court Room was the work of William, father of the sculptor Joseph, Wilton, and was presented by him in 1745, the year the west wing was ready to receive it. Wilton was also employed as stucco worker and plasterer in the Chapel. At about the same moment John Sanderson presented the fine pine wood sidetable, with rectangular green Grecian marble top, supported by carved figures of a goat and two children before a tree stump (Plate 47). These were the first presentations, leaving aside the portrait of the founder painted before the Hospital came into existence, and some untraced Harding roundels said by Vertue in 1745 to have been presented to the Hospital. They were quickly followed by the mantelpiece, designed for the Court Room and presented by J. Devall before the end of 1746 (Plate 48). This encloses a white marble bas relief of *Charity* (Plate 49), the second considerable work of art to become the possession of the Hospital, carved and presented by John Michael Rysbrack in the same year.[20]

Rysbrack was proposed as Governor on 26 December 1744 by Taylor White, the Treasurer in 1745, interested in the arts and an admirer of Brooking. He was elected Governor on 27 March 1745, and attended

[18] See illustrations in Nichols and Wray, 1935, opp. pp. 65 and 75.

[19] Dickens (*Household Words*, 19 March 1853) described the staircases at the Hospital as having 'balustrades such as elephants might construct if they took to the building arts'.

[20] I have failed to trace the source for the statement in Nichols and Wray, 1935, p. 262, that Hogarth designed the carved mantelpiece in the Committee Room, and feel they must have been mistaken.

meetings in the two following years. It is possible that he had promised his relief of *Charity* to the Hospital soon after his election, when the Court Room was more or less ready, and that he had submitted his painted terracotta study for it for approval.[21] This was noted by Vertue[22] probably in October 1746: 'the Modell of Clay of the same magnitude [as the marble] is admirably well done and therein shows his great Skill in the plastic Art wherein as the Materia is moleable, still permitts the Artist to express his mind more Artfully & with greater freedom ...'. The model was subsequently bought by Sir Edward Littleton and sent to Teddesley Hall. It is now in the Victoria and Albert Museum (Plate 22). In 1759 Rysbrack supplied Littleton with a drawing for a fireplace to support and frame it. In a letter dated 18 November 1756[23] he explains his intentions: 'According to Your Honour's desire I have made You a Drawing of a Chimney Piece Proportioned to Your Room and the Model of the Basso Relievo for the Foundling Hospital. ...' He goes on to propose that the relief should be framed in woodwork and placed over a marble fireplace, and offers his services as the designer of the fireplace.[24] This terracotta model was the immediate study for the Foundling marble. Another terracotta by Rysbrack of *Charity* in the Herron Museum of Art, Indianapolis (Plate 23) is inscribed and dated 1745. The head of Charity and one of the boys are clearly connected with the Foundling relief, but it is not known whether Rysbrack ever intended it for presentation to the Charity.

The Foundling Hospital during crucial months of 1746 took on a new lease of life. It now had an immense and handsome building housing hundreds of forsaken children, with a staff to cope with them and officers to direct policy. The planning stage was over; the operational stage was under way. I am not concerned in this book with the medical and administrative history of the Hospital. This has already been adequately told by Nichols

[21] See Webb, 1954, pp. 131–2, and below under catalogue No. 103.

[22] Vertue, III, p. 132, under date '1746 Octob.' (added later).

[23] Quoted by Webb, 1954, p. 196.

[24] Further letters from Rysbrack to Littleton, dated 11 December 1759 and 7 April 1761, quoted by Webb, 1954, pp. 204–5, continue the story of the terracotta. In the latter, Rysbrack announces that the cow's horn has been broken. The horn at the Foundling Hospital has suffered a similar fate: 'but it looks the more antique as Doctor Mead said of it'.

and Wray in their *History* published in 1935. I am concerned with the Hospital as a centre of artistic activity, and have reached the most dramatic moment in the story: when suddenly this institution dedicated to the 'Maintenance and Education of Exposed and Deserted Young Children' became the most prominent art centre in the British Isles, and continued as such for fourteen years. I must now turn to the circumstances which brought this about.

III

ARTISTS ASSOCIATED WITH THE HOSPITAL
(1746-51)

UNTIL the last day of 1746, the General Court Minutes had been largely concerned with administrative problems of no special relevance to the history of art. Then suddenly on that day, with Hogarth and Rysbrack both present, we come on the following announcement:

The Treasurer also acquainted the General Meeting, That the following Gentlemen Artists had severally presented and agreed to present Performances in their different Professions for Ornamenting the Hospital viz Mr. Francis Hayman, Mr. James Wills, Mr. Joseph Highmore, Mr. Thomas Hudson, Mr. Allan Ramsay, Mr. George Lambert, Mr. Samuel Scott, Mr. Peter Monamy, Mr. Richard Wilson, Mr. Samuel Whale, Mr. Edward Hateley, Mr. Thomas Carter, Mr. George Moser, Mr. Robert Taylor and Mr. John Pine. Whereupon this General Meeting elected by Ballot the said Mr. Francis Hayman etc. etc. etc. Governors and Guardians of this Hospital. Resolved That the said artists and Mr. Hogarth, Mr. Zinke, Mr. Rysbrack and Mr. Jacobsen or any three or more of them be a Committee to meet Annually on the 5th of November to consider of what further Ornaments may be added to this Hospital without any Expence to the Charity.

Thereafter the artists occasionally attended General Court meetings. Hogarth and Rysbrack were the most assiduous attenders, but on the occasion of the presentation of Arms (1 April 1747), besides these two, Hayman, Moser, Pine, Ramsay, and Zincke (who had been Governor for six years) were present, and on 11 May 1748, only Pine, although there were eighty Governors at the meeting. The proceedings, if they were ever kept, of the Committee formed to meet annually to consider possible future donations have not come to light. This precious document would have illuminated a rather dim corner in art history. Perhaps some intellectual among nineteenth-century Secretaries, sensing its value, made off with it.

Works of art by all the artists named in the Minutes have been identified among the property of the Hospital except those presented by Scott, Carter, Moser, Taylor, and Pine. Monamy's picture has disappeared. Since it is made clear that some have merely 'agreed to present Performances', perhaps their performances never materialized. Scott had specialized in marine painting until the mid-1740s when he took to topographical views, and no doubt his contribution was intended to be a shipping subject. Monamy's enormous canvas, *The English Fleet in the Downs*[1] has not been seen since about 1909, and the only record we think we still have of it is a view of the left half hanging on the wall of a room in a charming engraving of 1749 (Plate 24), depicting the admission of foundlings to the Hospital.[2] Here the Highmore of *Emerson* (Plate 42) hangs over the mantelpiece. Beneath it is a scene of balloting for admission of infants. A woman takes her chance in a bag; on the right a lucky woman has picked out the winning white ball; on the left an unlucky one has picked out a black ball, and will be obliged to take her baby away. So numerous were the applications that a rigorous system of selection had thus to be enforced. When later a policy of indiscriminate admission was adopted, all that ensued was chaos.

To return to the list of missing artists: Thomas Carter I (d. 1756) is known among other occupations as a maker of marble fireplaces[3] and it is possible that with Devall he was responsible for work of this character in the Hospital. We are equally at sea over the sculptor Robert (afterwards Sir Robert) Taylor, though we know he acted as Surveyor to the Hospital. As for George Michael Moser, gold-chaser, medallist, and enameller, nothing in the Hospital can be associated with his name. All we know of the contribution of John Pine the engraver are references in the Minutes to his having presented in 1749 a plan of London, and in 1750 'a silver seal of the crest of the Hospital with a handle, to be used on the small seal of the Hospital'.[4] He engraved plates for Handel's musical performances,[5] and

[1] Whatever is known about the Monamy is summarized in my catalogue entry under B, 'Pictures Untraced in the Collection'.

[2] By N. Parr after a drawing by S. Wale, published 9 May 1749.

[3] See Whinney, 1964, p. 128.

[4] Gen. Comm. under 1 November 1749 and 18 April 1750 respectively.

[5] Gen. Comm. under 4 April 1750 and 20 March 1751. For further details, see below p. 46.

regularly attended meetings of the General Court in the early 1750s. George Frederick Zincke, the miniaturist and enameller, one of the artists invited to join the special committee to meet annually, was a favourite of George II, and Governor of the Hospital as early as 1740.

Here were gathered together almost all the leading artists of the day, including some quite young men who had yet to make their name and who were given their chance by the Charity to do so. The circumstances of their admission as Governors and Guardians is not precisely known, but they can be inferred. In order to understand how this talented band ever came together, I have to go back some years to the early history of art Academies and Societies in Great Britain, and examine the artistic situation in the 1740s. The story has often been told, and I must be excused for providing nothing more than a summary.

An Academy was opened in St. Martin's Lane in October 1720 by Cheron and Vanderbank. This was a life class. Highmore and William Kent are named among the students. It only lasted a few years, but revived when Hogarth, whose name appears for the first time among the list of members, founded a second St. Martin's Lane Academy in 1735.[6] The latter had no charter but seems to have developed in the late 1740s into a more ambitious organization than a life class. It was managed by a Committee of artists, and a Sub-Committee to examine the credentials of students, on which at times Hogarth, Gravelot, Hayman, and Roubiliac served. In 1743 it was managed by Wills. In 1744 Gravelot was its drawing master, and Hayman the teacher of painting. Gainsborough is said to have been introduced by Gravelot, and Richard Wilson is said to have been a member.[7] In 1745 Roubiliac was elected to the post of lecturer on sculpture. In the following year it 'continued—with success and great improvement.—the principal Directors Hayman Hogarth Ellis. Wills painters. Statuary and Mr. Moser chaser—&C'.[8] Here, then, was a flourishing institution, dedicated

[6] See Vertue, VI, p. 170; Whitley, 1928, I, pp. 17, 21; Vertue, III, pp. 76, 170.

[7] According to Bate-Dudley in his obituary of Gainsborough in the *Morning Herald*, 4 April 1788, Gravelot introduced Gainsborough there. In fact there is no mention of Gainsborough's name at the Academy in the 1740s (see Kitson, 1968, p. 72, note 104). John Thomas Smith (*Nollekens and his Times*, (London, 1828), p. 343) was told by Nollekens that Wilson was a member.

[8] Vertue, III, p. 170; Esdaile, 1928, p. 133.

to the artistic education of the young, to which some of the most prominent painters and sculptors gave their services. Of those mentioned, only the names of Gravelot, Roubiliac, Gainsborough, and Ellis fail to turn up as Governors of the Foundling Hospital on that memorable day 31 December 1746. Gravelot returned to Paris in that year; Gainsborough was a mere boy; and as for Ellis, the last survivor among Kneller's pupils, perhaps he was thought or thought himself too old. The absence of Roubiliac alone is puzzling, but perhaps the strong position Rysbrack held in the Hospital was an impediment.

At about the same time as Hogarth's Academy was founded, another school of painting run by Moser was opened with premises in Arundel Street, but it was afterwards united with the St. Martin's Lane Academy.[9] More important and better established—described by Vertue as the 'Tip Top Clubb of all'—was the Society of Virtuosi of St. Luke, or St. Luke's Club, tracing its origin back to the seventeenth century. The custom was to dine at a Tavern on St. Luke's Day. Two of the names of Stewards appear among the Hospital's Governors and benefactors: Zincke (1731) and Rysbrack (1735).[10] Rysbrack was the last Steward in 1735, and the only sculptor-member in the 1730s. Mercier was Steward in 1728 and attended regularly in the early 1730s, but was away from London between 1739 and 1751, the period when he might have become eligible for Governorship of the Charity.[11] The annual feasts of the Virtuosi continued until at least the mid-1740s, and served as models for similar festive occasions held in the fifties at the Foundling Hospital.

By the mid-1740s, thanks largely to Hogarth's Academy, British art was in a more flourishing state than at any time since the seventeenth century. Native talent was blossoming. Some of the best painting may have been ignored by a philistine Court and aristocracy, but there were new middle-class patrons eager to encourage the more popular forms of visual art, decoration, engraving, book illustration. The infusion of French rococo was stimulating artists to new experiments. Great encouragement was given

[9] Whitley, 1928, I, p. 21; Edwards, 1808, p. xxi.
[10] Virtuosi of St. Luke MS., p. 75.
[11] Catalogue of Mercier Exhibition, York/Kenwood, 1969, p. 11.

to Hogarth, Hayman, and Monamy by the commission for the adornment of Vauxhall Gardens.[12] The moment was ripe for patronage on a still grander scale. The Foundling Hospital supplied it.

It is easy enough to reconstruct what happened even though we are not in possession of the facts. The politician Hogarth, back in 1739, had seen the possibilities for self-advancement by identifying himself with the Charity. At that time he can hardly have realized that the Foundlings were to become within ten years a place of pilgrimage, one of the sights of the town, to which Londoners, the mighty and the humble, would flock for a glimpse of the toddlers, now cleaned up and tidy in their school uniforms, properly looked after and taught useful trades. But he must from the very first have foreseen that at least some distinguished visitors would make their way to Lamb's Conduit Fields, and would be bound to notice, not only the infants and their charges, but any embellishments the Hospital had to offer; and so conceived the idea of persuading his colleagues in the St. Martin's Lane Academy to present paintings and sculpture, because by so doing not only would they be supporting a fine enterprise, but they would be exhibiting their works to new, wealthy clients, who might in turn be persuaded to commission from them further work. (In fact, as it turned out, the opportunities presented did not result in important new commissions, but nobody could have guessed this at the time.) Thus the Hospital was destined to become with Vauxhall Gardens the first premises where works of art were on public display. In return, the Hospital would profit by having its walls embellished free of charge.[13]

By July 1746, even before the artists were elected Governors, some of their pictures were already on the walls in the west wing.[14] In May of the following year, at a meeting which needless to say Hogarth attended, in view of his passionate concern about copyright, it was resolved that artists presenting works of art should have liberty to appoint their own engravers,

[12] See Pye, 1845, chapters III and IV; Gowing, 1953, pp. 6 ff.; Waterhouse, 1958, p. 14.
[13] See Gwynn, 1766, p. 24.
[14] Gen. Comm. under 16 July 1746: 'Resolved: That all the Pictures which are or shall be put up in this Hospital for the Preservation therof be lined with Boards.'

and that 'no other Person have Power to Copy, Engrave, or Print the same Except this Corporation . . .'.[15] Hogarth's influence was paramount.

One suspects it was Hogarth once more who laid down the iconographic programme for the pictorial decoration of the Court Room (see Plate 21). Over Devall's fireplace hung Rysbrack's relief of *Charity*. Around the walls were four large canvases illustrating scenes from the Old and New Testament related to the theme of the rescue of young children: Highmore's *Hagar and Ishmael* (Plate 50) begun in about the winter of 1945–6; Hayman's *The Finding of the Infant Moses in the Bullrushes* (Plate 51), and Wills's *Little Children brought to Christ* (Plate 53), both painted and presented in 1746; and Hogarth's own *Moses brought before Pharaoh's Daughter* (Plate 52) ready before the end of 1746. All four pictures were in place by the beginning of the following year. Between them hung small tondo canvases showing views of the Foundling Hospital itself and seven other views of London hospitals. There is some confusion about these tondos. Vertue tells us in 1745 that some 'peices of Landskip in Rounds' were presented to the Hospital by Francis Harding, and implies that in 1751 there was more than one Gainsborough and that the roundels numbered twelve in all. On the other hand an untraced list of 1751 mentions only eight—the number now surviving. This discrepancy cannot yet be accounted for. Gainsborough's *Charterhouse* (Plate 54) and three tondos by Wale, *Christ's*, *St. Thomas's* and *Greenwich* (Plates 59, 60, 61) were in the Collection by 11 May 1748. Haytley's *Chelsea* and *Bethlem* (Plates 57, 58) and Richard Wilson's *St. George's* and *Foundling Hospital* (Plates 55, 56) were in place by 1751.[16] All four history pictures and the eight tondos now hang in 40 Brunswick Square in their correct relative positions.

Hogarth appreciated that British painting could only rival continental schools if it essayed heroic histories on a grand scale. But his colleagues at the St. Martin's Lane Academy, Hayman and Wills, and his old friend from the days of Cheron's and Vanderbank's Academy, Highmore, were not practised in this field, and in consequence their three pictures are somewhat provincial, in contrast to what was going on at the same time in Paris,

[15] G.C.M. under 13 May 1747.
[16] See catalogue entry under the Gainsborough (No. 31) for further details.

Rome, and Venice. They fall far short of the splendid portraits by Ramsay and Highmore himself which were being presented concurrently to the Hospital; but then the tradition of British portrait painting, though it may have sunk to a low ebb after the death of Kneller, had never been lost. Wills's picture (Plate 53), for instance, is a weak importation from the Roman High Renaissance. He was probably wise to take up a curacy in Leicestershire in the 1750s and to give up painting. His excuse for doing so does not sound at all convincing. '... If when I put up the Foundling Hospital picture', he wrote, 'there had been patrons, judges, or lovers of the art, I need not have suffered this exile or have been under the necessity of resigning the art itself. ...'[17] Hayman's picture in a similar style, though more Frenchified (Plate 51) falls into the same fault of strained expressions on the faces, but the group on the left with Moses being carried out of the bullrushes has a pleasant liveliness. As one would expect from an artist steeped in the tradition of Kneller, Highmore's *Hagar* (Plate 50) is the most English of the four, but he was not attuned to the Grand Manner, and as a result his figures are stilted, his landscape setting conventional and dull.

Hogarth's own picture (Plate 52) is the most successful, though even his effort falls between the stools of the ideal and the particular.[18] We are not surprised to find him appropriating the theme of the infant Moses for his own use. 'There is not perhaps in holy writ another story so exactly suitable to the avowed purpose of the foundation', wrote Ireland,[19] and indeed from the days of Coram onwards the Hospital was haunted by that first foundling. The child Moses is shown brought before Pharaoh's daughter by his mother (whom the princess takes to be his nurse) like any foundling to Lamb's Conduit Fields, while the mother receives from the Treasurer the wages for her services. A crocodile lurks under the Princess' chair, and vaguely Egyptian-looking pyramids and buildings, and a sphinx, are

[17] Quoted by Whitley, 1928, II, p. 274. Letter to Dr. Birch of February 1756.

[18] I take this good idea from Paulson, 1965, I, pp. 27–8, who writes: '... he [Hogarth] failed [in showing how heroic painting should be done] not because he was unable to achieve the accepted convention of ideal beauty but because, refusing to be bound by such conventions, he was yet unwilling or unable to commit himself thoroughly to an alternative approach; the result was an incongrous mixture of the ideal and the particular (as in *Paul before Felix* or *Moses brought to Pharaoh's Daughter* ...)'.

[19] Ireland, 1791–8, II, p. 89.

glimpsed in the distance. The picture lies half-way between the High Baroque and incipient realistic classicism. It may be going too far to claim that it is influenced by an engraving after Poussin,[20] but it does foreshadow classicizing artists of the second half of the eighteenth century in France, like Greuze, who turned back to Poussin for inspiration.[21]

An unpublished red chalk drawing of this composition (Plate 25) exists in a collection in North Berwick, along with a companion drawing repeating Hogarth's *Paul before Felix* in Lincoln's Inn. The only essential difference between them is that, whereas the *Moses* drawing is in the same direction as the painting, the *Paul* is in reverse. Both drawings were used for engravings published in 1752 after the two pictures. The *Moses* engraving was a collaboration between Luke Sullivan and Hogarth (which could account for the fact that the drawing in this case follows the painting more closely than the other follows its counterpart). On the grounds of style alone I am inclined to attribute the drawing for *Moses* to Sullivan, since it does not seem—even taking into account its pedestrian purpose—to have Hogarth's masterly touch. This view is supported by examination of the companion drawing of *Paul before Felix* about which we are better informed. This is a study for Sullivan's engraving which Hogarth rejected, whilst another, apparently superior drawing in the Pierpont Morgan Library is a study for the engraving Hogarth himself substituted, and dated on the same day as Sullivan's. It is reasonable to argue that Sullivan would have been responsible for the composition study for his own print; and since the two North Berwick drawings are clearly by the same hand, it follows that he would have designed the other as well.[22]

[20] I fail to see the connection with Poussin's *Child Moses treading on Pharaoh's Crown* (Blunt catalogue, 1966, Nos. 15, 16) which Antal has proposed (1962, p. 152). Nevertheless, the comparison is instructive as showing the direction Hogarth was taking.

[21] Antal, 1962, pp. 200-1, compares to Vien's *Marchante d'Amour* of 1763, and thinks that Vien was influenced by the Hogarth. This is conceivable, but I find the comparison with Greuze more illuminating.

[22] The two engravings by Hogarth and Sullivan after the *Paul before Felix*, and the engraving by Hogarth and Sullivan after the *Moses* are reproduced by Paulson, 1965, plates 207, 280 and 208 respectively. Whitfield, 1971, believes that the North Berwick drawings are by Hogarth, and working on this assumption, deduces that Hogarth originally intended certain features of Sullivan's print after the *Paul*, such as Paul's lectern, the volute to the right, and the eagle in front of Tertullus, to have

The roundels of Wale and Haytley suffer from being too literal and painstaking. They are no more than typical mid-century topographical views, which became fashionable once Canaletto had reached London, and are best judged as charming decorative elements in no way superior to their oak-leaf and acorn frames (Plate 61). The three remaining roundels are in a different class altogether. Wilson's two views of the *Foundling Hospital* and *St. George's* (Plates 55, 56) detach themselves from the strict topographical tradition, to take their place in the world of landscape proper. Here we are permitted to enter a genuine countryside, where weather and light play parts no less crucial than architecture, where people inhabit the landscape and do not merely strike attitudes in it. Wilson was chiefly known as a portrait painter at this stage, but some early landscapes in a similar vein are recorded,[23] influenced like the Foundling Hospital tondos by George Lambert. Finally there is Gainsborough's little masterpiece of the *Charterhouse* (Plate 54), painted just before his return to East Anglia. It goes beyond even Wilson in its denial of the topography by its emphasis on light, atmosphere, and picturesqueness. The buildings can no longer be converted in imagination into their plan. 'It is the loveliest and the most natural English landscape that had been painted up to date, the work of a youth of twenty-one . . .',[24] that owes much to the Dutch, to artists like Van der Heyden, and yet is typically English in its intimacy. This is the first picture in the history of art that invites the comment 'England at last has its school of landscape painting'.

Its school of portrait painting, on the other hand, was well established, and the high quality of the portraits presented to the Hospital comes as no surprise, especially since the artists were driven to give of their best, in the knowledge that their talents were to be put for the first time to the test of the public. Between 1746 and 1751 no less than five portraits were presented,

formed part of the composition; and indeed nineteenth-century restorers repainted the picture to include them. The two Berwick drawings are evidently those mentioned by Oppé, 1948, under No. 69, as having been in Dr. Monro's sale in 1792 (for further details, see catalogue No. 42 below). Both drawings are dated 1752, but this may be no more than a record of the date of the issue of the prints.

[23] Constable, 1953, illustrates Plate 44a a *Westminster Bridge* (Philadelphia Museum of Art) apparently dated 1745, and Plate 38a a view of *Dover* engraved in 1747.

[24] In the words of Waterhouse, 1953, p. 183.

one of which, the *Earl of Uxbridge* by an unnamed painter, is unidentified.[25] The other four are two portraits by Hudson of *Milner* and *Jacobsen*, Highmore's *Emerson*, and Ramsay's *Mead*. These were contemporary portraits except for the Highmore which is dated 1731, but this must all the same have been considered appropriate for exhibition, not only because it is exceptionally beautiful, but because Thomas Emerson had been elected Governor of the Hospital in December 1739, and had died in 1745 leaving a large fortune to the Charity. He had been a sugar merchant in Thames Street. Highmore's father had also been in business in Thames Street, and it has been suggested that Emerson was a friend of the family.[26] I have already discussed the portrait of *Jacobsen*. Hudson's portrait of *Milner* (Plate 64) is another rather prosaic likeness, but like *Jacobsen*, highly professional and calculated to appeal to the more down-to-earth visitors to the Hospital. It cannot compare with Ramsay's *Richard Mead* (Plate 62) which with Roubiliac's *Handel* and Hogarth's *Coram* stands at the pinnacle of the Hospital's portrait collection, and is a masterpiece by any standards.

Dr. Richard Mead (1673–1754) was the most distinguished physician of his day, and I like to think that artists are inspired by true distinction to produce their best work. He had studied in the Universities of the north Netherlands, had travelled in Italy, and in the early years of the eighteenth century had had all honours showered upon him: 1703, F.R.S.; 1716, Fellow of the College of Physicians; 1727, physician to George II. His collections of manuscripts, printed books, coins, gems, drawings, statuary, and pictures were famous throughout Europe. He had known Ramsay in the mid-1730s and had supplied him with letters of recommendation during his visit to Italy.[27] A glance at his portrait (Plate 62) proves how effectively Ramsay on his return from Italy has assimilated the European Baroque tradition, expressing himself with the utmost fluency—the same

[25] See catalogue below, under B, 'Pictures Untraced in the Collection'. There is a mysterious entry in Gen. Comm. under 18 April 1750: 'The Treasurer acquainted the Committee that Mr. Hudson had offered to present the Hospital with Mr. Handel's Picture, and that Mr. Handel had consented to sit for it. Ordered that the Secretary do write to Mr. Hudson a letter of Thanks for his said offer, and acquaint him with Mr. Handel's having agreed to sit to him for his Picture . . .'. Nothing more is heard of this portrait, and Kerslake, 1966, note 1, is probably correct in thinking it never materialised.

[26] In the Highmore exhibition catalogue, Kenwood, 1963 (7).

[27] Vertue, III, pp. 93–4; Smart, 1952, p. 52; catalogue of the Ramsay exhibition, R.A., 1964 (15).

cannot be said of the Hospital's history paintings—yet at the same time has penetrated to the core of the man (Plate 63). A drawing by Van Haecken of *Dr. Mead* is in the National Galleries of Scotland (Plate 26). So closely does the design follow that of the portrait that one supposes it must have been done afterwards, for a possible future pose, and is not a preparatory study. The same remarks apply to Van Haecken's drawing of Hudson's *Milner* (Plate 27), also in Edinburgh.[28]

The contrast between *Coram* and *Mead* is instructive. In spite of his swagger, what could be more English than Coram's stocky body? Here is the typical middle-class Northerner, who, if he had ever taken it into his head to tour the Continent of Europe, would have been ill at ease, and rude, in the salons of Paris and Rome. Mead, on the other hand, takes his place comfortably in cosmopolitan society. It is just as easy to imagine him attending a reception in a Roman *palazzo* as presiding over a meeting of the College of Physicians, or paying his respects to the crude Hanoverian Court. Ramsay had Hogarth's portrait in mind when he painted Mead. It was a challenge. He saw that his only chance was to go to the opposite extreme, by producing an image blatantly European; only thus could he 'show up' Hogarth's defiant insularity. As a result, they both win.

Besides the Casali altarpiece in the Chapel, which I am leaving aside for the moment, only one other picture was acquired by the Hospital before 1751: this is Hogarth's famous *March to Finchley* (Plate 70). So often has it been described, so famous has it grown with the years, that I do not propose to go over the same ground once more.[29] It is sufficient to recall that the English guards in September 1745, brought back from the Low Countries and Germany by the invasion of Scotland by the Young Pretender, are marching through London and have assembled at the Tottenham Court Turnpike before proceeding to Finchley where they are to guard the approaches to the city. They have spent a night in revelry and are the worse for wear. Prostitutes hang out of the windows of the brothel on the right, bidding them farewell. Venereal disease threatens some of them; others are taking their passionate leave of the girls they slept with; others again pillage

[28] Inv. Nos. D. 2164 and D. 2165 respectively.
[29] The reader is referred to the bibliography cited in my catalogue entry, No. 41.

and fight, or nurse their hangovers. Their personal plight is aggravated by the infiltration of Jacobite agents who try out every device to corrupt them. Nevertheless, they march off in good order. This is not an anti-militarist or subversive picture at all, because the Jacobites are routed and virtue triumphs. It is therefore not such an inappropriate present for the virtuous Hospital as it at first appears. Hogarth held a lottery for the picture, and presented all the unsold tickets to the Hospital, foreseeing the profit to himself by its permanent display. Very conveniently, the winning number was among these tickets, and it was thus that a fourth masterpiece, added to *Coram*, *Mead*, and Gainsborough's *Charterhouse*, became the Hospital's property.

IV

ARTISTIC DEVELOPMENTS IN THE 1750s

GIFTS to the Hospital continued into the 1750s. John Ellicott presented his pendulum clock (Plate 67) in 1750, and three years later the future Royal Librarian Richard Dalton offered the Hospital thirteen plaster busts after the antique, two of which survive, of *Caracalla* and *Marcus Aurelius* (Plates 68, 69). The first Old—not so Old—Master entered the Collection in 1757: an unidentified *Elijah* of no great consequence (catalogue No. 47), the gift of the playwright and auctioneer Abraham Langford, perhaps on the occasion of the flattering invitation he received that year to dine at the Hospital in the company of the artists. The presentation of portraits continued apace. In 1757 Benjamin Wilson gave the Corporation his rather indifferent portrait of *Francis Fauquier* (Plate 77), a Governor of the Hospital, and in 1760 the Vice-President, the Earl of Macclesfield, presented his own portrait by this artist (Plate 80). In 1758 Shackleton gave his respectable full-length of *George II* (Plate 79). The only pictures of real distinction to enter the Hospital in the 1750s were portraits by Cotes and Reynolds, a seapiece by Brooking, and a landscape by Lambert.

The pastel by Cotes of *Taylor White* (Plate 76) dated 1758 is one of the least familiar pictures at Brunswick Square, being kept in a room there not open to the public; yet it is one of the most vivid, and commemorates a sitter who served for twenty-seven years as Treasurer of the Hospital, who was something of a patron of the arts, having proposed Rysbrack as Governor, and befriended Brooking. Reynolds in 1757 presented his portrait (not one of his outstanding works of this period) of another Vice-President, the *Second Earl of Dartmouth* (Plate 78). He was rewarded by being elected as Governor in 1759. A letter from him addressed to the then

Secretary, Thomas Collingwood, dated 28 February 1782 from Leicester Fields, is preserved among the Hospital papers (Plate 28): 'Sir, I beg my most respectfull Comp.ts may be presented to the Governors, I consider the nomination of myself to be one of the Stewards as a great honour conferr'd on me, and will certainly attend at the Hospital on the Anniversary in May next. . . .' This was the fortieth anniversary of the decision to go ahead with the building of the Hospital.

The Brooking seapiece (Plate 74), painted as a companion to the lost Monamy and presented by the artist in 1754, was his most ambitious and largest work. It is unlikely that such a little known painter would ever have come to the Hospital's notice had he not had the support and encouragement of the Treasurer, Taylor White. Lambert's introduction to the Hospital (Plate 75) was probably due to Hogarth, who was a close friend, and with whom he collaborated in the landscape backgrounds for the two religious paintings at St. Bartholomew's. Lambert's pastoral scene has the serenity of a truly mature landscape style in the Hobbema tradition.

Except for the Court Room, which has been reconstructed in the new offices more or less as it was, it is difficult to imagine the original appearance of the remaining rooms on the ground floor. One thing is clear; that the Hospital was dedicated to the children's welfare, and that therefore the children had to benefit from the presentations, hard though it may have been to instil into these barbarians respect for fragile canvases. In 1756[1] it was ordered 'That the Girls' Dining Room be particularly appropriated to receive all whole length Portraits, which have already, or may hereafter be given to this Hospital, and that the Rooms where they are placed at present, may be appropriated to receive all smaller works; and that the Whole Length Portraits be immediately removed into the said Dining Room.' In an attractive watercolour on long loan to the Hospital, signed by John Sanders and dated 1773 (Plate 30), the whole lengths are indeed shown on the walls of the girls' dining room. Reading from left to right are three pictures presented to the Hospital after the order for the concentration of

[1] Gen. Comm. under 10 November 1756. Nothing was done for a year, but the room was ordered on 19 October 1757 to be made ready to receive the full-lengths before 5 November, the evening of the artists' dinner at the Hospital (see below).

whole lengths in this room had been given: *Dartmouth, George II*, and *Macclesfield*; then an invisible work which could have been *Mead*; and finally *Coram*. *Milner* and *Jacobsen* were possibly on the near wall, or beyond what could be *Mead*.[2]

No sooner had the west wing been completed, than the Hospital became a centre for extravagant entertainments. A public dinner was held of the Governors 'and other Gentlemen that had inclination—about 170 persons great benefactions given [by] them towards the hospital'[3] on 1 April 1747, by which time the four history pictures were in place in the Court Room, and were admired by the assembled company (which is just what Hogarth hoped for). So great did the pressure for admittance become, that it was decided that at a ladies' breakfast to raise money for the Chapel, planned for 1 May 1747, no persons should be admitted except by tickets subscribed by those Governors who applied for them,[4] and special precautions had to be taken, such as the nailing of windows, so as to keep out uninvited guests.[5] Another ladies' breakfast given by the Governors, and a Governors' dinner, were planned for May of the following year. Tickets were again issued for the breakfast, and precautions again taken.[6] A further breakfast, at which it was again proposed to hold a collection for finishing the Chapel, was held in 1749, this time with the High Constable and six assistants to control the guests and the crowds.[7] The generally staid Hospital Minutes suddenly grow hilarious.

These early entertainments of Governors and their ladies gave the artists the idea that they could follow suit, on the model of the annual dinners of the Virtuosi of St. Luke, to which some of them had belonged in the 1740s.

[2] In the early days the pictures were always being moved about. In 1747, for example, the *Coram* was hung in the Secretary's Office; the *Mead* was moved from the Committee Room to an unspecified place where *Coram* hung earlier; and the Monamy was moved to the Committee Room. Later in the century, *Mead* went to the girls' dining room. The Brooking and the Monamy were both in the boys' dining room in the early nineteenth century. (See the respective catalogue entries.)

[3] Vertue, III, p. 135.

[4] Gen. Comm. under 1 April 1747. For further details about this and subsequent breakfasts (1748, 1749), see below p. 40.

[5] Gen. Comm. under 2 April 1747.

[6] Gen. Comm. under 24 February, 6 April, and 20 April 1748.

[7] Gen. Comm. under 5 and 19 April 1749. Nichols and Wray, 1935, opp. p. 201, reproduce the invitation card to this breakfast.

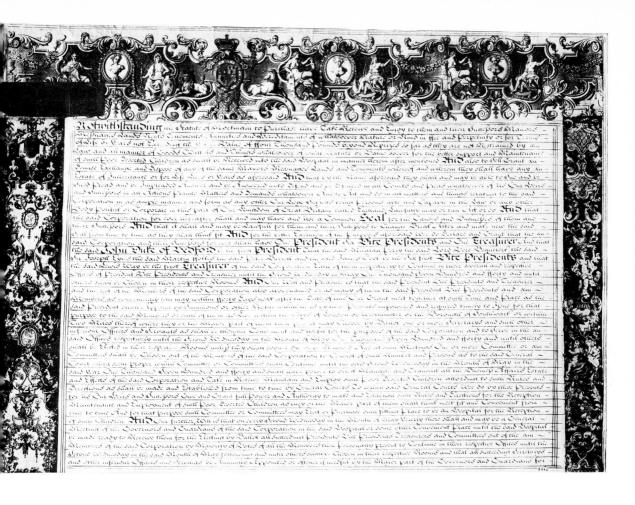

1. Royal Charter for the Incorporation of the Foundling Hospital, October 1739

2. Entrance to the Hospital looking north towards the Chapel, with statue of Coram by W. Calder Marshall, R.A.

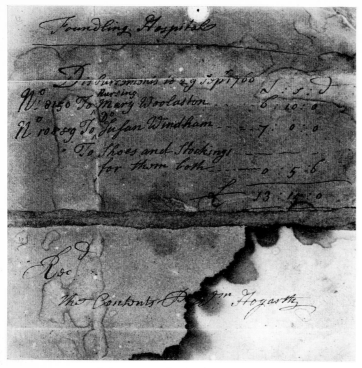

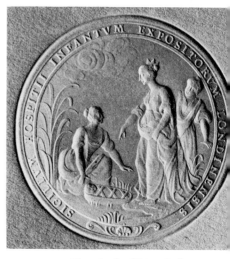

3. Receipt signed by Hogarth for 'Disbursements to 29 Sept 1760' on behalf of three children

5. First Seal of Hospital, 1739

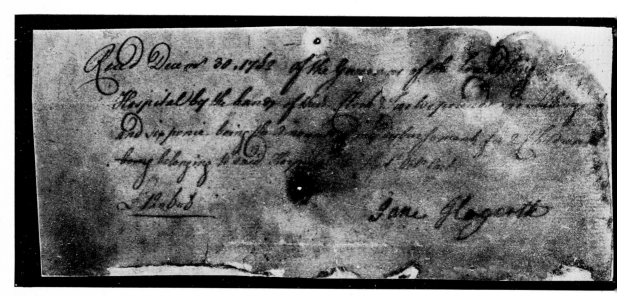

4. Receipt dated 30 December 1762 signed by Jane Hogarth for maintenance of children

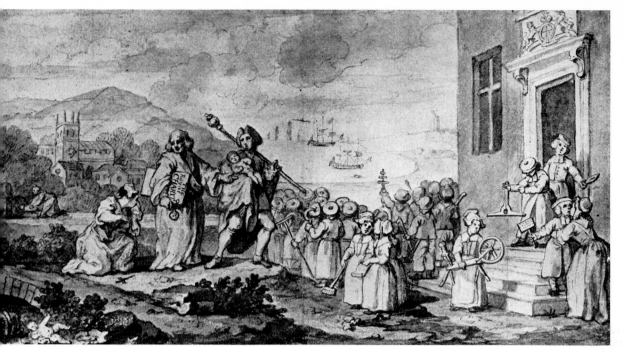

6. *The Foundlings*, by William Hogarth. Head piece to a Power of Attorney

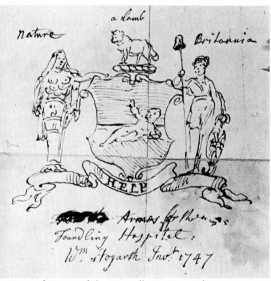

Coat-of-Arms of the Foundling Hospital,
by William Hogarth

8. *Infant studying Nature*, by William Hogarth

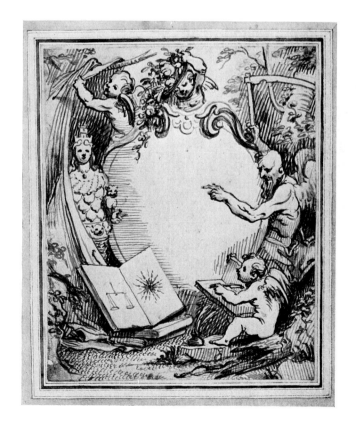

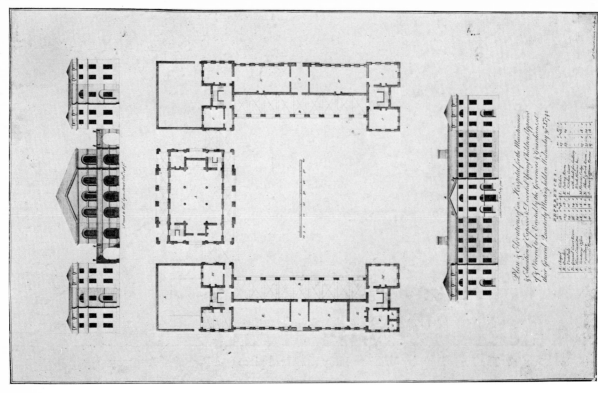

Plan and elevations of the Foundling Hospital. Engraving by ...

Engraving by Drevet after Rigaud's portrait of Samuel Bernard

Samuel Bernard
Chevalier de l'Ordre de St. Michel, Comte de Coubert
Conseiller d'Estat

11. *Bernard des Rieux*, by Maurice Quentin de La Tour. 1741

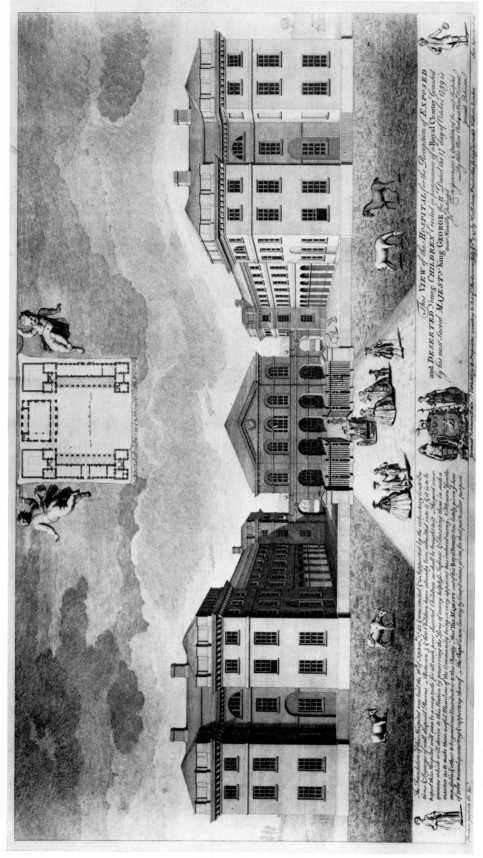

12. Plan and perspective view of the Foundling Hospital. Engraving by K. Roberts after a drawing by Jeremiah Robinson, published 6 July 1749

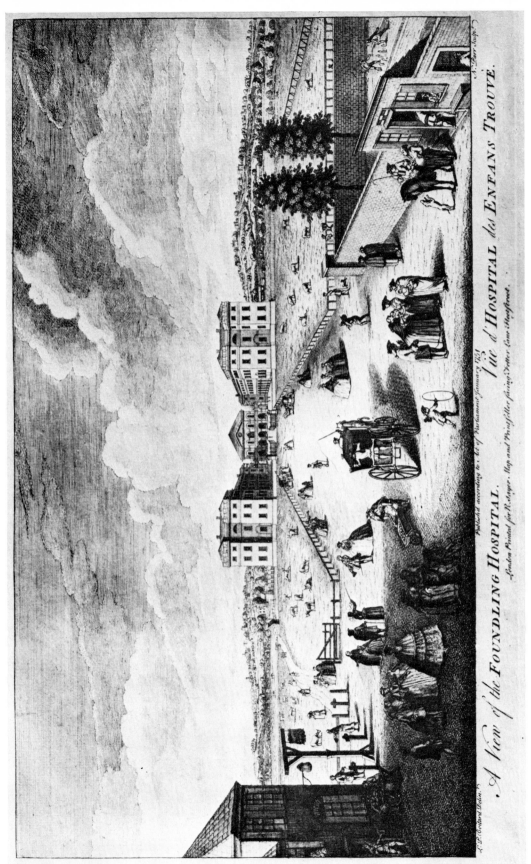

13. Perspective view of the Foundling Hospital. Engraving by N. Parr after a drawing by L. P. Boitard, published 1751

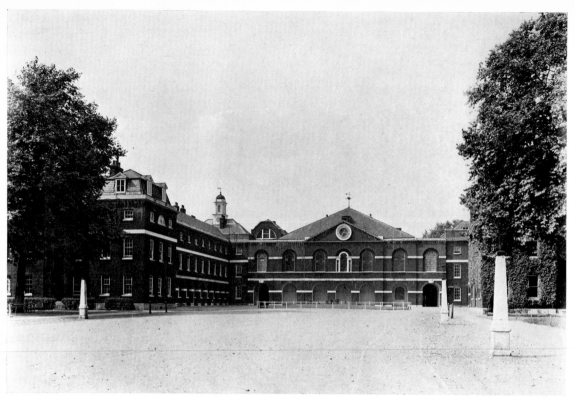

14. South front of the Hospital. Photograph taken shortly before demolition in 1920s

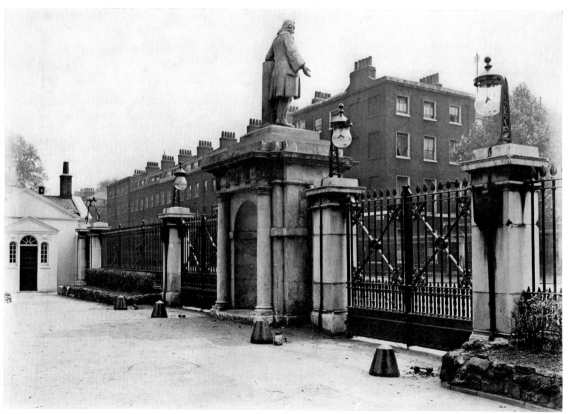

15. Front entrance to the Hospital overlooking Guildford Street. Photograph taken in 1920s

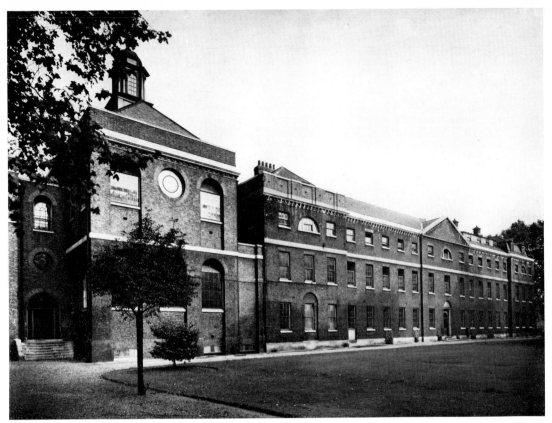

16. West front of the Hospital seen from the west. Photograph taken shortly before demolition in 1920s

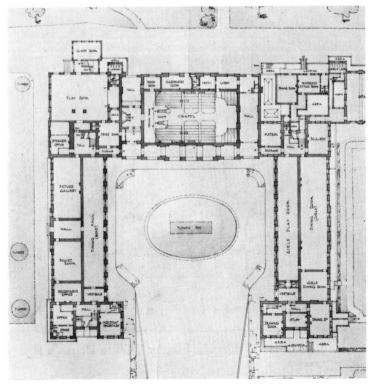

17. Detail from plan of the Hospital precincts, 1912

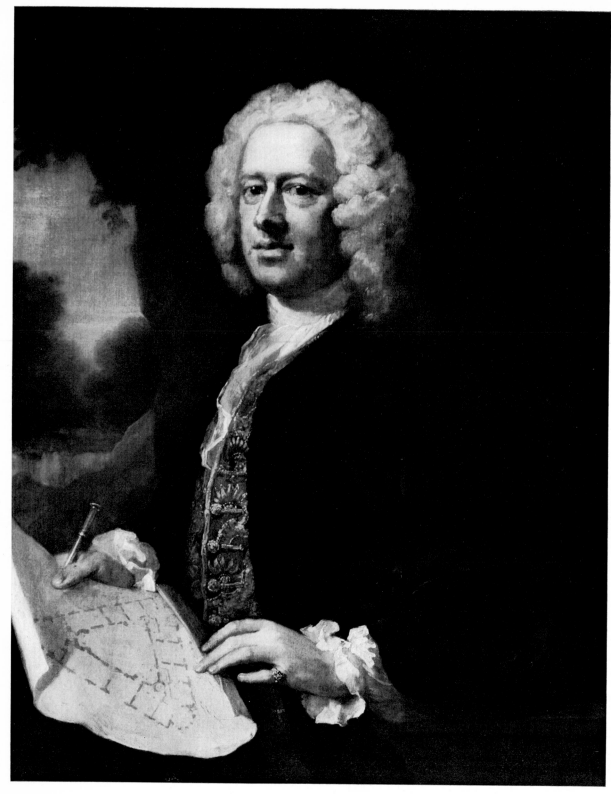

18. *Theodore Jacobsen*, by William Hogarth. Signed and dated 1742

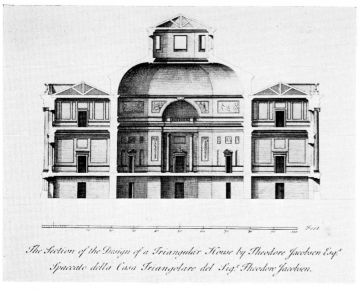

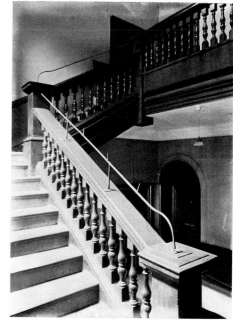

The Section of the Design of a Triangular House by Theodore Jacobsen Esq.
Spaccato della Casa Triangolare del Sig.r Theodore Jacobsen.

19. Elevation of a triangular house designed by Jacobsen. Engraving by Fourdrinier, c. 1749

20. Oak staircase in the west wing of the Hospital. Photograph taken shortly before demolition in 1920s, but the staircase survives in 40 Brunswick Square

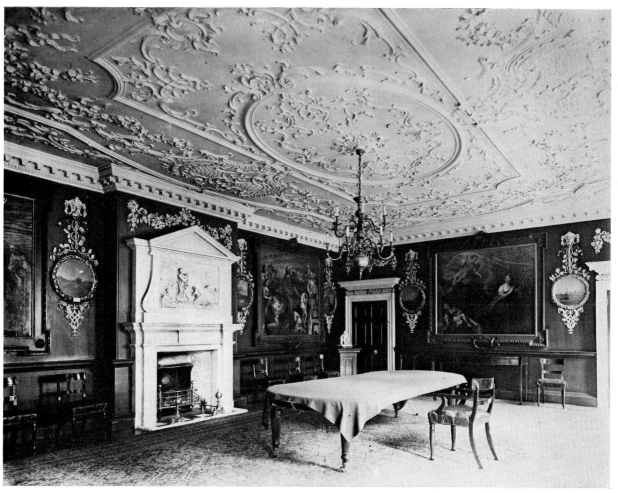

21. Court Room of the Hospital. Photograph taken shortly before demolition in 1920s, but the Room survives in 40 Brunswick Square

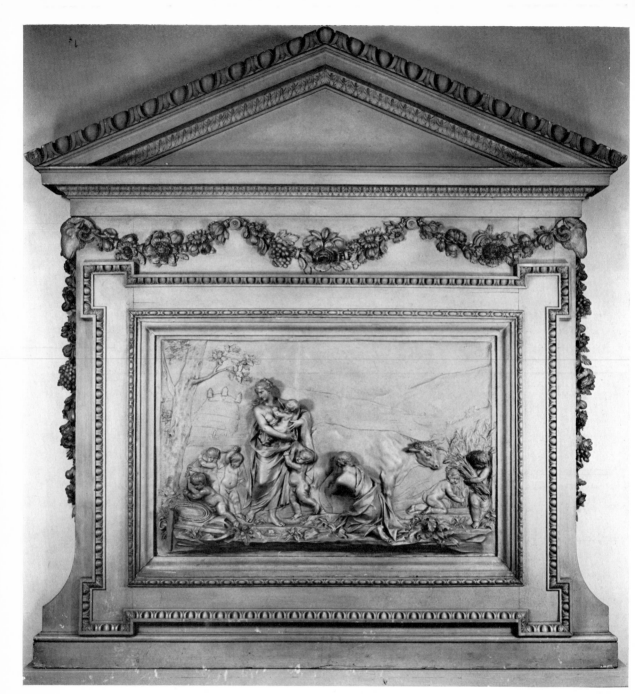

22. *Charity*, by John Michael Rysbrack

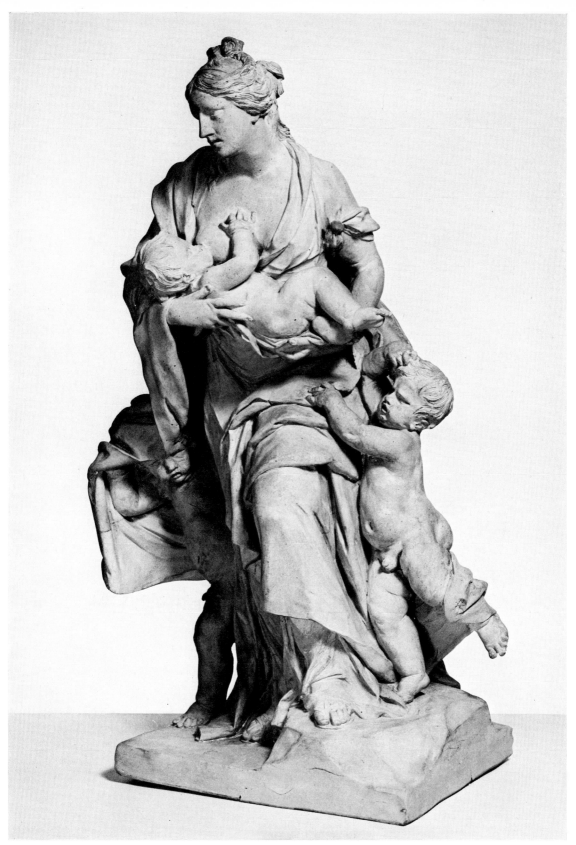

23. *Charity*, by John Michael Rysbrack

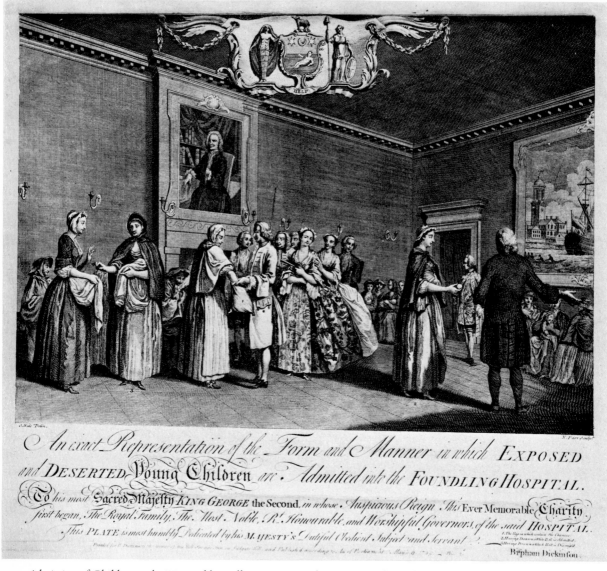

An exact Representation of the Form and Manner in which EXPOSED and DESERTED Young Children are Admitted into the FOUNDLING HOSPITAL.

To his most Sacred Majesty KING GEORGE the Second, in whose Auspicious Reign this Ever Memorable Charity first began, The Royal Family, The Most Noble, Rt. Honourable, and Worshipful Governors, of the said HOSPITAL. This PLATE is most humbly Dedicated by his MAJESTY's Dutiful Obedient Subject and Servant

Brspham Dickinson

24. *Admission of Children to the Hospital by Ballot.* Engraving by N. Parr after a drawing by S. Wale, published 9 May 1749

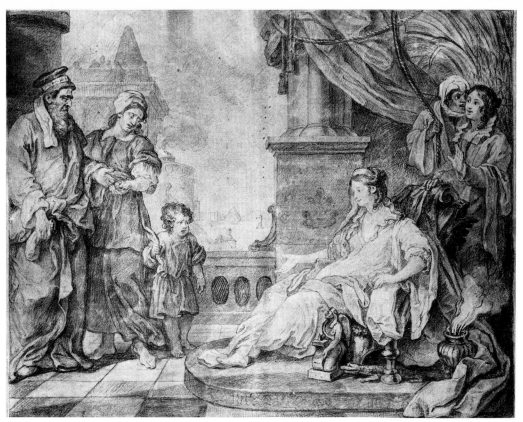

25. Study for engraving of Hogarth's *Moses brought before Pharaoh's Daughter*, here attributed to Luke Sullivan

26. *Study after Ramsay's Dr. Richard Mead,* by Joseph Vanhaecken or Van Aken

27. *Study after Hudson's John Milner,* by Joseph Vanhaecken or Van Aken

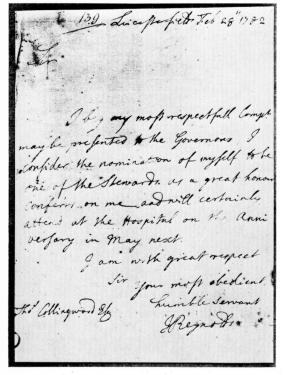

28. Letter from Reynolds to the Secretary of the
 Foundling Hospital, Thomas Collingwood,
 dated 28 February 1782

29. Declaration by artists, dated from Turk's Head
 Tavern, 7 December 1760

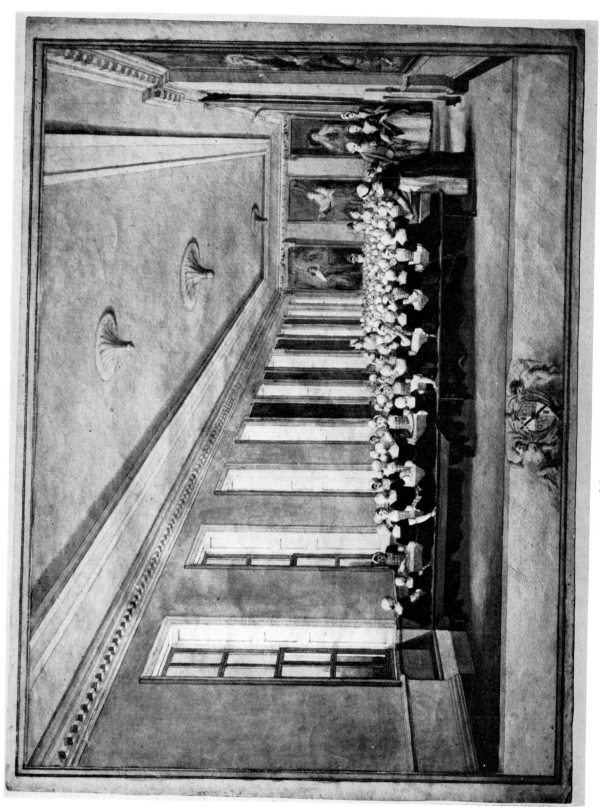

30. *View of the Girls' Dining Room*, by John Sanders

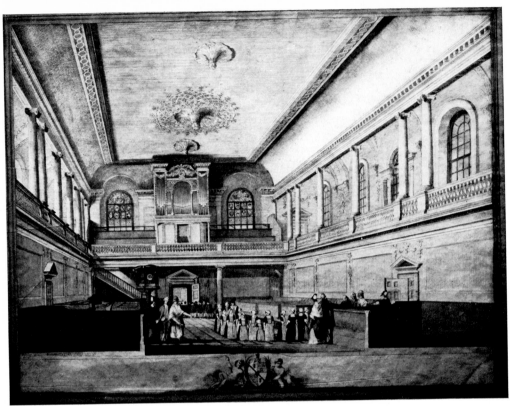

31. *View of the Chapel looking West,* by John Sanders

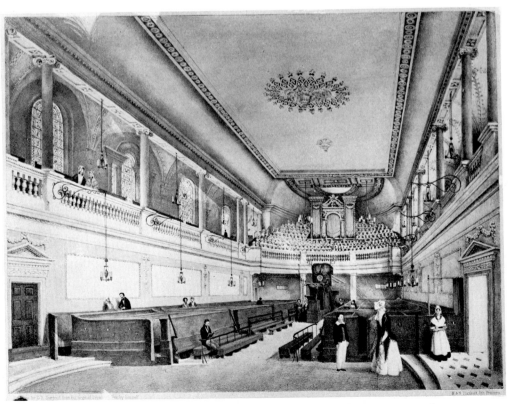

32. *View of the Chapel looking West.* Lithograph by G. R. Sarjent after a drawing

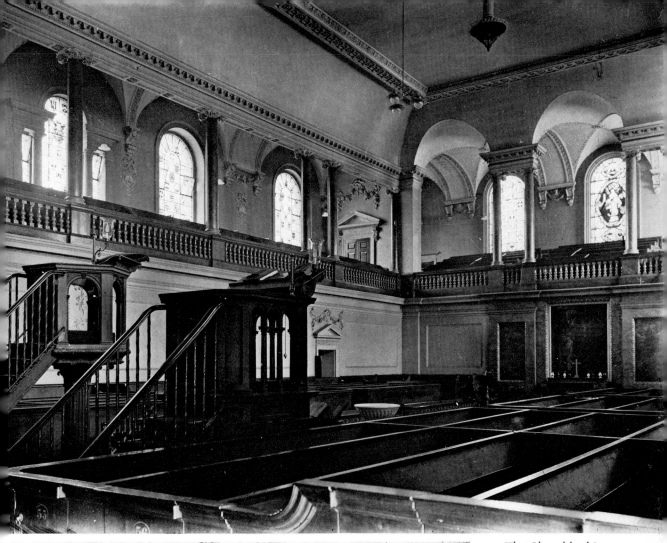

33. The Chapel looking east. Photograph taken shortly before demolition in 1920s

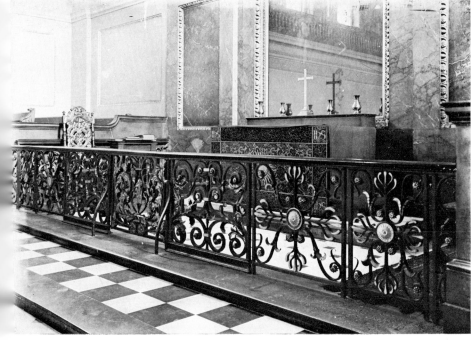

34. Altar Rails and Altar in the Chapel. Photograph taken shortly before demolition in 1920s

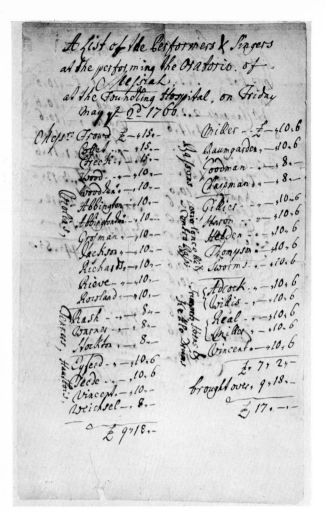

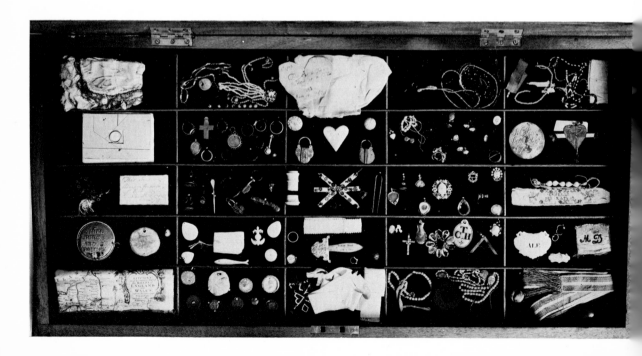

35. List of performers and singers at performance of *Messiah* in the Chapel, 2 May 1760

36. Collection of Foundlings' Coins and Tokens

It is generally said that these feasts were held regularly at the Hospital on 5 November, the anniversary of William III's landing, but in fact we only have accounts of feasts from 1757 onwards into the early 1760s. The first one recorded, in 1757, was an enormous gathering for dinner of 157 people: a document preserved at the Hospital headed 'Dilettante, Virtuosi, Feast' includes the names of artists of every description, architects, engravers, and members of other professions who attended the feast. However, before going on to describe subsequent celebrations—particularly the crucial gathering of 5 November 1759—I must return to the proceedings at the St. Martin's Lane Academy and describe the changes that were taking place there, because it is only against this background that the significance of the artists' feasts at the Hospital can be evaluated.

The idea of founding a public Academy on a regular basis, with a constitution and officers, was already being debated among the artists at St. Martin's Lane in the early 1750s. In 1753 a circular letter in the form of a press advertisement was sent to all artists of repute in London inviting them to meet at the Turk's Head Tavern, Greek Street, on 13 November, for the purpose of setting up a Committee to advise on the constitution.[8] Paul Sandby was the leading light in this, and Francis Hayman—one supposes to the great distress of his old confederate Hogarth—sided with him. Hogarth had always wanted a democratic constitution, not this new-fangled French oligarchy that was being proposed. As it happened the scheme came to nothing. But this was the signal for Hogarth's withdrawal from the deliberations in St. Martin's Lane.

Two years later negotiations were opened between the Dilettanti Society and twenty-five artists from St. Martin's Lane including Hayman and Reynolds (who joined the artists' group shortly after his return from Italy), with the intention of founding a Royal Academy. The two bodies could reach no agreement, and this scheme also fell through, because the Society of Dilettanti, which was only marginally concerned with artistic matters, wished to impose its own terms which were unacceptable to the artists. A third attempt was made by Robert Edge Pine who proposed to the Society

[8] The circular letter is printed by Edwards, 1808, p. xxii. See also Whitley, 1928, I, pp. 157–8, and Kitson, 1968, pp. 55–6.

of Arts, of which he was a member, that they should hire a room for the works of 'the present painters and sculptors'. Since suitable premises could not be found, this proposal was also dropped.[9] This was in 1759. It was not until 5 November of that year that all these abortive plans came to a head when Hayman took his chance at the artists' feast at the Foundling Hospital that night.

A contemporary journalist[10] reports that on this occasion a feature of the entertainment was the singing of an ode in which the guests were invited 'nobly to think on Hayman's thought' of founding 'A great Museum all our own'. The scheme must already have been debated at length among the artists at St. Martin's Lane, and it only needed this extra push to set it in motion. The immediate outcome was the drafting of an advertisement on the same day, inviting all artists to a general meeting at the Turk's Head Tavern, Gerrard Street, on 12 November 'to consider . . . a proposal for the honour and advancement of the Arts'. It was signed by John Wilkes (President, and a Governor of the Foundlings) and F. M. Newton (Secretary).[11] At this meeting it was decided to hold an exhibition every year in April. By January 1760 everything was settled except the exhibition premises. The Society of Arts agreed to lend their premises in the Strand, but quarrels broke out between the artists and the Society, and in the following year the exhibitors opened their own Society of Artists' exhibition in Spring Gardens. Thereafter annual exhibitions were held, and the Foundling Hospital lost its importance as an artistic centre.

However, this did not quite mark the end to festivities. A document preserved at the Hospital (Plate 29) dated from the Turk's Head Tavern 7 December 1760 announces that 'We whose Names are hereunto subscribed do agree to appear next 5th Novem.ʳ [1761] at the artists' Feast at the Foundling Hospital in Lambs Conduit Fields, in a Suit of Cloths manufactured by the Children of the Hospital at Acworth in Yorkshire. to be all of one Colour & that they be made in Yorkshire'. There follow fifty-one

9 Hudson, Luckhurst, 1954, p. 35.

10 Whitley, 1928, I, p. 170, quoting from the *Royal Magazine*.

11 Waterhouse, 1965, p. 47, makes the interesting suggestion that Wilkes was really the sponsor of the academy, and not Hayman, and that Wilkes was acting as cover for Reynolds, his old crony, but we know little about these backstairs machinations and can only guess.

artists' signatures (the name of Robert Edge Pine, one of the originators of the idea of an Academy, being deleted). Hayman, Wale, Richard Wilson, Reynolds, and Moser, who were all Governors and benefactors of the Hospital and all foundation members of the Royal Academy eight years later are present. Other foundation members include the miniaturist Jeremiah Meyer; the architects Gwynn, William Chambers, and Tyler; the medallist Yeo; the sculptor Joseph Wilton whose father had been a Hospital benefactor; and the painters Newton, Nathaniel Hone, and Paul Sandby. Roubiliac puts in his first appearance as a supporter of Hospital activities. Hogarth, who felt that the ideals of St. Martin's Lane had been betrayed, is defiantly absent from the list. Some of those who one might have expected to attend, such as Rysbrack, Highmore, and Lambert, were over sixty, and may not have relished the idea of appearing at the feast in these costumes.

A branch of the Foundling Hospital had been established at Ackworth, Yorks., and the children were employed there mainly on the manufacture of cloth. The Rev. Timothy Lee, Rector of Ackworth, informs the Treasurer Taylor White on 2 January 1759: '. . . Sixty [boys] is as many as we have room to employ for the present & that number in a very short Time will be able to make y.ᵉ greatest part of the Cloathing for all y.ᵉ Children belonging to the Charity. . . .' A few days after the Turk's Head Tavern meeting, on 15 December 1760, Lee writes to White: '. . . M.ʳ Paine [the architect, one of the signatories to the document] has wrote ab.ᵗ Cloathing for y.ᵉ Artists of y.ᵉ Turks Head Club. . . . He writes in y.ᵉ name of those Gentlemen who will Honor us wᵗʰ an Uniform against their next Annual Meeting. I am to send Him Patterns of Colours, but hope He'll choose that of Your Coat or something near it. . . .'[12]

From then onwards the artists had their own exhibition premises, their own rules and regulations, and just as the great period of British art opened, they had no further use for the school where they had been nurtured. They had found their feet in the world outside, and the Hospital was never to fulfill the same function for them again. This must not allow us to forget that during the fifteen years before the foundation of the Society of Artists, the Hospital had been the only exhibiting centre in the Kingdom (if we

[12] The letters from Lee to Taylor White are quoted in Nichols and Wray, 1935, pp. 163 ff.

except Vauxhall Gardens which was a pure pleasure resort); that as a result the art of the middle years of the eighteenth century can today be nowhere so well studied and assessed as in Brunswick Square. The years around 1750 may not have been our finest artistic hour, but they did see the awakening of our national artistic consciousness; they did mark the period of growth of common aims and aspirations; they put us for the first time at least since Thornhill on the map of Europe; they produced two painters of the first rank, Ramsay and Hogarth; they witnessed the peak period of a number of artists of considerable accomplishment: Rysbrack, Highmore, Hayman, Hudson, Brooking, Lambert. The Hospital alone of public institutions gave them the opportunity to exhibit their works for permanent display to potential patrons, long before a Royal Academy was contemplated, and they responded by presenting the best of which they were capable. Nothing in the whole œuvre of Ramsay and Hogarth is superior to their Hospital pictures, while for Highmore, Gainsborough, and Lambert one would be hard put to find better individual examples elsewhere. No other Charity came forward to encourage the artists to embark on history and religious painting on such a generous scale. Thanks to Handel, as we shall see, the Hospital Chapel became the liveliest centre in London for musical recitals. And to crown all this, the idea of the formation of an academy of artists which would hold annual exhibitions was born at a meeting held in the Hospital's own premises.[13] Ironically enough Hogarth, by persuading his colleagues to use the Hospital as an exhibiting centre, had brought about the very situation—the establishment of an academy with a strict constitution— which he was the first to deplore.

[13] This point was already noted a mere fifteen years after the event; see Strange, 1775, p. 63: 'The artists, observing the effects that these paintings [at the Foundling Hospital] produced, came, in the year 1760, to a resolution to try the fate of an exhibition of their works.'

V

THE CHAPEL AND MUSIC

IT was not until 26 March 1746—at least five months after the west wing had been completed—that the decision was taken to go ahead with the construction of the Chapel, the next most important element in this complex of buildings. Jacobsen was instructed 'to lay before the General Committee a plan for the building of a chappel for this Hospital'.[1] By 14 May the plan (which had evidently been considered in detail much earlier) was ready, and it was resolved 'that it should be carried into Execution without Vaults'.[2] The vaults were in fact retained, because after the plan had been approved in July the General Committee accepted the 'general Estimate of the Expence of building the Chappel upon the largest Plan given in by Mr. Jacobsen which including the arcades at each end of the Chappel to join it to the buildings on either side, with Vaults underneath the Chappel amounted to £4,195–17–4d'.[3] The arcades linking the Chapel to both wings can be seen in all the early engravings (see Plates 11, 12, 13); later, the Chapel was united by buildings to the two wings (see Plate 14). A man named Horne was to be appointed Surveyor. In August 1747 Devall, the designer of the mantelpiece in the Court Room, bought two Venetian windows for the Chapel from Canons, but they proved too large, and Devall agreed 'to vacate this Purchase'.[4] William Wilton, the designer of the Court Room ceiling, was employed in 1749 as plasterer and stucco-worker in the interior of the Chapel.

[1] G.C.M. under 26 March 1746.
[2] G.C.M. under 14 May 1746.
[3] G.C.M. under 1 July 1747, and Gen. Comm. under 29 July 1747.
[4] Gen. Comm. under 12 August 1747 and 23 March 1748. This was not, like the Court Room mantelpiece, a gift from Devall but was to cost the Hospital £24. 10s.

Money had to be raised for all this considerable expense, and accordingly a public breakfast was arranged to take place on 1 May 1747 for which tickets were issued, specifying: 'At the Desire of several Ladies of Distinction there will be a Collection towards building a Chappel for the use of the Hospital: The Foundation of which will be laid that day at One o'Clock.' A week after the breakfast we hear details of the first batch of donations.[5] Encouraged by this initial success the ladies organized breakfasts in the following two years, and more money was subscribed.[6] Plans for the completion of the Chapel could then go ahead, but the builders were dilatory and the date of the opening ceremony was constantly being postponed. It was scheduled for May 1750, but the matter was referred to a Sub-Committee to decide 'the Manner of opening the Chapel, and having a performance of Musick, and that they do consult Mr. Handel thereupon'. The opening was then planned for December 1752, but it was not until 16 April of the following year that the Chapel was finally opened for divine service,[7] although as we shall see it had been used for musical performances long before then.

One has to use one's imagination in reconstructing the original appearance of the Chapel, since its interior was much altered over the years. Our most precious document is a watercolour by John Sanders, signed and dated 1773, on long loan to the Hospital (Plate 31), a pair to the view of the Girls' Dining Room already illustrated (Plate 30). The differences between this, an early Victorian view of the Chapel (Plate 32),[8] and a photograph taken shortly before the demolition in the late 1920s (Plate 33), demonstrate the changes clearly enough. The two earlier scenes show approximately the same aspect, towards the west. The ceiling is unchanged. The galleries on the north and south sides remained more or less as they had been, down to the 1920s, except that after 1773 stained glass was added to the five windows on both sides. The order was given in 1749[9] to brick up the lower windows,

[5] Gen. Comm. under 8 April and 6 May 1747.

[6] Gen. Comm. under 8 April 1748, and 5 and 19 April 1749.

[7] Gen. Comm. under 7 and 25 February 1750; 25 October and 6 December 1752. See also Nichols and Wray, 1935, pp. 201–4 for further details.

[8] Lithograph by G. R. Sarjent after a drawing by himself, printed by M. & N. Hanhart.

[9] Gen. Comm. under 14 June 1749.

on the grounds that sufficient light came in from without, but the early engravings (Plates 11, 12, 13) do not yet show the windows blocked on the ground floor.

The west end was totally renovated. The original organ built by Dr. Jonathan Morse of Barnet and presented by Handel to the Hospital in 1750 was already in need of repair about 1765, and in the late 1760s was replaced by the new organ seen in Sanders' watercolour, built by Thomas Parker, which appears against the flat back wall in the west gallery flanked by two stained glass windows.[10] By the early Victorian period these windows had been eliminated (and presumably the stained glass was removed to two of the other windows in the Chapel), and the west wall was converted into a vast shallow niche against which Parker's organ still stood, by this time flanked by stalls where, as can be seen in the lithograph (Plate 32), the foundling boys and girls, judiciously segregated, formed a choir in tight clusters to either side. Between 1773 and the early Victorian period the pulpit—clearly dated 1751 on the purple drape in the Sanders drawing— was done away with. This pulpit was by a Mr. Keene: the plan for it was presented by Keene to the Governors on 20 February that year[11] and approved by Jacobsen. It was replaced by a three-decker affair, combining pulpit, reading and clerk's desk (see Plate 32). By the early 1920s, a pulpit of the same design as Keene's was substituted, with a separate reading and clerk's desk beside it (see Plate 33). The black marble slabs seen in Plate 32 in front of the north and south entrances, and in Plate 34 in front of and behind the altar rails, were part of the Chapel's original construction. We know this to be the case because on 13 December 1749 it was resolved 'That the stone pavement in the Middle Isle [sic] of the Chapel and the crossing be dotted with black marble.'[12] Devall, the maker of the Court Room mantelpiece, was commissioned to provide this, and also to pave the altar with marble.[13]

[10] Deutsch, 1955, p. 687. Langley, 1968, informs us that the organ case transferred to Berkhamsted and moved again to St. Andrew's, Holborn, in 1962, and generally regarded as Handel's organ, is not in his expert opinion the original organ, but is Parker's.

[11] Gen. Comm. under 20 February 1751.

[12] Gen. Comm. under 13 December 1749.

[13] According to Gen. Comm. under 10 February 1748, Devall is employed as a mason in the

It is more difficult to reconstruct the changes at the east end since to my knowledge we do not have any early views to it. However, it seems that the iron rails in front of the altar, seen in Plate 34 as well as in Emma Brownlow's *The Christening* (Plate 95) which happens to show precisely the same view of the altar, were erected under Jacobsen's direction. On 7 February 1750 it was announced that ' . . . M.r Wragg his Majesty's Smith had offered to make a present of Iron Rails in the Chapel'. Thanks are conveyed to him, and he is asked to refer to Jacobsen and Hogarth 'to consult him thereupon'.[14] Plans were laid for the altarpiece long before the Chapel had a hope of being ready. Before the end of 1747 a frame was being set aside for this purpose. On 30 November 1748 the Cavaliere Andrea Casali appeared before the General Committee to offer his altarpiece of *The Adoration of the Magi* (Plate 71). It was reported to have been finished by April 1750. Its framing was to be, like all constructional work in the Chapel, under Jacobsen's supervision. It was not until 31 March 1752, just over a year before the Chapel was formally opened, that the order was given for Casali's altarpiece to be installed. It remained above the altar until 1801 when it was replaced by West's *Christ presenting a Little Child* (Plate 86), and hung at the south end of the Boys' Dining Room.[15]

The substitution of the West for the Casali tells us much about changes in taste between successive Governors, and between the reigns of George II and George III. The Casali is in the spirit of the contemporary history pictures in the Court Room, particularly of the Hayman (Plate 51): that is to say, it lacks religious intensity, and depends for its effect on extravagant poses, sumptuous costumes, picturesque ruins, and crowds of men and animals disappearing into the distance away from the central foreground group. It is more exuberant than any of the English history pictures, overblown like an autumn peony, as one would expect it to be from a Central Italian painter brought up at the tail end of a tradition, on the late Baroque of Rome and Naples;[16] whereas to the English, struggling to establish their

Chapel. Gen. Comm. under 24 January 1750: he is made responsible for the Chapel floor; and for paving 'the Altar with Marble as Mr Jacobsen shall direct' (see catalogue below, No. 110).

[14] Gen. Comm. under 7 February 1750.

[15] For further information, see catalogue Nos. 24 and 81.

[16] Antal, 1962, p. 245, note 47, has correctly noted its artistic origins in Conca and Trevisani.

own tradition as they went along, such full-bloodedness did not come naturally when they tried to ape it. Whatever one may find to say against the Casali, at least it has the merit of effortlessness that the English pictures (except the Hogarth) lack. At the opposite end of the scale stands the Benjamin West, which bypasses the Italian Baroque in its conscientious progress back to Correggio and Titian. Behind the religiosity, there is genuine concentration of feeling here, a certain hesitancy in the gestures, and a brooding look in the eyes symptomatic of the unease of the *fin de siècle*. Even the President of the Royal Academy could not quite escape this. We would be hard put to it today to choose between them. To the Governors of 1801 the Casali must have come to seem too theatrical, and the West more appropriate both in subject and restraint for the foundlings' altar. The West is somewhat smaller, and its substitution involved some remodelling of the east end of the chapel.

The West was originally painted for Macklin's Bible, and presented to the Hospital after Macklin's death in 1797.[17] Four Governors purchased the picture for the altar in place of the Casali. But it soon showed signs of deterioration, of cracking 'by an improper application of Varnish', and West agreed to restore it in his studio at his own expense. On 15 September 1801[18] he wrote from Newman Street to the Treasurer Thomas Bernard as follows:

Sir,

I hold myself unfortunate to have been from home yesterday, when you favoured me with a call; but at the same time much gratified that you saw the Picture of Christ shewing the little Child which I have just finished for the Foundling Hospital,[19] and that it met with your Approbation.

The care with which I have passed that Picture, I flatter myself has now placed it in the First Class of Pictures from my Pencil (at least) I have the satisfaction to find that to be the sentiments of the judges of Painting who have seen it: should this be the opinion of the gentlemen of the Foundling, I shall think myself highly rewarded for that trouble, and beg of yourself, and them, to accept of the same; and with it my thanks for the handsome Letter I was honored with from them, by the hands of their Secretary, on the permission of my retouching that Picture, and bringing it to the condition it is now in. . . .

[17] See Edwards, 1808, p. 23. For further details about the acquisition, installation and restoration of the West, see under catalogue entry No. 81.

[18] Letter transcribed in Gen. Comm. under 16 October that year.

[19] Presumably West means it had been *adapted* for the altar, since we know he did not paint it for this purpose.

On 18 November Bernard reported to the Committee that the picture had been

extremely injured by the application of a strong Mastic Varnish applied by the Person for whom it was originally done [Macklin], before the Colours of the Picture had sufficiently hardened; that Mr. West as a compliment to the Hospital had removed this Varnish and in retouching and restoring the Picture had almost entirely new painted it, and had much improved it:—That if this application of his time and Professional Skill (which had been gratuitous on his part) had been to be paid for, he conceived that the pecuniary compensation would not have been so little as 100 guineas.

West was elected Governor at the end of the year in return for his services.

This was not the end of the story. Fourteen years later the picture was again found to be in bad condition—as the Secretary Morris Lievesley put it in a letter to West, it was 'suffering from want of care'. West, who had meanwhile been playing an active part as adviser on restoration of works of art to the Hospital, wrote to Lievesley from Newman Street on 15 May 1816:[20]

Sir,
 Last Autumn when I took a Survey of the Pictures in the Foundling I saw the condition of the picture I had the honour to paint was such, that demand attention, and then I requested to have it to my house to do what I saw it wanted. I was informed that the inside of the Church was also out of condition, and it was the intention of the Managers to have the whole repaired this Summer, and I defered taking the Picture under my care until the Church was cleaned, should that be carried into effect this Summer, I request to be indulged by having the Picture at my house while the church is putting into condition, then I will do what is proper for the picture's preservation, and I request this as a favour.

During that summer the Chapel was completely redecorated,[21] and by 15 September when it was reopened the altarpiece was back in its place 'not only retouched, but almost repainted by Benjamin West Esq. . . .'[22] It was still hanging over the altar in 1863 when Emma Brownlow copied it behind the priest officiating at the christening (Plate 95), but had disappeared from its position by the early 1920s, to be replaced by a mirror (see Plate 34).

The Chapel was not famous for its painting or its architecture. It was, and

[20] Transcribed in Gen. Comm. under 22 May 1816.
[21] Gen. Comm. under 12 June 1816. On this occasion the organ was cleaned and repaired, the Chapel washed, painted, and varnished.
[22] G.C.M. under 18 September 1816.

still is, famous for its music, and I must now retrace my steps to the middle years of the eighteenth century, to give an account of one of the Hospital's most imaginative enterprises, and of its greatest artistic benefactor besides Hogarth, George Frederick Handel. Handel's name has done more than anything else to spread the name of the Hospital wide over the world of music, and in every biography of the composer the Foundation looms large.

Music had always been one of the Hospital's activities, long before the Chapel had been built. At the premises in Hatton Garden in 1741, the Committee announced its intention of 'having an Anniversary sermon with Musick'.[23] But it was not until Handel became interested in promoting the Charity in 1749 that music became an integral part of the proceedings, and incidentally a money-spinner, as the wily Governors were quick to grasp. The ladies' breakfasts held from 1747 onwards had given the Governors, and Handel, the idea that funds could best be raised for the completion of the Chapel by concerts; and in 1749 Handel offered to conduct a musical performance in the Chapel, the profits being for the benefit of the building fund. The concert took place on 27 May in the presence of the Prince and Princess of Wales.[24] The advertisement announced that there was to be a 'Grand Performance of Vocal and Instrumental Musick under his direction, consisting of several Peices composed by him:

First. The Musick for the late Royal Fireworks.
 The Anthem on the Peace
Second. Select Peices from the Oratorio of Solomon relating to the
 Dedication of the Temple
Third. Several Peices composed for the Occasion, the words taken from
 Scripture, and applicable to this Charity, and its Benefactors.'

Handel was offered the Governorship, but declined on the grounds that his services would be better employed in organizing these musical perform-

[23] Gen. Comm. under 18 April 1741.
[24] Gen. Comm. under 4 May 1749 and G.C.M. under 10 May.

ances. However, in the following year he was elected Governor by ballot.[25]

So successful was the 1749 concert that it was decided to repeat it in the following year, but this time on a more ambitious scale. Handel presented the Hospital with Morse's organ for the Chapel, and a performance of the *Messiah* was scheduled for 1 May. Pine was commissioned to engrave a plate for the entrance ticket, 1,500 copies of which were to be printed. The text ran as follows: 'George Frederick Handel Esq[r] having presented this Hospital with a very fine Organ for the Church thereof, and repeated his Offer of Assistance to promote this Charity; on Tuesday the First Day of May 1750, at Twelve o'Clock at Noon, Mr. Handel will open the said Organ; and the Sacred Oratorio called Messiah will be performed under his direction. . . .' The concert raised £728. 3s. 6d.[26] On the invitation card, under Hogarth's plate of the Hospital Arms, gentlemen are requested to come without swords, and ladies without hoops, so as to make more room in the overcrowded Chapel.[27] Great confusion was caused by the arrival of 'many persons of Distinction' asking for tickets at the door, and being wrongly issued with them, with the result that others who had already subscribed had to be turned away. So Handel offered to give a second performance a fortnight later. Meanwhile Dr. Jonathan Morse of Barnet had failed to finish the organ in accordance with his contract made with the Hospital in 1749, and was asked to do so as soon as possible, in time for the second concert, and 'to have as many stops therein, as he can, for Chorus's'.[28]

All this was too good to be true. The money kept pouring in. At least three concerts were given in the Chapel in the first half of 1751.[29] The

[25] Gen. Comm. under 4 and 10 May 1749, and 9 May 1750. For further details about the 'Peices' selected, see Deutsch, 1955, pp. 670–1, who gives full quotations from the Minutes as well as from contemporary periodical literature.

[26] Gen. Comm. under 4 and 18 April 1750, and G.C.M. under 9 May 1750. See Deutsch, 1955, pp. 686 ff.

[27] The invitation card to the concert is reproduced by Nichols and Wray, 1935, opp. p. 203. This card was used on other occasions as well, the times and dates being left blank. (See Paulson, 1965, p. 277, for the card issued for a concert of Handel's music on 24 May 1759.)

[28] Gen. Comm. under 2 May 1750. The organ was reported to be still unfinished early in 1751 (Gen. Comm. under 23 January that year).

[29] Gen. Comm. under 24 December 1750 (announcement of concert for 14 February 1751); under 6 March (Handel Concert planned for 18 April); G.C.M. under 8 May (thanks to Handel for his

Messiah was again performed in April 1752[30] and yet again in May 1754 when the profits amounted to £607. 10s. 6d.[31] On the occasion of the opening of the Chapel for divine service in April 1753, an Anthem by Handel was performed, and the *Messiah* the following month. So popular had these occasions become that Jacobsen was instructed to design extensions to the galleries to accommodate Oratorio audiences.[32] Handel was elected to the General Committee in May 1752, but became practically blind within a year, and by 1754 his health had deteriorated to such an extent that he felt obliged to excuse himself to the Committee 'from giving any further Instructions relating to the Performances'. He approved the appointment in his place of John Christopher Smith, his assistant and amanuensis, as organist of the Chapel and conductor of his compositions.[33] Under Smith's direction, the profits from *Messiah* performances yearly between 1755 and 1759 inclusive amounted to £679. 4s., £662. 11s. 6d., £507. 18s., £368. 12s., and £408. 8s. respectively—showing a slight drop year by year except the last after Handel's death, but this was to be expected during the period of his decline. As a memento of the performance of the *Messiah* in 1760, the Hospital has preserved a list of the performers and singers (Plate 35), with the sums they were paid. Smith appears valiantly to have kept the tradition going. A considerable musician in his own right, he continued to be re-elected organist until 1770, when he was succeeded by Stephen Philpot.

On Handel's death in April 1759 a performance was given in the Chapel in his honour. Smith who was to direct it, was instructed by the Committee to 'chuse such subjects as he shall think proper'.[34] A copy of the word-book

'repeated Benefaction in the Oratorio's performed in the Chapel'). A performance of the *Messiah* was scheduled for 16 May (Gen. Comm. under 1 May). Gen. Comm. under 16 October, announcement of opening of Chapel on 5 December with another Handel concert, but as we know the opening was postponed. For further details, see Deutsch, 1955, pp. 706 ff.

[30] Gen. Comm. under 4 March 1752.

[31] Gen. Comm. under 17 April and 29 May 1754.

[32] Gen. Comm. under 29 May 1754.

[33] Gen. Comm. under 25 June 1754.

[34] Gen. Comm. under 8 May 1759. Another *Messiah* (not the Memorial Concert) was given on 3 May that year.

survives in the British Museum.[35] 'Sacred Musick', it is headed, composed by Handel and performed at the Hospital 'in grateful memory of his many noble benefactions to that Charity'. These did not cease with the offer of his services as a musician. A letter read in General Committee from his co-executor George Amyand on 25 April 1759 informs us that 'The late George Frederic Handel Esq:, has by a Codicil to his Will left to your Charity a Fair Copy of the Score, and all the Parts of his Oratorio call'd the Messiah, which I [Amyand] have desired Mr. Christopher Smith, to have prepar'd & to be deliver'd to you as soon as possible.' Smith delivered the score six weeks later,[36] and it has remained among the Hospital's greatest treasures. Though not in Handel's own handwriting but in that of Smith, it is consulted by musicologists all over the world as a guide to the original orchestration.[37] In 1898 Robert Grey, the Hospital's Treasurer, presented what is commonly described as the keyboard of the original organ given by Handel to the Chapel (Plate 73), but I have been unable to discover the authority for this identification.

One further memento of Handel survives in Brunswick Square, along with Hogarth's *Coram* and Ramsay's *Mead* the greatest portrait in the collection: the model in terracotta by Roubiliac (Plate 43) for the marble at Windsor Castle of 1739, presented by Sir Frederick Pollock to the Hospital in 1844.[38] This bust was most successfully restored early in 1966 by the Victoria and Albert Museum. Up to that time it was smothered all over with plaster, and seemed to be no more than a second-rate object. John Kerslake first discovered it was a terracotta. The plaster and paint were removed, and it is now revealed as one of Roubiliac's most important works in this medium. The iconography of Handel has still to be worked out in detail. By Roubiliac alone, at least four representations of the musician are known: besides the Foundling/Windsor bust, the marble done for Vauxhall Gardens in 1738 and erected there by Jonathan Tyers (now in

[35] See bibliography under Handel, 1759.

[36] Gen. Comm. under 13 June 1759. The third codicil to Handel's will specifying this bequest is quoted in Deutsch, 1955, pp. 788–9.

[37] The Foundling Anthem composed by Handel is also among the Hospital's documents, as well as some Handel manuscripts.

[38] For full details of the terracotta since its spectacular restoration, see Kerslake, 1966, p. 475.

the Victoria and Albert Museum), with the terracotta model in the Fitzwilliam; the late roundel acquired by the Victoria and Albert in 1961; and the Westminster Abbey monument.[39] Whoever undertakes the task of putting together all representations of Handel must surely conclude that none teaches us as much about what he actually looked like as the Foundling bust, with his fiery eyes, his self-indulgent jowls, his obstinate mouth. The telling details of the face are not lost in the overall pattern, with the result that one marvels at the realism no less than at the controlled design.

Just as painters and sculptors ceased after 1760 to play an active part in Hospital affairs, so Hospital music after Handel's death until well into this century went into decline. There is no further mention of performances of the *Messiah* after 1777, except for one in 1839 to mark the centenary of the foundation. But the twentieth century has seen a revival of Handel's music at the Hospital, and the annual performance in the Picture Gallery at Brunswick Square of one of the oratorios is now once more an event of importance in the musical world. To celebrate the bi-centenary in 1939, Hubert Langley, who became one of the Governors and was an authority on Handel, organized an oratorio in the new offices. The choir was composed of some thirty-five picked voices from some of the big London Choral Societies, and the soloists were all professionals. The concerts were revived after the war, and the Hospital has continued ever since, under Langley's inspiration, to be a centre of Handelian activity. Since his death in 1968, the tradition is being maintained.

[39] Both Whinney (1964, pp. 102 ff.) and Kerslake (1966, p. 475) are doubtful about the small bust in the N.P.G. which Mrs. Esdaile thought could be a study for the Windsor bust.

VI

THE HOSPITAL SINCE 1760

ALTHOUGH the artists themselves (except for West) may have deserted the Hospital after 1760, Governors and other benefactors have continued up to the present day to present paintings and sculpture to the Charity. The painted portraits cannot compare with the eighteenth-century presentations: nothing reaches even the level of Shackleton's *George II*, except Dance's *Wilmot* (Plate 81), given in 1845 by the great-grandson of the sitter, painted in the Grand Manner of the late 1760s and retaining a certain pig-like impressiveness; and a competent late Millais (Plate 99) of an Honorary Surgeon of the Hospital, and its benefactor, *Luther Holden*. In sculpture, the bust of *Beckwith* by Tomlinson dated 1807 (Plate 87) is the best nineteenth-century work of art in Brunswick Square: it combines dignity with a determined effort to register the sitter's personality. Haydon's *Gleadhall* (Plate 92) is here to represent a late phase of romanticism. And there are some sweet Victorian genre scenes by Mrs. King (Plates 94, 95) and Mrs. Anderson (Plate 96) where the pompous benefactors are shoved aside and the foundling children themselves invited to hold the centre of the stage. No nasty thoughts ever enter their heads as they perform their duties, wearing the touching Hospital uniforms, bringing up babies to be christened in the Chapel, or neglecting their hymn books as they suck their thumbs. These are the Victorian equivalents of the James Wills and Benjamin West religious pieces, just as the Millais is the Victorian equivalent of the eighteenth-century full-lengths.

The Old Masters are not up to the standard of the more modern works. Three drawings by Giulio Campi of a *Bacchanalian Procession* (Plates 38a, b, c) are so far as we know the only objects to enter the Collection during the last forty years of the eighteenth century. They form one continuous

drawing, as can be proved by the fact that the male nude on the extreme right of No. 16 (in the 1965 catalogue) is missing a right hand, to be found on the extreme left of No. 10; and that on the extreme right of No. 10 the satyress is missing her right hoof, to be found on the extreme left of No. 18. The order, then, was 16, 10, 18. Evidently the frieze was regarded as too long by the Hospital, and cut up into three on its authority: because when Philip Burton offered the frieze to the Hospital in 1776 it was described as 'a Capital drawing of Giulio Romano', not three drawings. The provenance of the *Woman taken in Adultery* (Plate 41) is not known, but was presumably added in the following century.[1] It is here attributed to a respectable Tuscan artist Giovanni Camillo Sagrestani soon after 1700. By far the most important Old Master is the cartoon of the *Massacre of the Innocents* from the School of Raphael (Plate 37) bequeathed by Prince Hoare in the late 1830s. There is good reason to suppose that Giulio Romano was responsible for the design, but Raphael himself can have had no hand in it, since it was conceived at about the time of his death. Unfortunately it has been reduced to the ghost of itself, ruined by retouchings, as cartoons which serve a practical purpose are apt to be; and now exercises little aesthetic appeal, although it retains its documentary value as the largest surviving fragment of a cartoon for one of a series of tapestries in the Vatican.

Of the 108 paintings and sculptures catalogued below, I have discussed or mentioned less than half in this introductory essay. Like everyone else I am the victim of contemporary taste, and prefer to illustrate the fashionable *Pinch of Poverty* of 1891 (Plate 98) to a Kelly of 1934-5 (catalogue no. 49) which has now reached its nadir in our estimation, although in fifty years time an art historian at least as perceptive as myself may well prefer the

[1] However, it should be pointed out that the Treasurer Bernard was instructed on 22 July 1801 (see quotation from the Committee Minutes under that date, in catalogue entry No. 81) to arrange 'the placing of the Organ, and of the two other Pictures' in the Chapel, as a result of the acquisition of the West as the altarpiece. These other two pictures, certainly religious subjects, may have been the Sagrestani (catalogue No. 72) and the one of *Our Lord appearing to St. Peter* (Plate 40) of about the same size (and therefore suitable as a pair) and possibly even by the same artist. The *Elijah* (catalogue No. 47) presented in 1757—the only possible alternative candidate—is unlikely to have been one of the two because it was in the Small Committee Room six years later.

latter, and laugh at me up his sleeve or whatever he then wears, for my blindness. In the history of taste, pictures have had their ups and downs, and we all kick ourselves for not having spotted the downs as ups earlier. Nevertheless, certain objects will never take an upward course and with all due respect to the Hospital, half its possessions still continue to exist on such a low aesthetic level that they will never deserve more than brief catalogue entries. Most of them are there for iconographic reasons. The sitters to portraits were prominent Governors or benefactors or physicians, and they too had to take their place in the collection alongside Roubiliac, Ramsay, Hogarth, and Highmore, just as they do in every other institution devoted to some purpose other than a strictly artistic one. There exists one work of art which cannot be so curtly dismissed: this is the Copley sketch of the *Siege of Gibraltar* (Plate 85), presented to the Hospital by the Treasurer Sir Roger Gregory in 1925, shortly before Jacobsen's building was due to be pulled down. What relevance it has to the Hospital is difficult to imagine. But this does not prevent it from being among its most treasured possessions. It is the only object of real importance to have entered the collection since the eighteenth century, except for the cartoon from the School of Raphael and the Roubiliac terracotta of *Handel*.

It is a study for the famous painting of the *Siege of Gibraltar* in the Guildhall Art Gallery—famous in the sense that it is fully described in the contemporary literature, and fully documented by drawings and oil sketches, though almost no one has ever seen the vast canvas itself. It represents the final defeat of the Spanish forces on 14 September 1782 when their floating batteries were sunk by the British. The event created a stir in the British press at the time, not only because great heroism was displayed by British officers and men during the action, but because we were still smarting under the loss of the American colonies, and needed a boost to our flickering morale. General Elliot (afterwards Lord Heathfield) on a white Van Dyck horse, points to British officers and seamen rescuing the enemy from the sinking ships. Could it be this theme of mercy, of the rescue of anonymous, defenceless human beings, that induced Sir Roger Gregory to regard it as suitable for an institution dedicated to this very activity? However this may be, we can be sure that Copley was inspired

by this idea, to produce one of the most spirited sketches of his entire English period. The Guildhall picture was engraved by William Sharp in 1810. Did the print cross the British Channel during the course of the following decade and fall into the hands of the omnivorous Géricault? It could be claimed that the Antonio Carracci *Flood* in the Louvre was the principal source for Géricault's masterpiece. But there is nothing in the whole eighteenth century which foreshadows so poignantly as the Copley the disaster on board the raft of the *Medusa*.[2]

No great works of art are ever likely to enter the Hospital again. Like the Nebot portrait (Plate 46), presented by Sir Alec Martin in 1949, all we can hope for from now onwards are paintings, sculpture, and engravings of no real intrinsic merit but precious documents concerning the history of the Charity. The collection is complete, an admirable cross-section of a particular phase in British art, unparalleled elsewhere. Meanwhile, after the desertion of the artists, the Hospital itself went from strength to strength as an educational and medical centre. Its finances were well administered; its foundlings grew up useful citizens. The time came when it was realized that the health of the children would suffer if they were kept longer in what had become a thickly populated Metropolitan area, and that they must be moved to the country. The decision was made to sell the Hospital site.[3] In 1922 James White, a property speculator, offered to purchase the whole Hospital estate of fifty-six acres. In 1925 a contract was entered into for the sale of the property to White who later transformed it into a Syndicate. The sale for a very large sum was completed on 25 November 1926, and Jacobsen's building was pulled down. Luckily the old photographs survive to remind us what we have lost. Nowadays the Georgian Society and the correspondence columns of *The Times* would together stir up a public outcry against such vandalism, but in the late 1920s the best architecture

[2] See B. Nicolson, 'The "Raft" from the point of view of subject-matter', *The Burlington Magazine*, August 1954, p. 243. The study in the Tate Gallery for the *Siege* is actually more significant in connection with Géricault.

[3] The article in *Country Life*, 1920, discusses the Foundling Hospital site as a possible one for London University. If this had been achieved, the charming Old Bloomsbury Squares might never have been ruined.

of the reign of George II (admittedly, not the most inventive period in our history) was more easily expendable.

A voluntary Committee was set up to collect funds for the purchase and preservation of the site as an open space. Three-quarters of the site was thus rescued as a playground for children. At one moment it seemed as though the remaining quarter would be developed for building, but the Governors of the Hospital offered to repurchase the northern portion of the site. The policy of the Governors was that the Headquarters of the Foundation should remain in Bloomsbury, both for its previous association and also for the advantage of being centrally placed in London. The Headquarters were erected in 1947 at 40 Brunswick Square, adjoining the old school site in the northern portion of which they built an Infant Welfare Centre and Gregory House for the use of the Old Coram Association of former boys and girls.

With the advent of the Welfare State and the improved educational facilities supplied by the state, the necessity for a school of their own became superfluous and the Governors therefore decided to sell the school at Berkhamsted which was bought by the Hertfordshire County Council in 1954. This had the advantage of ensuring a home life for the children, as the foster homes became permanent homes rather than holiday resorts. At the same time the Charity was renamed the Thomas Coram Foundation for Children.[4]

In recent years, efforts have been made to link the Foundation more closely with the Royal Academy. Sir Albert Richardson was elected a Governor in 1939, and Sir Charles Wheeler in 1965. Sir Thomas Monnington was the first President of the Academy to be made Vice-President of the Foundation, and in future all Presidents of the Academy will be ex-officio Vice-Presidents of the Foundation.

The works of art discussed in this book are now all housed in the new Headquarters building. It is open to the public twice a week throughout the year, but like the Soane Museum is seldom visited. Anyone who decided on a Monday or Friday afternoon to make the pilgrimage to Brunswick Square would not be disappointed by what they found there. There are pathetic relics of the children in the showcases: little coins and trinkets, the

[4] For further details, see Nichols and Wray, 1935, pp. 323-4, and 1965 catalogue, p. 4.

identification badges of the foundlings, and descriptions of each child with notes of distinguishing marks (see Plate 36). There are invitations to forgotten breakfasts and to performances of the *Messiah* in the Chapel. There is Handel's fair copy of the score of the *Messiah*, and letters from Hogarth, Coram, and Reynolds. There is the keyboard said to have come from Handel's organ (Plate 73). There is a model of the Hospital in the entrance, and engravings throughout the centuries showing the children playing on the grass in the Hospital Courtyard. There is much besides, most of it quite trivial, but every scrap of paper, every badge, helps to bring the past alive. There are also, as I hope I have made clear, some first-rate works of art. But the casual visitor is not overawed by these as he might be in a museum or exhibition gallery, because there is a certain informality about the arrangement of the objects around a room. You never know what you are going to find next: the majestic and the touching, the pompous and the intimate, are cheek by jowl. The pictures and sculpture take their comfortable place in the setting as part of the decoration of the house. And this is what they were always intended to do.

CATALOGUE OF
THE HOSPITAL TREASURES

References to the literature are given by shortened titles, in cases where full bibliographical references are to be found in the Bibliography. Publications not given in the Bibliography are cited in full in the catalogue entries.

It has not been possible to take pictures out of their frames. The dimensions given here may therefore sometimes be a few inches short. Height precedes width.

Left and right are to be understood as left and right of the spectator unless otherwise specified.

The catalogue is based in large part on a draft catalogue compiled by John Kerslake, of the National Portrait Gallery, in the early 1960s. This has been revised to take account of recent restoration, literature, etc. More information than is recorded here about certain nineteenth-century pictures and sculpture is given in Mr. Kerslake's catalogue, typescript copies of which are available at the National Portrait Gallery and at the headquarters of the Thomas Coram Foundation for Children.

Not all the possessions of the Hospital are included. For example, it was thought that only exceptional pieces of furniture were worth separate catalogue entries. Some documents belonging to the Hospital, though they may be referred to in the text of this volume, are not catalogued here. All pictures, drawings, and sculpture of any consequence are included, but not engravings (though the same remarks apply to some engravings, such as views of the Hospital, as to the documents).

Only the latest catalogues are cited, unless earlier catalogues or lists give further information.

A. PICTURES AND DRAWINGS

1. ANDERSON, Mrs. (Walter) Sophia (fl. 1855–96)
Foundling Girls in the Chapel. Canvas, 26½ × 21 ins. (Plate 96).
Signed bottom right *S. Anderson.*
Purchased 1931.
Engraved. By G. H. Every, 1877.
Literature. Nichols and Wray, 1935, illus. opp. p. 215. 1965 catalogue (24).
Seven girls in Foundling Hospital uniform stand at prayer in the Chapel, facing right towards the altar, not shown in the picture.

2. BRIGGS, Henry Perronet (1793–1844)
Benjamin Hawes. Canvas, 55 × 43½ ins.
Source and date of acquisition untraced.
Engraved. By E. Goodall, 1838, 'the likeness altered by F. Goodall, 1849'.
Literature. Nichols and Wray, 1935, illus. opp. p. 240. 1965 catalogue (89).
Another version, National Portrait Exhibition, 1868 (527), is in the Royal Humane Society.
Benjamin Hawes (d. 1861) was the son of Dr. William Hawes, founder of the Royal Humane Society. He was elected Governor of the Hospital, 1934, and was Chairman and Treasurer of the Royal Humane Society after his father's death (1806).

3. BRITISH SCHOOL, *c.* 1710–30
Portrait of a Man, called George Frederick Handel. Canvas, 30 × 25 ins. in painted oval.

Presented by Charles Pott, 1843.
Literature. Nichols and Wray, 1935, p. 262 speaks of it as in Committee Room; and illus. opp. p. 202, as Kneller. 1965 catalogue (92) as English School, 1710–30.
Pott was Treasurer of the Hospital, 1839 and Vice-President, 1856–64.
 Not impossibly a portrait of Handel, but certainly not by Kneller.

4. BRITISH SCHOOL, *c.* 1730
Portrait of a Man, called George Frederick Handel. Canvas, 23 × 17½ ins.
Presented by John Tattersall, 1921.
Literature. 1965 catalogue (57) as English School, *c.* 1730.
The date of the costume would be right for 1730 but the sitter bears little resemblance to authentic portraits of Handel.

5. BRITISH SCHOOL, ?Eighteenth Century
Portrait of a Man, called Captain Coram. Oil on paper stuck down on panel, 14 × 10¼ ins.
Presented by J. R. B. (later Sir Roger) Gregory, 1917.
In pose of Hogarth's portrait of the Jacobite Lord Lovat, of which it is a pastiche. The features are twisted to resemble Coram. Previously (wrongly) attributed to Hayman, it bears a modern inscription along the bottom *Captain Coram Foundling Hospital.*

6. BRITISH SCHOOL, late Eighteenth Century (?M.C.)

Thomas Coram. Black crayon on grey paper, 18 × 12½ ins.

A signature or inscription with initials *M.C.* bottom left, and inscribed *Capt^n Coram* bottom right.

Presented by S. S. Lansdown Esq., 1921.

Literature. Nichols and Wray, 1935, illus. opp. p. 174 as 'Mason Chamberlin, R.A., 1768'.

The style suggests a rather crude copy of the M^cArdell print after the Hogarth (No. 40, below). No authentic drawings by Chamberlin are recorded for comparison.

7. BRITISH SCHOOL, late Eighteenth Century

Mrs. Caroline Collingwood. Canvas, 14 × 12 ins., in oval mount.

Presented by her grand-daughter, Mrs. L. Plumley, 1868.

Literature. 1965 catalogue (28).

Wife of Thomas Collingwood, Secretary to the Hospital 1758–90.

8. BRITISH SCHOOL, late Eighteenth Century

George Whatley. Pastel on paper, 25 × 19¾ ins.

Source and date of acquisition untraced, but in or before 1858, since it is recorded in Brownlow, 1858, p. 136.

Literature. Nichols and Wray, 1935, illus. opp. p. 313. 1965 catalogue (58).

Whatley was Vice-President of the Hospital (1772–9) and Treasurer (1779–91).

9. BRITISH SCHOOL, ?late Eighteenth Century

Landscape. Canvas, 38 × 48½ ins.

Presented by Lt. Col. James C. Hyde, 1862.

Literature. 1965 catalogue (11).

A poor work, formerly known as imitation of Claude, with whom it has nothing whatever in common.

10. BRITISH SCHOOL, early Nineteenth Century

Prince Hoare. Canvas, 43 × 34 ins.

Provenance. Gen. Comm. under 9 November 1850: 'Read a letter from Robert Stafford Esq. of 31, Hyde Park Square addressed to William Foster White Esq., one of the members of this Committee, requesting him to be the medium on his [Mr Stafford's] behalf for presenting to the Governors of this Hospital a portrait of the late Prince Hoare Esq. who presented to this Charity the Cartoon of the Murder of the Innocents by Raffael [see No. 69], and the portrait having been presented by Mr White', thanks etc. 'The said portrait to be placed in the Boys Dining Hall.' 'William Foster White Esq. had at his own expense caused a new frame to be provided for the said Portrait.'

Literature. Nichols and Wray, 1935, illus. opp. p. 279, with no attribution. 1965 catalogue (97) as self portrait.

The picture does not look like a self portrait, and was not described as such when it was presented. Prince Hoare (1755–1834), playwright and artist, son of William Hoare the portrait painter, who was elected Governor, 1744.

11. BRITISH SCHOOL, early Nineteenth Century

Rev. C. T. Heathcote. Canvas, 50 × 38 ins.

Presented by his family, date of presentation not known.

Literature. Report and Accounts, 1928 as presented by his family, no date. Nichols and Wray, 1935, illus. opp. p. 222. 1965 catalogue (23).

Probably by the same hand as *The Ven. Archdeacon Pott* (No. 12, below).

Dr. Heathcote was Chaplain to the Hospital 1802–20.

12. BRITISH SCHOOL, early Nineteenth Century

The Ven. Archdeacon Pott. Canvas, 62 × 46½ ins. (Plate 88).

Source and date of acquisition unknown.

Literature. Nichols and Wray, 1935, illus. opp. p. 223. 1965 catalogue (91).

Probably by the same hand as *Rev. C. T. Heathcote* (No. 11, above).

13. BRITISH SCHOOL, date uncertain

William Shakespeare. Panel, 17 × 13¼ ins.

Presented by Frederick William Pott, 1851.

Literature. Nichols and Wray, 1935, illus. opp. p. 284. 1965 catalogue (61). Intended as Shakespeare, being based loosely on Droeshout engraving.

14. BRITISH SCHOOL, date uncertain

Portrait of a Man, called Ben Jonson. Panel, 20 × 16½ ins., enlarged at bottom by about one inch.

Presented by Frederick William Pott, 1851.

Literature. Nichols and Wray, 1935, illus. opp. p. 285. 1965 catalogue (59). Possibly covers an earlier portrait, altered to make it look like Jonson.

15. BRITISH SCHOOL, Nineteenth Century

Charles Plumley. Canvas, 31 × 24 ins.

Presented by Mrs. L. Plumley, 1868.

Literature. 1965 catalogue (88).

Plumley was Governor of the Hospital 1841–68.

16. BRITISH SCHOOL, Nineteenth Century

Michael Drayson. Canvas.

Presented by Walter Drayson, 1924.

Literature. 1965 catalogue (83).

Drayson was Governor of the Hospital 1865–79. There appears to be a signature bottom left, but it is indecipherable. The numbers '63' could be a date.

17. BROOKING, Charles (*c.* 1723–59)

A Flagship before the wind, under easy sail, with a cutter, a ketch, and other vessels. Canvas, 70¼ × 123¾ ins. (Plate 74).

Signed bottom left *C. Brooking Pinx.*

Presented by the artist, 1754.

Literature. Gen. Comm. under 6 February 1754: 'The Treasurer [Taylor White] acquainted the Committee, that Mr. Brooking was painting a Sea-Piece for this Hospital, to match that of Mr. Monamy's. Resolved that the Treasurer be impowered to prepare a proper Frame for the said Picture.' G.C.M. under 8 May 1754 (Vol. 1, p. 289): 'Mr. Brooking having presented this Hospital with a very valuable Sea-Piece in Painting'—resolved that he be thanked and nominated for election as Governor. He was elected Governor on 26 June. Gen. Comm. under 15 July 1807 (Vol. 29, pp. 53–4): 'Mr. Everett Mr. Cox and Mr. Raynsford reported, that they had examined the Pictures in the Hospital with the Assistance of Mr. West and that they

were of the opinion, that the two sea views [*sic*] by Brooking in the Boys Dining Room should be cleaned and repaired.... Resolved that Mr. Ashby be desired to execute the above-mentioned repairs to the Pictures [others are cited], under the direction of Mr. West.' Presumably one of the pictures was the Monamy (see under B(d), below). Brownlow, 1847, pp. 138–9, where it is stated that the picture was painted in the Hospital in eighteen days. This information is re-peated in the catalogue of the 'Marine Art' exhibition, B.F.A.C., 1929 (see below). Nichols and Wray, 1935, illus. opp. p. 273. Colin Sorensen, introduction to Brooking catalogue, 1966, pp. 7–8, 10.

Exhibited. 'Marine Art', Burlington Fine Arts Club, 1929 (1). 'Charles Brooking', Aldeburgh and Bristol, 1966 (4), shown at Bristol only.

BROWNLOW, see KING

18. BUCKNER, Richard (fl. 1842–77)
Clement Hue, M. D. Canvas, 49¼ × 36¼ ins.
Painted for and presented by several Governors, 1849.
Literature. Nichols and Wray, 1935, illus. opp. p. 156. 1965 catalogue (25). Hue was Physician to Hospital 1815–37; Governor 1819; Vice-President 1847–61. He was also physician to St. Bartholomew's. He died in 1861 aged 82.

One of the volumes in the back-ground right is lettered *Hippocrates*.

19. CALCOTT, Sir Augustus Wall (1779–1844), attributed to
A Village Scene. Canvas, 47¾ × 29¼ ins. Presented by Mrs. Robert Grey, 1893.

Literature. Nichols and Wray, 1935, illus. opp. p. 101. 1965 catalogue (56).

20. CAMPI, Giulio (*c.* 1500/2–72)
Bacchanalian Procession (3 drawings). Sepia (Plates 38a, b, c).
Provenance. Gen. Comm. under 22 November 1775: Philip Burton recommended to General Court for Governorship; elected Governor 27 December. Gen. Comm. under 13 November 1776: Letter read from Burton 'to Mr. Scott, offering to present to this Corporation, a Capital drawing of Giulio Romano'. Thanks, and 'they [this Committee] will receive with acknowledgem't the same whenever he thinks proper to send it and will consult with him how to dispose of it so as it may best answer his intentions for the Benefit of the Charity'.
Literature. Nichols and Wray, 1935, illus. opp. p. 109 (one drawing) as Giulio Romano. 1965 catalogue (10, 16, 18), as Giulio Campi, an attribution made by Philip Pouncey. The reasons for supposing that originally it formed one continuous drawing are given in the text, p. 51.

21. CANALETTO (Giovanni Antonio Canal), follower of
View in Venice along the Cannaregio. Canvas, 33¼ × 45 ins.
Presented by Lt. Col. James C. Hyde, 1862.
Literature. Nichols and Wray, 1935, illus. opp. p. 140. W. G. Constable, *Canaletto...*, Oxford, 1962, II, No. 287 (b). Constable illustrates the same view as Plate 56, the much better version at Woburn.
Exhibited. Centro Internazionale delle Arti e del Costume, Venice, 1954.
Constable points out that it shows a

slightly higher viewpoint than the picture at Woburn; includes more of the Canal in the foreground and less of Palazzo Testa, left; and is a school piece. Michael Levey has suggested that it resembles in handling the hand of National Gallery No. 2514.

22. CARTER, William (1863–?)

Robert Grey. Canvas, 50 × 37 ins.

Signed and dated low on the right *William Carter/1904.*

Presented by Mrs. Patrick Forbes, 1939.

Literature. 1965 catalogue (94).

Robert Grey was elected Governor of the Hospital 1878, and was Treasurer 1892–1914.

23. CARTER, William (1863–?)

Mrs. Patrick Forbes. Canvas.

Bequeathed under the will of Mrs. Patrick Forbes, 1944.

Literature. 1965 catalogue (95).

She was Governor of the Hospital, 1934–44.

24. CASALI, Andrea (1720?–83?)

Adoration of the Magi. Canvas, 100 × 81½ ins. (Plate 71).

Signed on the right-hand side of the bottom step *And Casali pin[xit].*

Presented by the artist, 1750.

Literature. Gen. Comm. under 30 December 1747: Ordered 'that the Frame [for the Monamy, see under B(d)] he [Linnell] intended as a Bene-faction to this Hospital may be adapted to a Picture for the Altar Piece of the Chappel'. Gen. Comm. under 30 November 1748: 'Chevalier Cassali came to the Committee and offered his Benefaction of a Peice of Painting for the Altar in the Chapel.'

'Resolved/That it be referred to Mr. Jacobsen, Mr. White and Mr. Waples or any two of them, to settle the Ornaments within the Chapel.' Gen. Comm. under 18 April 1750: 'The Treasurer acquainted that the Chevalier Cassali has finished the Picture for the Altar in the Chapel.' Dr. Conyers to thank Casali 'and to beg the favour that it may be sent immediately to the Hospital, for a proper Frame to be made to it. [/Resolved/That. . . .] Mr. Linnell do make the said Frame, in such manner as Mr. Jacobsen shall direct.' Vertue, III, p. 157, under date 1751: 'at the foundlying Hospital besides the four paintings given to be put up in the Governors Room [by Hogarth, Hayman, Highmore, and Wills] . . . —is one altar peece. done by Sign. Cav. Casali. being the adoration of the 3 Kings. which being tho't to be not strong enough, by some & of a pale weakly colouring is ["rejected &" struck through] not put up in its place at present till the chapple is finished quite. Qu. if this did not disgust the signor—. . . .' Gen. Comm. under 31 March 1752: 'Ordered/That Mr. Spencer be immediately sent to, to put up the Picture, and fit up the Chapel with Benches, as before.' Edwards, 1808, p. 23: 'This picture [the Casali altarpiece] remained several years in its primitive situation, but has lately been removed, to make way for the picture of Mr. West, which now occupies the place. . . '. Gen. Comm. under 24 February 1905: on the recom-mendation of a Committee on the treatment of the pictures it is resolved 'that the two pictures "Elijah raising the Widow's Son" [attributed to Lan-franco, see No. 47 below] and "The Offering of the Wise Men" be placed in the hands of Mr. Uppard to be

treated according to his specification at the estimated cost of £3.7.0 and £16.16.0 respectively'. Nichols and Wray, 1935, illus. opp. p. 25. Antal, 1962, p. 245, note 47. 1965 catalogue (90).

The Benjamin West *Young Children brought to Christ* (No. 81, below) was presented in 1801 and replaced the Casali as the Chapel altarpiece.

25. CAWSE, John (1779–1862)
Sir George (Thomas) Smart. Canvas, *c.* 30×25 ins.
Source and date of acquisition untraced (but by 1904).
Literature. 1965 catalogue (81).
Exhibited. Music Loan Exhibition, 1904.
A portrait of this pattern was engraved by E. Stalker. One of this sitter was exhibited by Cawse, R.A. 1830 (175). Sir George Thomas Smart (1776–1867), conductor and editor, particularly of Handel.

Framed as a pair with the following:

26. CAWSE, John (1779–1862)
Carl Maria von Weber. Canvas, 30×25 ins.
Source and date of acquisition untraced (but by 1904).
Literature. 1965 catalogue (85).
Exhibited. Music Loan Exhibition, 1904.
This can be reconciled with authentic portraits of Weber (1786–1826). It is possible that this and No. 25 came from the Smart family. Sir George Smart when Director of the Covent Garden Opera, commissioned *Oberon* from Weber, who died in his house. A portrait of this type, stated to be after Cawse from a lithograph by E. J. Lane

is reproduced in H. S. Wyndham, *Annals of Covent Garden*, II, 1906, p. 32.

CHAMBERLIN, Mason, *see* No. 6 above

27. COLLET, John (*c.* 1725–1780), attributed to
The Press Gang. Canvas, 39×49 ins. (Plate 83).
Presented in the will of Charles Devon, 1872.
Literature. 1965 catalogue (54).

28. COPLEY, John Singleton (1738–1815)
Siege of Gibraltar. Canvas (monochrome), 39½×49½ ins. (Plate 85).
Provenance. Lyndhurst Sale, Christie's, 26–27 February 1864 (65): 'THE SIEGE OF GIBRALTAR. A sketch for the celebrated picture at the Guildhall. Painted for the Common Council of the City. ([bt] Gregory, 16.16.0)'; George Burrow Gregory, M.P., Treasurer of the Hospital, 1857–92; his son Sir Roger Gregory, Treasurer from 1914; by whom presented to the Hospital, 1925 (Gen. Comm. under 23 April 1925: 'The Treasurer, Sir Roger Gregory, had presented to the Hospital a monochrome by J. S. Copley R.A. of the Siege and Relief of Gibraltar').
Literature. 1965 catalogue (22). Prown, 1966, II, catalogued pp. 447–57 with all known studies (for full details, see p. 447); illus. Plate 499.
Exhibited. Copley Exhibition, Washington D.C., New York, Boston, 1965–6 (84).
Copley had already begun work on this subject in 1783. The final enormous picture in the Guildhall Art Gallery was finished in 1791.

Copley had painted portraits in Hanover of the Hanoverian officers in 1787 and produced the Hospital sketch after the portraits had been taken. Prown suggests a date for it early in 1788 on the evidence of a notice in the *World* (28 March 1788) stating that Copley was then at work on a *Gibraltar* and that 'the well-known alacrity of Major Lewis *not waiting for his boots*, is properly remembered on the Canvas'. The seated figure of Major Lewis in this sketch is missing one boot.

29. COTES, Francis (1726–70)

Taylor White. Pastel on paper. 30× 25 ins. (Plate 76).

Signed and dated above his right hand *F. Cotes pxt./1758*, the F.C. in monogram.

Provenance. Gen. Comm. under 8 November 1758: 'The Secretary reported, that Mr. Cotes had presented to the Corporation a fine Painting of Mr. White, the Treasurer.' According to G.C.M. under 21 February 1759 this was 'Humphrey Cotes Esq of St. Martin's Lane'.

Literature. Nichols and Wray, 1935, illus. opp. p. 312.

Taylor White (b. 1701) was a barrister with a large practice on the Northern Circuit. He was Treasurer of Lincoln's Inn, 1764; Judge of North Wales; afterwards Judge of Chester County Palatinate; Deputy Recorder of Notts. and Steward of East Retford. He served as Treasurer to the Hospital, 1745–72. Humphrey Cotes was made Governor, 1759, but his relationship to Francis is not known. Apparently Francis had no children since he mentioned none in his will.

30. DANCE, Nathaniel (Sir Nathaniel Dance-Holland) (1735–1811)

Lord Chief Justice Wilmot. Canvas, 83×65 ins. (Plate 81).

Presented in 1845 by Lord Saye and Sale, great-grandson of the sitter.

Engraved. Half-length only, as frontispiece to the *Opinions and Judgements*, London, 1802, by J. Heath.

Literature. Nichols and Wray, 1935, illus. opp. p. 304.

As the sitter has the collar of SS, the portrait is datable 1766/71 when Wilmot held the office of Lord Chief Justice of Common Pleas. A portrait by Dance was recorded at Wimpole (Earl of Harwicke) in 1798 (B.M. Add. MS. 6391 f.20), and another whole-length version is now on loan from Ministry of Works to the Royal Courts of Justice. Sir John Eardley-Wilmot (1709–92), judge, and school fellow of Garrick and Johnson.

31. GAINSBOROUGH, Thomas (1727–88)

The Charterhouse. Canvas (tondo), 22 ins. diameter. (Plate 54).

Provenance. Gen. Comm., under 11 May 1748: 'Mr. Monamy, Mr. Whale, and Mr. Gainsborough; having presented Pictures to this Hospital.

/Resolved/ That the thanks of this Committee....'

Literature. Vertue, III, p. 157 under date 1751: 'in the foundling Hospital in the Governors Room where the pictures are. is small rounds prospects & views of the Several Hospitals— very well done. amongst them those done by. Gainsboro—are tho't the best & masterly manner there is twelve in all done by different painters—...'. *Art Union*, 1840, p. 109. Describes three Gainsborough views, two of Chelsea, and '1 of Old Bedlam' (obviously a mistake: *Bethlem* is by Haytley, see No.

36 below). Whitley, 1928, I, p. 164, quotes a list of 1751 where eight roundels only are described. Waterhouse, 1953, p. 183, illus. plate 148. Waterhouse, 1958, pp. 12 ff. Nichols and Wray, 1935, illus. opp. p. 268. 1965 catalogue (79). Waterhouse, 1965, pp. 21–2.

Exhibited. Manchester Art Treasures Exhibition, 1857 (not in catalogue but label on reverse). 'Views in London', Burlington Fine Arts Club, 1919 (72). 'Gainsborough', 45 Park Lane, 1936 (80). 'Thomas Gainsborough', Tate Gallery, 1953 (2). 'Landscape by Thomas Gainsborough', Nottingham University Art Gallery, 1962 (6).

Accurate topographically, the view being from the Terrace above the former west walk of the Cloister. The Chapel tower is seen in the left background. The Charterhouse was founded in 1611 by the Charity of Thomas Sutton as an asylum for poor brethren, and so an educational and religious institution. The school moved to Godalming in 1872.

There are eight roundels of London Hospitals now in the collection: besides the Gainsborough, two by Haytley (Nos. 35, 36), three by Wale (Nos. 77, 78, 79) and two by Richard Wilson (Nos. 85, 86). In 1745 Vertue speaks of more than one by Harding, and in 1751 (see above) more than one by Gainsborough. In the latter year he lists twelve in all, but Whitley's list (source untraced) said to be also of 1751 has eight. For a full discussion, see text above, p. 25.

GIULIO ROMANO, see under RAPHAEL, School of (No. 69)

32. GREEN, George Pycock Everett (d. 1893)

Adolphus Frederick, Duke of Cambridge. Canvas, 49 × 39 ins.

Presented by the artist, 1850.

Literature. Nichols and Wray, 1935, illus. opp. p. 305. 1965 catalogue (96).

Exhibited. ?R.A. 1851 (231)—a portrait of Cambridge by Green.

Adolphus Frederick, Duke of Cambridge, seventh son of George III (1774–1850). President of the Hospital, 1827–50.

33. HALL, Sydney Prior (1842–1923)

Rev. Richard Whittington, M.A. Canvas, c. 35 × 25 ins.

Signed and dated bottom left, *Sydney P. Hall/1884.*

Presented by Mrs. Whittington, 1938.

Literature. 1965 catalogue (99).

Rev. Richard Whittington (1825–1900). Prebendary of St. Pauls. Governor of the Hospital, 1879; Vice-President, 1889–1900.

34. HAYMAN. Francis (1708–76)

The Finding of the Infant Moses in the Bulrushes. Canvas, $68\frac{1}{4} × 80\frac{1}{2}$ ins. (Plate 51).

Inscribed bottom right *Painted & given by F. Hayman, 1746.*

Provenance. Vertue, III, p. 134: 'the beginning of this year [174$\frac{6}{7}$] was put up. three Historical pictures painted & presented to the Foundling Hospital [these four words interlineated] by three English Painters—Highmore Hogarth. Wills. the fourth not yet quite finisht—["by" struck out] to be done by Hayman. that also done. & some other smaller pictures'. By 1 April 1747 the Hayman was seen in place by the Governors and others at a public entertainment (Vertue, III, p. 135).

Literature. Nichols and Wray, 1935, illus. opp. p. 253. Waterhouse, 1953, p. 146. Waterhouse, 1958, p. 14. Antal, 1962, p. 152. 1965 catalogue (76). Waterhouse, 1965, p. 19.

A sketch for the design was sold Langford, James Ralph Sale, 21 April 1762 (1st day): 'Mr Hayman 60—The Finding of Moses—The Design for the picture at the Foundling Hospital' (information from Mr. Michael Levey). *Exhibited*. 'Francis Hayman, R.A.', Kenwood, 1960 (28).

35. HAYTLEY, Edward (fl. 1746–61)

Chelsea Hospital. Canvas (tondo), 22 ins. diameter (Plate 57).

Since Vertue (see quotation under No. 31) lists twelve roundels in 1751, this and No. 36 must have been in the Collection by then.

Literature. Nichols and Wray, 1935, illus. opp. p. 267. 1965 catalogue (77). *Exhibited*. 'Twee Eeuwen Engelsche Kunst', Amsterdam, 1936 (63).

View towards the Main Court, seen from the river bank. Chelsea Hospital was founded by Charles II, for the reception of maimed and superannuated soldiers, and built to designs by Wren.

36. HAYTLEY, Edward (fl. 1746–61)

Bethlem Hospital. Canvas (tondo), 22 ins. diameter (Plate 58).

For provenance, see under No. 35.

Literature. Nichols and Wray, 1935, illus. opp. p. 269. 1965 catalogue (64). The view from the front entrance. Bethlem Hospital was from 1377 a Priory of the order of St. Mary of Bethlem at Bishopsgate and was used as an institution for acute mental illness. A second Hospital was built at Moorfields, the one here depicted. It

was here that Hogarth set the eighth scene of the *Rake's Progress*.

37. HAZLITT, John (1767–1837), attributed to

Patrick Kelly. Canvas, 29 × 24 ins. Presented by Mrs. Shepherd, 1929.

John Hazlitt was the elder brother of the essayist. Patrick Kelly (1775–1842), Governor of the Hospital, 1812–42.

38. HIGHMORE, Joseph (1692–1780)

Thomas Emerson. Canvas, 48 × 57¼ ins. (Plate 42).

Inscribed on the curtain *Tho: Emmerson Esq*. Signed and dated along the base of the column *Jos Highmore pinx. 1731*.

Provenance. The portrait was already in the Hospital by 1749 since it is shown hanging over the mantelpiece in the engraving by Parr after S. Wale representing the admission of foundlings, dated that year (see Plate 24). It is generally supposed that the portrait was presented by the artist in 1746, perhaps because the contemporary frame is inscribed *J. Highmore 1746*.

Literature. Nichols and Wray, 1935, illus. opp. p. 53. 1965 catalogue (109). Waterhouse, 1965, p. 19, note 31. *Exhibited*. 'Paintings by Joseph Highmore', Kenwood, 1963 (7).

Emerson was elected Governor of the Hospital, 1739. *Gentleman's Magazine*, 1746, p. 383, under 'A list of Deaths for the Year 1745': 'Tho. Emerson Esq, sugar-baker in Thames Street, who by will left 12,000 l. to the Foundling Hospital, and very large legacies to other public charities.'

39. HIGHMORE, Joseph (1692–1780)

Hagar and Ishmael. Canvas, 68 × 76 ins. (Plate 50).

Believed to be inscribed or signed on a stone in the foreground, in line with Ishmael's hip, at present illegible.

Provenance. Vertue, III, p. 131, under date 1745–6: 'he [Highmore] has begun one of the History pictures. (Hagar & Ishmael) 15 [written over 10]f.— ["12" has been struck through] to be set up in the Foundling Hospital it promises much and shews that his genius is not so confined, but it may extend it self in that branch of painting with due commendation—as painter of History if he coud meet with suteable incouragement—'. Vertue, III, p. 134: 'the beginning of this year [174$\frac{6}{7}$] was put up. three Historical pictures painted & presented to the Foundling Hospital [these four words interlineated] by three English Painters—Highmore Hogarth—Wills. . . .' According to Vertue (III, p. 135) it was seen by the Governors and others in place at a public entertainment on 1 April 1747.

Literature. Art Union, 1840, p. 109: 'the body of the ground colour has forced its way through the upper surface of the paint, and has given it a black appearance'. Nichols and Wray, 1935, illus. opp. p. 89. Waterhouse, 1953, p. 137. Antal, 1962, p. 152, Plate 101a. 1965 catalogue (65).

Exhibited. 'Paintings by Joseph Highmore', Kenwood, 1963 (28), Plate VIII.

40. HOGARTH, William (1697–1764)

Captain Coram. Canvas, 94 × 58 ins. (Frontispiece and Plates 44, 45).

On cleaning in 1967, a signature and date appeared, on the left hand side of the bottom step: *W. Hogarth Pinx*.*[?] 1740.* Roll of Papers on table middle left inscribed *The Royal Charter.* On the right of his left foot is a globe showing *The WESTERN OR AT-LANTICK OCEAN* and a letter addressed to *Cap*. *Coram.* Inscribed on a step beneath his feet *Painted and given by Wm. Hogarth, 1740.*

Provenance. G.C.M. under 14 May 1740. Resolved: 'Mr. [Martin] Folkes acquainted the Governors that Mr. Hogarth had presented to them a whole length Picture of Mr. Coram for this Corporation to keep in Memory of the said Mr. Coram's having Solicited and Obtained His Majesty's Royal Charter for this Charity.' Resolved 'That Mr. Folkes be desired to return the Thanks of this Corporation to Mr. Hogarth for his said Present.' G.C.M. under 1 April 1741: '[Hogarth] was pleased to give the Corporation the Gold frame in which Mr. Coram's Picture is put.' Gen. Comm. under 16 December 1747: ordered 'That Captain Coram's Picture be put up in the Secretary's Office and Dr. Mead's Picture [see No. 68 below] to hang up in its room. . . .'

Engraved. By McArdell, 1749. A copperplate by W. Nutter after the portrait was presented to the Hospital by E. H. Dring, 1917 (see 1965 catalogue, No. 45).

Literature. Vertue, III, p. 102, under date inserted by Vertue 'beginning 1741': 'a picture at whole length of Mr. Coram. the old Gent that proposed, & projector first of the hospital for foundlings—this was done and presented to the hospital by Mr. Hogarth. and is thought to be very well. this is another of his efforts to raise his reputation in the portrait way from the life'. Ireland, 1791–98, III (*Supplement to Hogarth Illustrated*, 1798), pp. 48–9, gives 'quotation' from Hogarth's autobiographical *Anecdotes of an Artist.* This is Ireland's tidying up of

the difficult passage in Hogarth's manuscript (quoted from the manuscript by Burke, 1955, see below). Nichols and Wray, 1935, illus. opp. p. 249. Antal, 1947, pp. 43–4, Fig. 15. Beckett, 1949, No. 116. Waterhouse, 1953, p. 131. Burke, 1953, pp. 212–13, quoting folios 14 and 14b of the *Analysis of Beauty*; see also p. 218, quoting folios 34b and 35. Whinney/Millar, 1957, p. 195, note 1. Antal, 1962, pp. 16, 28–9, 45–6, 228 (note 59). 1965 catalogue (36). Waterhouse, 1965, pp. 13–14.

Exhibited. British Institution, 1814 (113). Art Treasures, Manchester, 1857 (30). 'Twee Eeuwen Engelsche Kunst', Amsterdam, 1936 (70), and on other occasions.

Copies. (See under No. 6 above.) A copy of Hogarth's *Coram* belongs to the Hospital (1965 catalogue No. 108). Canvas, 93 × 59 ins. Presented by Reginald H. Nichols, F.S.A. on his retirement as Secretary of the Hospital and election as Governor, 1946.

41. HOGARTH, William (1697–1764)
March to Finchley. Canvas, $39\frac{1}{2} \times 52\frac{1}{2}$ ins. (Plate 70).

Inscribed *Tottenham Court Nursery 1746* on the inn sign on the left.

Provenance. The General Advertiser, 16 March 1749/50 and 23 April, reports that Hogarth proposes to publish by subscription a print of the *March to Finchley in 1746* engraved on a copper plate, price 7/6. Subscriptions can be taken at his house, and the picture seen there at the same time. This was to remain in effect until 30 April; thereafter the print would be half a guinea. In the Subscription Book are the 'Particulars of a Proposal, whereby each Subscriber of three Shillings over

and above the said seven shillings and sixpence for the Print, will, in consideration thereof, be entitled to a chance of having the original Picture, which shall be delivered to the winning Subscriber, as soon as the Engraving is finished.' On 1 May 1750 *The General Advertiser* reports that the subscription closed on the previous day. '1843 Chances being subscrib'd for, Mr. Hogarth gave the remaining 167 Chances to the Foundling Hospital; at two o'Clock the Box was open'd, and the Fortunate Chance was Number 1941, which belongs to the said Hospital; and the same Night Mr. Hogarth delivered the Picture to the Governors.' Vertue, III, p. 153, under date 1750 tells the same story more shortly; so does G. C. M. which reports on 9 May (when Hogarth was present): 'The Treasurer acquainted the General Court, that Mr. Hogarth had presented the Hospital with the remainder of the Tickets Mr. Hogarth had left, for the Chance of the Picture he painted, of the March to Finchley in the time of the late Rebellion; and that the fortunate Number for the said Picture being among those Tickets, the Hospital had received the said Picture.'

Engraved. (See under 'Provenance'.) Print by Sullivan noted by Vertue, VI, p. 204, under date 1750; also Nichols, 1782, pp. 243–7. Paulson, 1965, I, pp. 277–80, II, plate 277. The painting is unreversed in the print. Paulson explains that the print was engraved by Hogarth's assistant Luke Sullivan, with some retouching by Hogarth ten years later. According to *London Evening Post*, 29 December–1 January and 3–5 January 1750/1 the finished engraving was issued to subscribers on 3 January (see Paulson, 1967, p. 285).

Literature. Nichols and Wray, 1935,

illus. opp. p. 255. Beckett, 1949, No. 158. Antal, 1962, pp. 2, 28, 119–20, 222–3 (note 92). Paulson, 1965, I, pp. 16 ff., 277–80. 1965 catalogue (60).

Exhibited. Art Treasures, Manchester, 1857 (26). 'English Conversation Pieces', 25 Park Lane, 1930 (137). R.A. 1934 (210), and on other occasions.

Copies. A copy is at the Hospital, source and date of acquisition untraced.

42. HOGARTH, William (1697–1764)
Moses brought before Pharaoh's Daughter.
Canvas, 68 × 82 ins. (Plate 52).

Provenance. Vertue, III, p. 134: 'The beginning of this year (174⁹₇] was put up. three Historical pictures painted & presented to the Foundling Hospital [these 4 words interlineated] by three English Painters—Highmore Hogarth. Wills. . . .' According to Vertue, seen by Governors at public entertainment on 1 April 1747 (*op. cit.*, III, p. 135). Vertue adds later: 'its generally said and allowd that Hogarths paece gives strikeing satisfaction— & approbation'. *Engraved.* Vertue, III, p. 155, under date 1751: 'lately was advertized 2 paintings done by Mr. Hogarth in large pictures. one at the foundling Hospital—one done by the 4 Competitors painters', the other a *Paul before Felix* for Lincoln's Inn Chapel. 'Of these two peeces he has proposd to put them in print. . . .' Vertue, VI, p. 204, under date March 1751: 'Mr. Hogarth two Prints. one Moses brought to Pharaohs daughter—from a picture in the foundling Hospital painted by himself. . . .' Nichols, 1782, p. 257, catalogues engraving by Hogarth and Luke Sullivan. He states that early impressions bear the words 'Published February 5, 1752. . . .' Paulson, 1965, I, p. 218; II, plate 208, 2nd state, dated

5 February 1752. The caption of the engraving (as does the contemporary frame of the picture) gives the source: *Exodus*, 2:10.

Literature. Ireland, 1791–8, II, p. 89. Nichols and Wray, 1935, illus. opp. p. 262. Oppé, 1948 illus. (No. 69) a red chalk drawing of *Paul before Felix* (Fig. 23) in the Pierpont Morgan Library, connected with the Lincoln's Inn Hall painting (1748). He points out that red chalk drawings of both *Paul before Felix* and *Pharaoh's Daughter* were lots 48 and 49 on the fifth day of Dr. Monro's Sale, 30 April 1792 and five following days at Greenwood's, where they are said to have been given to Dr. Monro by Hogarth: 'These may have been the two red chalk drawings Lots 99 and 100 at the Capel Cure Sale 1905, bought for £9 5s and £11 by Harvey.' He thinks the *Paul before Felix* drawing may only have been a preparation by Hogarth or by another for the purposes of engraving. Beckett, 1949, No. 159. Antal, 1962, pp. 28, 151–2, 179, 200–1, 245. 1965 catalogue (73). Paulson, 1965, I, pp. 27–8. Waterhouse, 1965, p. 19. Whitfield, 1971, p. 213, note 14, correctly identifies the drawings in the Monro sale as two now in a collection in North Berwick, but denies that any such drawings appeared in the Capel Cure Sale in 1905.

43. HONE, Nathaniel (1718–84) attributed to
?William Beckwith. Canvas, 25½ × 22 ins. (Plate 82).

Presented by Charles Devon (d. *c.* 1872), date of presentation unknown.
Literature. Nichols and Wray, 1935, illus. opp. p. 292.

The head only is more or less finished. The features of Beckwith are not easy

to reconcile with the bust by Tomlinson of 1807 (see No. 107 below), and the picture is a comparatively late acquisition.

44. HUDSON. Thomas (1701–79)
Theodore Jacobsen. Canvas, 93 × 54 ins. (Plates 65, 66).
Inscribed bottom left *Theodore Jacobsen Esq.* and bottom right *PAINTED & GIVEN BY THO: HUDSON.*
Provenance. Vertue, III, p. 157, under date 1751: '—the portraits at length given their. [there] by Mr. Hudson. of Justice Milner Mr. Jacobsen the builder of the Hospital—....'
Literature. Nichols and Wray, 1935, illus. opp. p. 42. *Country Life,* 1942, p. 621. Waterhouse, 1953, p. 150. Antal, 1962, p. 16. 1965 catalogue (55). Waterhouse, 1965, pp. 15, 17, Fig. 4.
The engraving he holds shows the west front of the Hospital which he built. It is part of the engraving by Fourdrinier here illustrated (Plate 11). Jacobsen (d. 1772), designer of the Royal Naval Hospital for Sick Sailors at Gosport, Hants (see Colvin, 1954, *ad vocem.*) Vertue, III, p. 135 under date 1 April 1747, speaks of 'some other portraits ... done & doing by Ramsay Hudson. & Landskip &c.' This suggests that either the *Jacobsen* or the *Milner* (see below, No. 45) or both were by that date ready or nearly ready. The landscapes are clearly some of the roundels.

45. HUDSON, Thomas (1701–79)
John Milner. Canvas, 93 × 57 ins. (Plate 64).
Books on the floor bottom left, inscribed *George II Regis,* and *THURLOE'S STATE PAPERS.* Inscribed

bottom right *Painted & Given by Thom! Hudson. 1746.*
Provenance. Vertue, III, p. 157, under date 1751: '—the portraits at length given their. [there] by Mr. Hudson. of Justice Milner Mr. Jacobsen the builder of the Hospital—....' (See also Vertue's remark quoted under the portrait of *Jacobsen* (No. 44) under the date 1 April 1747.)
Literature. Nichols and Wray, 1935, illus. opp. p. 43. Antal, 1962, p. 228 (note 62). 1965 catalogue (107).
Milner, Vice-President of the Hospital, 1740–50. A whole-length drawing by Vanhaecken for the costume in National Gallery of Scotland, D. 2165 (see Plate 27).

46. ITALIAN SCHOOL, Seventeenth Century
A Piping Shepherd Boy. Canvas, 56¾ × 76¾ ins. (Plate 39).
Presented by William Agnew, later Sir William Bt., 1891.
Previously ascribed to Pier Francesco Mola. Mr. Michael Levey has suggested that it is nearer, though perhaps not by Giovanni Benedetto Castiglione. It seems too poor to be by any identifiable artist.

47. ITALIAN SCHOOL, ?late Seventeenth Century
Elijah raising the Son of the Widow of Zarephath. Canvas, 53½ × 36¾ ins.
Presented by Abraham Langford, playwright and auctioneer, 1757, as Lanfranco.
Literature. Gen. Comm. under 15 July 1807: Mr. Everett, Mr. Cox, and Mr. Raynsford reported to the Committee that they had 'examined the Pictures in the Hospital with the Assistance of

Mr. West', and were of the opinion that the 'Picture by Lanfranc in the Small Committee Room' should be 'lined, washed & oiled'. Resolved 'That Mr. Ashby be desired to execute the above-mentioned repairs to the Pictures [others being cited] under the direction of Mr. West.' Nichols and Wray, 1935, illus. opp. p. 262. 1965 catalogue (29).

Abraham Langford (1711–74) was the best-known auctioneer of his day. His name appears with those of the artists dining at the Hospital in 1757. The picture is rather damaged. It could be North Italian, as late as 1700. Dr. Erich Schleier confirms that it has nothing to do with Lanfranco.

48. ITALIAN SCHOOL, ?early Eighteenth Century

Our Lord appearing to St. Peter. Canvas, 59½ × 45 ins. (Plate 40).

No source or date of acquisition has been traced (but see note 1, p. 51).

Literature. 1965 catalogue (41) as a follower of Crespi. It has been associated with the Sagrestani (No. 72, below) but is perhaps not by the same hand, although similar. It is presumably also Tuscan of the early eighteenth century.

49. KELLY, Sir Gerald Festus (b. 1879)

Sir (John) Roger (Burrow) Gregory. Canvas, 41 × 32½ ins.

Signed and dated bottom right: *Kelly 1934–5*.

Presented by the Governors, 1935.

Literature. Nichols and Wray, 1935, p. 316, illus. opp. p. 317.

Exhibited. R.A. 1935 (187).

Sir J. Roger B. Gregory, son of George Burrow Gregory, M.P., Solicitor and senior partner in the firm of Gregory, Rowcliffe & Co.

50. KENNINGTON, Thomas-Benjamin (1856–1916)

The Pinch of Poverty. Canvas, 45 × 40 ins. (Plate 98).

Signed and dated bottom right: *T. B. Kennington, 1891*.

Presented under the terms of the will of W. J. H. Le Fanu, 1926.

Literature. 1965 catalogue (5).

A similar picture, perhaps R.A. 1889 (734), was presented by Charles Drew in 1889 to the National Gallery of South Australia.

51. KING, Mrs. Emma (née Brownlow) (fl. 1850s to 1870s)

The Christening. Canvas, arched top fillet, *c*. 30 × 40 ins. (Plate 95).

Signed and dated bottom left: *Emma Brownlow 1863*.

Presented by the family of the late Baron Heath, 1879.

Literature. Nichols and Wray, 1935, illus. opp. p. 231.

Part of West's picture (No. 81, below) can be seen behind.

52. KING, Mrs. Emma (née Brownlow) (fl. 1850s to 1870s)

The Sick Room. Canvas, arched top fillet, *c*. 30 × 40 ins.

Signed and dated bottom left: *Emma Brownlow 1864*.

Commissioned by Lt. Col. James C. Hyde, 1864, and presented in memory of Robert Rainy Pennington.

Literature. Nichols and Wray, 1934, illus. opp. p. 127.

53. KING, Mrs. Emma (née Brownlow) (fl. 1850s to 1870s)

The Foundling restored to its Mother. Canvas, arched top fillet, 30×40 ins. (Plate 94).

Signed and dated bottom left: *E. Brownlow 1858.*

Presented by E. W. Wadeson, 1858.

Literature. Nichols and Wray, 1934, illus. opp. p. 185.

On the wall behind are the *March to Finchley* (No. 41), the supposed portraits of Shakespeare and Ben Jonson (Nos. 13, 14), the tapestry after Reni (No. 70), a view of the Hospital, and part of the supposed Lanfranco (No. 47).

54. KING, Mrs. Emma (née Brownlow) (fl. 1850s to 1870s)

Taking Leave. Canvas, arched top fillet, *c.* 30×40 ins.

Signed and dated bottom left: *Emma Brownlow King/1868.*

Presented by L. W. Maddock, Esq., 1868.

55. KING, Mrs. Emma (née Brownlow) (fl. 1850s to 1870s)

A Foundling Girl at Christmas Dinner. Canvas, 35×28 ins. (Plate 97).

Signed and dated bottom left: *E. Brownlow King 1877.*

Presented by F. J. Blake, 1877 (elected Governor, 1873).

Literature. 1965 catalogue (20).

56. KING, Mrs. Emma (née Brownlow) (fl. 1850s to 1870s)

Lt. Col. J. C. Hyde. Canvas, 35×28 ins.

Signed and dated bottom left: *Emma Brownlow 1865.*

Source and date of acquisition untraced.

Literature. 1965 catalogue (84).

Lt. Col. Hyde, Governor 1862.

57. LAMBERT, George (*c.* 1700–65)

Landscape with Figures. Canvas, 48×48 ins. (Plate 75).

Inscribed on a stone in centre foreground: *PAINTED & GIVEN BY GEORGE LAMBERT MDCCLVII.*

Literature. Art Union, 1840, p. 109 described as over the chimney in the Court Room. Four years later it was found to be in bad condition: Gen. Comm. under 4 May 1844: Ordered 'That the said picture [the Lambert landscape] be new lined, cleaned, & varnished by Mr. Taylor, at an expense not exceeding £4.' Nichols and Wray, 1935, illus. opp. p. 272. Waterhouse, 1953, p. 115.

A small near-replica, signed and dated 1753, was in a sale at Christie's 17 December 1948 (76) but with the addition of a dead tree in the foreground, a dog following the woman centre right, and a fence in front of the water, centre background.

58. LUNY, Thomas (1759–1837)

Action off the Coast of France, 13 May 1779. Canvas, 43½×62¼ ins. (Plate 84).

Signed and dated on a brown log near bottom left *T Luny 1779.*

Source and date of acquisition untraced.

Literature. Nichols and Wray, 1935, illus. opp. p. 232. 1965 catalogue (21). From the left four ships named on the sterns *CABOT, PALLAS, DANAE,* and *EXPERIMENT.* To the right is a French ship, her mast split off half-way up. A boat with a white flag puts off from her prow. The contemporary label describes the action. Sir James Wallace, Commander of H.M.S. *Experiment* with four brigs attacks three French frigates and a cutter in Concale Bay.

59. MILLAIS, Sir John Everett, Bart (1829–96)

Luther Holden. Canvas, 49×36½ ins. (Plate 99).

Bequeathed by the sitter, 1905.

Engraved. Unlettered (?proof) etching of the portrait is in the Hospital.

Literature. Gen. Comm. under 10 February 1905: 'The Secretary reported the death on the 6th instant of Luther Holden Esq. FRCS, who was elected Honorary Surgeon in 1864 and a Governor at the Midsummer Court 1868 in consideration of his services as such.' Gen. Comm. under 14 April 1905: Will of Holden who 'had left £1,000 to this Hospital and upon the death of his wife, half of £10,000 and half the proceeds of the Sale of his residence ... to the Benevolent Fund of this Hospital'. Nichols and Wray, 1935, illus. opp. p. 157. 1965 catalogue (98).

A portrait by Millais, signed and dated 1880, presumably R.A. 1880 (497) was presented to St. Bartholomew's Hospital on Holden's retirement (Millais Memorial Exhibition, R.A. 1898, No. 165). Luther Holden (1815–1905) was also Consulting Surgeon to St. Bartholomew's Hospital.

60. MURILLO, Bartolome Esteban (1617–82), copy after

Feeding the Five Thousand. Canvas, 47½×90 ins.

Presented by J. P. Gassiot (Governor from 1862).

Literature. 1965 catalogue (1).

Copy of one of the eight pictures painted by Murillo for the Hospital of the Church of St. George, Seville (probably completed by 1674). The copy is attributed to Castillote.

61. MURILLO, Bartolome Esteban (1617–82), copy after

Moses striking the Rock. Canvas, 47½×97 ins.

Presented by J. P. Gassiot (Governor from 1862).

Literature. 1965 catalogue (2).

Copy attributed to Castillote of one of the eight pictures painted by Murillo for the Hospital of the Church of St. George, Seville.

62. MURILLO, Bartolome Esteban (1617–82), copy after

Immaculate Conception. Canvas, 64½×41 ins.

Presented by Captain R. F. Britten R.N., 1893 (Governor, 1891).

Literature. 1965 catalogue (46).

Copy of the picture in the Seville Museum (K.d.K., 1923, plate 135).

63. MURILLO, Bartolome Esteban (1617–82), copy after

Holy Family. Watercolour, arched top, 31×23½ ins.

Presented by G. W. Younger, 1927.

Copy of the Murillo in the Louvre (1913 catalogue, No. 1713).

64. NEBOT, B[althazar?] (fl. 1737–62)

Thomas Coram. Canvas, 16¼×11½ ins. (Plate 46).

Presented by Sir Alec Martin, 1949 (who discovered it in Southampton).

Engraved. By Brooke (1751) as after Nebot, 1741, a painting in the possession of Dr. Robert Nesbit when the engraving was made. Nesbit was elected Governor in 1739. Engraving illus. Nichols and Wray, 1935, opp. p. 1.

Literature. Collins Baker, 1926, pp. 3–6, reproduces view of *Covent*

Garden by Nebot (1737) on loan from National Gallery to London Museum. Martin Davies, *National Gallery Catalogues—British School*, 1946, No. 1453 (*Covent Garden* picture). Davies thinks he is probably identical with a Balthazar Nebot 'alive in London at the right time'. 1965 catalogue (19).

65. NORTHCOTE, James (1746–1831)

The Worthies of England. Canvas, 45 × 57 ins. (Plate 90).

Signed and dated on the spine of a book at the top of a pile bottom right: *James Northcote Pinx/1828.*

Presented by Newbold Kinton (a Governor, 1836). Brownlow, 1858, p. 139 records a portrait of Prince Hoare as presented by Kinton, and thinks this may be our No. 10. But the latter was presented by Stafford, so evidently Brownlow had confused it with the Northcote.

Literature. Memorials of an Eighteenth Century Painter, ed. Stephen Gwyn, 1898, p. 288 (Northcote's picture listed under 1828). Nichols and Wray, 1935, illus. opp. p. 108. Wrongly given here as 1808. 1965 catalogue (104).

The nearer child has a drawing after Lawrence of William IV. The double row of portraits of worthies behind are inscribed with their names below. Top row from left to right: Alfred the Great, Edward the Black Prince, Shakespeare, Francis Bacon, Milton, Locke; lower row from left to right: Newton, Dryden, Pope, 2 heads partially obscured by the children, Reynolds. The rolled paper behind the vase of flowers has the words *Sic Transit Gloria Mundi.*

66. OPIE, John (1761–1807)

Sir Thomas Bernard. Canvas, 49 × 39 ins.

Presented by J. Bernard Baker, 1939. Sir Thomas Bernard, Bart. (1740–1818); Governor, 1787 and Treasurer, 1795–1806. Farington Diaries (typescript, British Museum Print Room), entry for 2 July 1806: 'West came in the evening. . . . He said Mr. Bernard had left the Foundling Hospital after having long served its interests. Some Attorneys had got to be Managers and they bred Disorder.' Entry for 12 December 1807: 'Mr. Watts told me that Mr. Bernard quitted His residence at the Foundling Hospital in consequence of having had continual disputes abt. the management of the concerns of the Hospital, with a party of which Mr. Everitt of Bedford Square was the Head and His principal opponent'. (For Everett, see under West, No. 81.)

67. PHILLIPS, Thomas (1770–1845)

Charles Pott. Canvas, *c.* 50 × 40 ins.

Painted for and presented by several Governors, 1842.

Engraved. By W. H. Mote. The engraving lettered: *Engraved for the Inmated and others in grateful remembrance of their Friend and Benefactor.*

Literature. Nichols and Wray, illus. opp. p. 316 (see also pp. 262, 315). 1965 catalogue (38).

Charles Pott; Governor, 1817; Treasurer, 1839–52; Vice-President, 1856–64. He was the son-in-law of Samuel Compton Cox who was Vice-President and Treasurer, and a vinegar manufacturer in Southwark. He resigned in 1852 owing to a misunderstanding with the Committee. He and his wife were buried beneath the Chapel. In the copy of Phillips's notebook in the National Portrait Gallery is an entry under 2 December 1842

'C Potts' [sic] 'Esq', which is probably this.

Exhibited. Presumably R.A. 1843 (24).

68. RAMSAY, Allan (1713–84)

Dr. Richard Mead. Canvas, 93 × 57 ins. (Plates 62, 63).

Inscribed bottom left *Rich.ᵈ Mead M.D.* and bottom right *Ramsay Pinxit* over an earlier signature which reads *Painted and given by Ramsay 1747*. The sitter points to a letter lying on the table beside him, inscribed *To Dr. Mead.*

Engraved. By B. Baron; and by Barratt for the *Biographical Magazine*, 1795. Also engraved by R. Houston in three-quarter length.

Literature. Vertue, III, p. 96 under date 1739 describes an earlier portrait by Ramsay of Mead. Vertue, III, p. 135 under date 1 April 1747: 'some other portraits are done & doing by Ramsay Hudson. & Landskips &c'. Gen. Comm. under 16 December 1747, ordered: 'That Captain Coram's Picture be put up in the Secretary's Office and Dr. Mead's Picture be hung up in its room, And that the Picture from Mr. Monamy [see below, under B. (d)] be put up in the Committee Room where Dr. Mead's Picture hung before.' Vertue, III, p. 157, under date 1751: '...—the [full length portrait] ... of Dr. Meade, which has the admiration of most people is by Mr. Ramsay ...' Gen. Comm. under 15 July 1807, report by Everett, Cox, and Raynsford 'with the Assistance of Mr West', to the effect that the portrait of Dr. Mead 'in the Girl's Dining Room' should be 'lined, washed & oiled'. Ashby is 'desired to execute' the repairs 'under the direction of Mr. West'. Jamot, 1921, pp. 269 ff., a futile attempt to prove that a late Watteau portrait represents Mead. Nichols and Wray, 1935, illus. opp. p. 27. Smart, 1952, p. 52, where Vanhaecken is credited with all the accessories (for his drapery study, see below). See also p. 188. Waterhouse, 1953, p. 152, illus. plate 121. Antal, 1962, p. 228 (note 61). Catalogue of the Ramsay exhibition, R.A. 1964. 1965 catalogue (105). Waterhouse, 1965, pp. 17–18.

Exhibited. Art Treasures, Manchester, 1857 (33). R.A. 1964 (15).

Richard Mead (1673–1754), minister of Stepney, famous throughout Europe as physician, scholar, and collector. Whole-length drawing by Vanhaecken for the costume in National Gallery of Scotland, D. 2164 (Ramsay exhibition, R.A. 1964, No. 142), see our Plate 26. Behind is a stone wall with the statue of Hygieia, the Goddess of Health, feeding a serpent with a dish in an arched alcove.

69. RAPHAEL (1483–1520), School of

Massacre of the Innocents. Small pieces of paper (later painted in oil), stuck down on canvas, 113 × 109 ins. (Plate 37).

Provenance. Nicholaes Anthoni Flinck (1646–1723), Director of Dutch East India Co., Rotterdam. Bought in Holland by Motteux, who brought it to England; William Hoare (1706–92); his son Prince Hoare. A note in Gen. Comm. under 11 February 1835 quotes a clause from Prince Hoare's will: 'I direct that my Cartoon painted by Raffaelli representing the murder of the Innocents ...' should be offered to the R.A. and National Gallery in that order, and if not required by either: 'Then I will direct that the said Cartoon be presented either to the

Foundling Hospital or to a Public Hall or College.' The Cartoon was already in the possession of the Hospital five years later (mentioned there in *Art Union*, 1840).

Literature. E. Müntz, *Les Tapisseries de Raphaël au Vatican*, Paris, 1897, p. 39. O. Fischel, Thieme-Becker, XXIX, p. 442. Nichols and Wray, 1935, illus. opp. p. 100. K. T. Parker, *Catalogue of the Collection of Drawings in the Ashmolean Museum*, Oxford, 1956, II (under Nos. 599–602). Philip Pouncey and J. A. Gere, *Italian Drawings in the Department of Prints and Drawings in the British Museum—Raphael and his Circle* ..., London, 1962 (under Nos. 137–8). 1965 catalogue (101).

Exhibited. Gen. Comm. under 9 February 1842, letter from Trustees of the National Gallery to the Hospital Governors: the Trustees 'have given directions for estimates to be prepared of the expence of glazing the cartoon by Raffaelle, with plate glass—which they consider may be required previous to its being hung up in the Gallery'. Gen. Comm. under 4 January 1843: the Governors of the Hospital request that a better position for it be found in the Gallery. Victoria and Albert Museum, 1927–38.

The largest surviving fragment of a cartoon for one of three panels of tapestry showing the *Massacre of the Innocents* in the Vatican, the second or 'Scuola Nuova' series of tapestries devoted to *Scenes from the Life of Christ* (twelve tapestries ordered under Clement VII). (Woven *c*. 1520–24; precise date of commission uncertain.) Two further fragments are in the British Museum (Pouncey and Gere, Nos. 137–38), four in the Ashmolean (Parker, Nos. 599–602) and one at Christ Church (Borenius catalogue of

the Christ Church pictures, 1916, No. 78). Many of these are from the collection of Jonathan Richardson the Elder. Pouncey and Gere deny to Raphael any responsibility for the design (and both style and date, and Raphael's death at about the moment when the weaving was begun, support their contention): 'Everything about the tapestries themselves suggests that Giulio [Romano] was in fact the designer.' The Hospital fragment shows the group of figures in the section reproduced by Müntz, p. 39 right. In a chiaroscuro woodcut dated 1544 by the Master NDB as well as in drawings in Turin and the British Museum, 'in all of which', to quote Pouncey and Gere, 'the three groups are juxtaposed unaltered to form one continuous composition' (in spite of the fact that the three panels of tapestry were intended as separate compositions) this group appears on the left. The Hospital's cartoon shows the assassins left-handed but the composition is reversed in the tapestry. The cartoon consists of the entire group of figures, but in the tapestry the composition continues above with architecture, and below with a plain foreground.

70. RENI, Guido (1575–1642), copy after *Salome with the Head of St John the Baptist*. Tapestry, $38 \times 31\frac{1}{4}$ ins.

Presented by Henry Laver, 1850. (Gen. Comm. under 17 August 1850, letter read offering the tapestry.)

Literature. Nichols and Wray, 1935, illus. opp. p. 141. 1965 catalogue (86). After the famous painting in the Corsini Gallery, Rome (C. Gnudi and G. C. Cavalli, *Guido Reni*, Florence, 1955, No. 79).

71. REYNOLDS, Joshua (1723–92)

William Legge, second Earl of Dart-mouth. Canvas, $91\frac{1}{2} \times 54$ ins. (Plate 78).

Provenance. Gen. Comm. under 18 May 1757: 'The Treasurer having acquainted the Committee, That Mr. Reynolds had given to this Corporation a Portrait of the Earl of Dartmouth ... the Sub-Committee be desired to give orders for proper frames to be provided for the said Portraits [also for Wilson's *Fauquier*, No. 83].' G.C.M. under 26 December 1759: recommended by Gen. Comm. for election as governor: 'Mr. Joshua Reynolds of Newport Street having presented to this Corporation a fine Portrait of the Earl of Dartmouth.'

Engraved. By R. Parkes, 1866.

Literature. Nichols and Wray, 1935, illus. opp. p. 299. Waterhouse, 1941, Plate 36; dates 1757. 1965 catalogue (113). Waterhouse, 1965, pp. 18, 45–6. William Legge, second Earl of Dartmouth (1731–1801), Vice-President of the Hospital, 1755–1801.

72. SAGRESTANI, Giovanni Camillo (1660–1731)

Woman taken in Adultery. Canvas, $54 \times 43\frac{1}{4}$ ins. (Plate 41).

Source and date of acquisition untraced (but see note 1, p. 51).

Literature. 1965 catalogue (42) as follower of Crespi.

The attribution to the Florentine Sagrestani is made chiefly on the basis of a *Christ and his Mother* (c. 1707) in a Florentine Collection, illus. catalogue '70 Pitture e Sculture del '600 e '700 Fiorentino', exhibition at Palazzo Strozzi, Florence, October 1965, No. 36. No. 48 above is very similar in style.

73. SCHENDEL, Petrus van (1806–70)

A Market Scene at Night. Oils on hardboard, 25×20 ins.

Signed bottom right *P. van Schendel del.*

Presented under the terms of the will of Mrs. L. Plumley, 1868.

Literature. Nichols and Wray, 1935, illus. opp. p. 298.

74. SHACKLETON, John (d. 1767)

George II. Canvas, $93 \times 56\frac{1}{4}$ ins. (Plate 79).

Inscribed bottom left *His Majesty King George the Second*, and bottom right *Shackleton Pinxit*.

Provenance. G.C.M. under 10 May 1758: 'John Shackleton Esq. has Presented a fine Portrait of His Majesty to this Corporation.'

Literature. Gen. Comm. under 21 February 1758: '... a Frame be provided for His Majesty's Picture....' Nichols and Wray, 1935, illus. opp. p. 16. 1965 catalogue (114). Shackleton was elected Governor of the Hospital, 1758. A second version commissioned for the British Museum, 1759, and touched up by the artist, 1762.

75. STUART, W. E. D. (fl. 1848–58)

Battle of Trafalgar. Canvas, c. 59×95 ins.

Signed bottom right *WE Stuart 1848*? (last two digits hard to read).

Presented by Sir Frederick Perkins, 1848.

Literature. Nichols and Wray, 1935, illus. opp. p. 194. 1965 catalogue (27). The ships include *Victory, Redoubtable, Temeraire, Santissima Trinidad, Royal Sovereign*. The time is about 2.30.

76. TIDEMAND, Adolf (1814–76)

Granny's Darling. Oils on hardboard, 16×13 ins.

Signed and dated bottom right *A. Tidemand 1861.*

Presented by Mrs. Louisa Plumley, 1868.

Literature. Nichols and Wray, 1935, illus. opp. p. 114.

77. WALE, Samuel (d. 1786)
Christ's Hospital. Canvas (tondo), 21 ins. diameter (Plate 60).

Provenance. Presented by the artist before 11 May 1748 (see quotation from Gen. Comm. under Gainsborough, No. 31).

Literature. See under Gainsborough (No. 31). Nichols and Wray, 1935, illus. opp. p. 265. 1965 catalogue (81). Courtyard and entrance in right distance, the tower of Christ Church, Newgate.

78. WALE, Samuel (d. 1786)
St. Thomas's Hospital. Canvas (tondo), 21 ins. diameter. (Plate 59).

Provenance. Presented by the artist before 11 May 1748 (see quotation from Gen. Comm. under Gainsborough, No. 31).

Literature. See under Gainsborough (No. 31). Nichols and Wray, 1935, illus. opp. p. 266. 1965 catalogue (72). Seen across one of the courtyards, with the statue of Edward VI.

79. WALE, Samuel (d. 1786)
Greenwich Hospital. Canvas (tondo), 21 ins. diameter (Plate 61).

Provenance. Presented by the artist before 11 May 1748 (see quotation from Gen. Comm. under Gainsborough, No. 31).

Literature. See under Gainsborough (No. 31). Nichols and Wray, 1935, illus. opp. p. 264. 1965 catalogue (66). Seen from the river.

80. WATSON, George (1767–1837), attributed to

Christopher Stanger. Canvas, 30 × 25 ins. (Plate 89).

Presented by C. Lowry, 1922.

Literature. Nichols and Wray, 1935, illus. opp. p. 146, without attribution. 1965 catalogue (93) as by Watson.

The books on the table include *Stanger on Contagion* and *Rights of the Licentiates.* On the shelf are *Hippocrates Opera* and *Cullen.* The attribution is suggested by a version at Christie's, 7 December 1934 (110) as by George Watson. Christopher Stanger, M.D. (d. 1829), Honorary Physician to the Hospital, 1792–1829; elected Governor 26 December 1792. The *Rights of the Licentiates* alludes to the battle for recognition he conducted unsuccessfully (1793–8) on behalf of the licentiates of the Royal College of Physicians to be admitted Fellows if they were not graduates of Oxford or Cambridge. The pamphlet was published in 1798.

81. WEST, Benjamin (1738–1820)
Christ presenting a little Child. Canvas, 85 × 73½ ins. (Plate 86).

Provenance. Painted for Macklin's Bible. Third day's sale of the Macklin Bible, 29 May 1801 (14) (having been bought in at an earlier sale). Edwards, 1808, p. 23: '...[West's picture]... was originally painted for Macklin's Bible: it was bought after the death of Macklin, by one of the Governors, and presented to the institution'. Gen. Comm. under 22 July 1801: 'The Chairman [Wilmot] stated to the Committee that Mr. Everett, Mr. Bernard, John Puget Esqr. and himself had purchased a Picture painted by Mr. West; the subject of which is "Little

Children brought to Christ", which they request the Governors to accept of, to be placed over the Altar of the Chapel. . . . Mr. Bernard to place the said Picture over the Altar in the Chapel, and to place the Picture now over the Altar [by Casali, see above No. 24] in the South end of the Boy's Dining Room, arranging the placing of the Organ, and of the two other Pictures accordingly.' Gen. Comm. under 29 July 1801: '. . . [West] desired it [the picture] might be sent him in order that he might see what is proper to be done to it; that since that, Mr. Wilmot and Mr. Bernard had seen Mr. West who found the Picture much injured and cracked by an improper application of Varnish, & desired it might be left with him for a Month or six weeks during which time, he would (without any charge to the Hospital) restore the Picture and make it worthy of a place in the Foundling.' Gen. Comm. under 16 October 1801: Letter from West to Bernard, dated 15 September 1801 transcribed in Minutes, in which he states he has retouched the picture, and will have it delivered to the Hospital within a few days.

Engraved. Gen. Comm. under 21 October 1801. Application by Valentine Green to engrave. *loc. cit.* under 28 October. Copies of letters from Green seeking permission to engrave 'in Mezzotinto', 'to be published on my own account'. He has West's permission. He intends to begin, and to present prints to the Hospital. *Loc. cit.* under 11 November: Permission given to Green, 'the Picture not to be removed'.

Literature. Gen. Comm. under 18 November 1801: Bernard reports on former injuries to the picture. G.C.M.

under 30 December 1801: 'Benj^m West Esq^r for Gratitude and Charitable Assistance as to the present Altar Piece of the Chapel'—elected Governor. Gen. Comm. under 22 May 1816: Letter from West to the Secretary dated 15 May 1816, in which he requests the return of the picture to his house for further repairs, while the Chapel is being renovated. G.C.M. under 18 September 1816: after restoration by West, the picture returned to the Chapel which had meanwhile reopened (for further details, see text above, pp. 43–44). Nichols and Wray, 1935, illus. opp. p. 214. 1965 catalogue (17).

82. WILLS, James (d. 1777)
Little Children brought to Christ. Canvas, 68 × 82½ ins. (Plate 53).

Inscribed bottom left *Painted and Given by James Wills 1746.* An earlier inscription which has all the appearance of being a signature in full and perhaps a date cannot at present be read.

Provenance. Vertue, III, p. 134: 'The beginning of this year [174⁶⁄₇] was put up. three Historical pictures painted & presented to the Foundling Hospital [these four words interlineated] by three English Painters—Highmore Hogarth. Wills. . . .' According to Vertue (III, p. 135) it was seen by the Governors and others in place at a public entertainment on 1 April 1747. *Literature.* Whitley, 1928, II, p. 273. Nichols and Wray, 1935, illus. opp. p. 88. Waterhouse, 1953, p. 147. Antal, 1962, p. 152. 1965 catalogue (80). Waterhouse, 1965, p. 19, note 31.

Contemporary frame inscribed *ST. MARK X Chap 14th Verse Suffer the little children to come unto me, and forbid them not. Wills P.*

83. WILSON, Benjamin (1721–88)

Francis Fauquier. Canvas, 36 × 28 ins. (Plate 77).

Provenance. Gen. Comm. under 18 May 1757: 'The Treasurer having acquainted the Committee, That Mr. . . . Wilson of Queen St. Westminster having also [as well as Reynolds who gave another portrait, No. 71 above] given to this Corporation a Portrait of Francis Fauquier Esq. . . . the Sub-Committee be desired to give orders for proper frames to be provided for the said Portraits.'

Literature. Gen. Comm. under 4 May 1850: 'the Treasurer [Charles Pott] has caused a portrait of Francis Fauquier, Esq., one of the early Governors, painted and presented by Wilson, to be restored and framed at his own expense'. Nichols and Wray, 1935, illus. opp. p. 39. Constable, 1953, illus. Plate 133c, and p. 232: says presented by Richard Wilson, but 'Richard' is not mentioned (see above). The picture was recorded at the Hospital as by Richard Wilson, but Constable correctly identifies the hand as Benjamin's.

Francis Fauquier (1704?–68), Governor of the Hospital, 1751, F.R.S., 1753; Lieutenant-Governor of Virginia, 1758. Gen. Comm. under 9 January 1754: 'Mr. Fauquier having presented to the Committee a Collection of Anthems & Church-Musick, for the use of this Hospital'. Richard Wilson settled in Covent Garden, not in Queen St., Westminster, on his return from Italy at about the moment the picture was presented.

84. WILSON, Benjamin (1721–88)
Earl of Macclesfield. Canvas, 94 × 57 ins. (Plate 80).

Inscribed bottom left below a paper *George Earl of Macclesfield*. Books on the table include *PHILOS TRANS* and *STATUTES RS*.

Provenance. Gen. Comm. under 10 December 1760: 'The Treasurer reported that the Earl of Macclesfield has presented this Corporation with his Portrait, painted by Mr. Wilson.'

Literature. Nichols and Wray, 1935, illus. opp. p. 32. Constable, 1953, p. 66, as 'in the style of Benjamin Wilson'. Has been described as by Richard Wilson. 'The style', writes Constable, 'wholly favours' the attribution to Benjamin. 1965 catalogue (106), as Benjamin.

George Parker, second Earl of Macclesfield (*c.* 1697–1764); active for reform of calendar, 1751; Vice-President of the Hospital, 1750–64; President of the Royal Society, 1752–64.

85. WILSON, Richard (1713?–82)
St. George's Hospital. Canvas (tondo), 21 ins. diameter (Plate 55).

Provenance. Since Vertue (see quotation under Gainsborough, No. 31) lists twelve roundels in 1751, this and No. 85 below must have been in the collection by then.

Literature. Nichols and Wray, 1935, illus. opp. p. 270. Constable, 1953, illus. Plate 43b. Waterhouse, 1953, p. 174. 1965 catalogue (74). Waterhouse, 1965, pp. 21, 32.

Exhibited. Art Treasures, Manchester, 1857 (164). Tate, 1925 (12). London, 45 Park Lane, 1938 (28).

86. WILSON, Richard (1713?–82)
Foundling Hospital. Canvas (tondo), 21 ins. diameter. (Plate 56).

For *provenance*, see under No. 85.

Literature. Nichols and Wray, 1935, illus. opp. p. 271. Constable, 1953, illus. Plate 43a. Waterhouse, 1953, p. 174. 1965 catalogue (75). Waterhouse, 1965, pp. 21, 32.

Exhibited. Art Treasures, Manchester, 1857 (149). Tate, 1925 (16) London, 45 Park Lane, 1938 (29).

87. WORLIDGE, Thomas (1700–66), attributed to
George II. Copper.

Literature. Nichols and Wray, 1935, illus. opp. p. 38, without attribution. 1965 catalogue (102).

Engraved. The type is engraved by Houston after Worlidge.

Worlidge is known chiefly as an etcher in the Rembrandt manner. It is not known whether he worked on copper.

B. PICTURES UNTRACED IN THE COLLECTION

(a) See Vertue's implied reference to more than one roundel painted for the Hospital by Gainsborough (under No. 31).

(b) Anon., portrait of *Earl of Uxbridge*. Gen. Comm., under 3 December 1746: 'Resolved: That Mr. Jacobsen be desired to send into the Hospital a half-length Frame for the Earl of Uxbridge's Picture, he being a Benefactor to this Hospital by his last will.' The portrait (again without attribution) is described as hanging in the Girls' Dining Room in *Art Union*, 1840, p. 109. Henry Paget, first Earl of Uxbridge, died in 1743. His grandson Henry (1719–69) succeeded him as second Earl.

(c) Vertue, III, pp. 126–7, under date 1745: 'Mr Harding, painter of Landskhipes &c & coach painter . . . he is continually immitating paintings of Canaletti of Venice Views &c. & also paintings of Paulo Panini with good success—he had lately painted some peices of Landskip in Rounds which he has presented to the Foundling hospital to adorn their rooms—.' Vertue mentions twelve roundels in the Hospital by 1751 and only eight are known. A further Gainsborough (see (a) above), and the roundels by Francis Harding, may therefore have existed.

(d) *English Fleet in the Downs*, by Peter Monamy (1670?–1749).

Provenance. Gen. Comm. under 11 May 1748: 'Mr. Monamy, Mr. Whale, and Mr. Gainsborough; having presented Pictures to this Hospital. /Resolved/ That the thanks of this Committee . . .'. *Literature.* Gen. Comm. under 16 December 1747: '. . . Mr. Linnell a Carver in Long Acre proposed to present this Hospital with a curious carved Frame for the Picture painted by Mr. Monamy.' Ordered: 'that the picture should be put up in the Committee Room'. Gen. Comm. under 30 December 1747: Linnell is to be directed to make a frame for the Monamy, 'agreeable to the Pattern of those in the General Court Room', whilst the frame he intended as a benefaction is to be adapted for the Casali (No. 24). Vertue, III, p. 157 under date 1751: '. . . and in the great room or eating room is a large ship peece by Monamy'. Gen. Comm. under 15 July 1807: 'two sea views by Brooking' are recommended for cleaning and repairing (see under Brooking, No. 17). One of them may have been the Monamy. Brownlow, 1847, p. 128, listed as 'Large sea-piece (Representing the *English Fleet in the Downs*)'; again Brownlow, 1858, p. 139. 'Marine Art' exhibition, B.F.A.C., 1929, catalogue under No. 1 (the Hospital's Brooking, No. 17), where it is stated that the Monamy disappeared 'about twenty years ago' (that is, *c.* 1909). According to the Hospital Minutes (see under No. 17) the Brooking was

painted to match the Monamy, so the latter must also have been enormous. Half of a very large and unidentified shipping picture hangs on the wall of a room in the Hospital in the engraving by Parr after S. Wale representing the admission of foundlings, dated 1749 (see Plate 24). It is hard to imagine what it can be if not the lost Monamy, to whose style it conforms.

C. SCULPTURE

88. BAILY, Edward Hodges (1788–1867)
A baby (*George Blakiston*). White marble on ebonized wood stand, 16 × 33 ins., including stand.

Inscribed on the base below the cushion *E. H. Baily R.A.*

Presented by Rev. J. A. Murray, 1939.
Literature. 1965 catalogue (8).

Baily exhibited R.A. 1836 (1136) 'Portrait in marble of George, the infant son of Arthur Browne Blakiston, Esq.', which is presumably this.

89. BEHNES, William (1795–1864)
Henry Earle. White plaster cast, on white plaster pedestal.

Painted on the base *HENRY EARLE* and incised on the back *W. BEHNES Sculptor in Ord.? to Her Majesty.*

Provenance. Gen. Comm. under 6 June 1838: '... the friends of the late Henry Earle Esq., formerly Surgeon of this Hospital (and a Governor) had sent a cast, from a bust of him by Mr. Behnes, for the acceptance of the Governors'.

Engraved. By S. Cousin, 1838.

Literature. Nichols and Wray, 1935, illus. opp. p. 147. 1965 catalogue (43).
The marble in St. Bartholomew's was presented by Earle's pupils there in 1838. Henry Earle (1789–1838) was Surgeon to St. Bartholomew's, 1827; Surgeon-Extraordinary to Queen Victoria, 1837; Hon. Surgeon to the Foundling Hospital, 1813–29 and Governor from 1817.

90. BEHNES, William (1795–1864)
Relief from Monument to Dr. Bell. White plaster, *c.* 25 × 40 ins. (Plate 91).

Incised on the side of the pedestal on which the boy stands *W. BEHNES SC18(39).*

Provenance. Gen. Comm. under 5 October 1842: letter from Behnes dated 30 September that year: 'Gentlemen, I have forwarded you a Basso Relievo part of a Monument now in Westminster Abbey to the Memory of the late Dr. Bell, it will be very flattering to me, if you will honor me by your acceptance of it, if you deem it worthy of a place in your truly philanthropic Institution.' Signed William Beynes 'Sculptor in Ordinary to Her Majesty'. The plaster was then accepted.

Literature. 1965 catalogue (50).
The plaster reflects a relief on Behnes's Monument to Dr. Bell in Westminster Abbey, S. aisle, last bay N. wall before transept. Dr. Andrew Bell (1753–1832), famous for a system of education of the poor; Minister of St. Mary's Church, Madras, 1789; Master of Sherburn Hospital, 1809; Prebendary of Westminster, 1810. The relief is based on the Flaxman in Winchester Cathedral (Whinney, 1964, Plate 152).

91, 92. BRITISH SCHOOL, mid-Eighteenth Century
Caracalla. Marcus Aurelius. Plaster, with

painted English wood wall brackets (Plates 68, 69).

Inscribed on the plinths *CARACALLA* and *MARCUS AURELIUS*.

Provenance. Sub-Committee, under 22 May 1754: 'Mr. Dalton having presented to this Corporation, 13 Busto's cast from the Antique . . .', he is nominated as Governor of the Hospital. The same report in Gen. Comm. under 29 May. If Nos. 91 and 92 are two of these, eleven remain untraced.

Literature. Esdaile, 1928, p. 141. Quotes an eighteenth century source for the theory that they were presented by Roubiliac and that they bore his signature and date 7 December 1760. She thinks that even if Dalton had presented them, they could be his work: '. . . repeated coats of paint had obliterated any lettering there may have been. . . .' Nichols and Wray, 1935, p. 261. 1965 catalogue (67, *Caracalla*; 71, *Marcus Aurelius*).

Richard Dalton, Royal Librarian (for the fullest account, see M. Levey, *Pictures in the Royal Collection—the later Italian Pictures*, London, 1964, pp. 28 ff.). Gen. Comm. under 8 May 1753: 'Mr. Dawson attended the Committee, and offered several Busts, as a Present to this Hospital, which offer the Committee accepted, and ordered that be properly placed when received.' Since Dawson is otherwise unrecorded, Dalton was probably intended.

93. BRITISH SCHOOL, Nineteenth Century

'*Prince Albert*'. Plaster, 32 ins. high.

Source and date of acquisition untraced.

Although known at the Hospital as a bust of Prince Albert, it is not certainly him, and does not seem to be related to the bust of *Queen Victoria* by Durham (see No. 97).

94. BRITISH SCHOOL, Nineteenth Century

'*Victoria Duchess of Kent*'. Marble, $15\frac{3}{4}$ ins. high, including base.

The base is incised *Copyright reserved Copeland A.*

Source and date of acquisition untraced.

Once thought to have been a bust of Queen Victoria, the features resemble those of her mother (1786–1861).

95. BRITISH SCHOOL, Nineteenth Century

Peasant Boy. White marble, $49\frac{1}{2}$ ins. high.

Source and date of acquisition untraced.

Literature. 1965 catalogue (9).

In Donatellesque pose but Berninesque style.

96. CLINT, Scipio (1805–39)

John(?) Capel. White marble medallion, *c.* 14 ins. high.

Incised on the cutaway of the neck *S Clint Joanno Brownlow*.

Source and date of acquisition untraced.

Literature. 1965 catalogue (15) as James Capel.

Nichols and Wray, 1935, p. 414 gives John Capel, M.P. as Vice-President of the Hospital, 1832–47, and p. 396 James Capel as Governor, 1818. The former is presumably the man portrayed.

97. DURHAM, Joseph (1814–77)

Queen Victoria. Plaster, painted white,

32 ins. high, including socle, on plaster pedestal plinth (Plate 93).

Lettered on socle *VICTORIA* and incised on the back *J. Durham/Sc/ Osborne/1855*.

Source and date of acquisition untraced.

Literature. Art Journal, 1857, p. 4, describing the Guildhall marble (see below), states that the Queen gave Durham several sittings. 1965 catalogue (26).

Plaster version of marble bust exhibited by Durham at R.A. 1856 (1222) and presented to the Guildhall Council Chamber by the Mayor, Alderman Moon. The marble was destroyed by enemy action, 1940.

98. HALSE, George (fl. 1855–88)

Treasure Trove ('*The Foundling*').

Terracotta, 27 ins. high, including base, on wood pedestal painted as marble.

Incised on the case *G. Halse Sc 1874*.

Presented by Mrs. E. Halse, 1900.

Literature. 1965 catalogue (13).

Presumably the model for R.A. 1875 (1304).

99. HAYDON, Samuel James Bouverie (1815–91)

Rev. J. W. Gleadhall. Plaster painted white, 27½ ins. high, including base (Plate 92).

Inscribed on back of shoulders *S. J. B. Haydon* [?*Sc*] *74*. Painted around the front of the base *REVᴰ. J. W. GLEAD-HALL* and below *PRESENTED BY S. T. P. HAYDON/SCULPTOR 1846*. This latter date is surely incorrect, since Gleadhall did not become morning preacher at the Hos-

pital until 1847. The date 1874 seems to be the correct one.

Literature. Nichols and Wray, 1935, illus. opp. p. 230.

100. LIEVESLEY, Morris (d. 1849)

Captain Coram. Small plaster, painted brown, 13¾ ins. high.

Incised on reverse of the chair *Morris Liversley Sculpsit* [followed by partly obliterated Latin inscription] *MDCCCXXXVIII*.

?Presented by John Brownlow, 1838.

Literature. 1965 catalogue (35).

After Siever (see No. 104 below), and based on the Hogarth (No. 40). Lievesley joined the staff of the Hospital as Treasurer's clerk in 1795 and succeeded as Secretary, 1799, remaining in this job until his death in 1849.

101. OLIVERI, E. A. (fl. 1852–61)

Baron Heath. Plaster.

Incised on the back of the shoulders *E. A. OLIVERI Sculpsit London 1861*, and painted on the bottom of the plinth in black *BARON HEATH*.

Acquired in 1867, source untraced.

Literature. 1965 catalogue (6).

John Benjamin Heath, Baron Heath in the Kingdom of Italy; Consul-General to Sardinia; Governor of the Hospital, 1817; Vice-President, 1847–79.

102. ROUBILIAC, Louis Francis (1695–1762)

George Frederick Handel. Terracotta with coating of reddish-brown ceramic glaze (Plate 43). *Provenance*. Brownlow, 1858, p. 137, states that it belonged to Barrett, the proprietor of Vauxhall, and to the bass-singer Bartleman, and was later acquired by Pollock on the advice

of the sculptor Beynes, but in the sale of Jonathan Tyes Barrett (1830) the only portrait of Handel was the statue from Vauxhall (now Victoria and Albert). Brownlow is probably mistaken. However, there was a terracotta in Handel's own sale in 1762, and one at Christie's, 29 March 1805 so described. Gen. Comm. under 25 May 1844: 'The Secretary reported that he was desired by the Right Honourable Sir Fredk Pollock [Vice-President of the Hospital] ... to present in his Name to the Governors, a Bust of George Frederick Handel Esq., in Terra Cotta by Roubeliac [sic].'

Literature. Vertue, III, p. 105, under date 1741: 'Mr. Rubbilac ... had modelled ... Mr. Handel— &c and several others. being very exact Imitations of Nature—.' Esdaile, 1928, reproduces marble bust at Windsor, Plate Xb, see also p. 51. Nichols and Wray, 1935, illus. opp. p. 233. Whinney, 1964, pp. 102 ff. 1965 catalogue (37). Kerslake, 1966, p. 475 for full publication since restoration.

Terracotta of the Windsor marble dated 1739. Another bust at the Hospital of the same (Windsor) type is a weak plaster copy. No. 102 was recently restored by R. B. Barnes and revealed as a splendid original. A few retouchings and minor repairs were necessary.

103. RYSBRACK, John Michael (1693?–1770)
Charity. White marble relief, 30 × 47½ ins. (Plate 49).
Incised bottom right *M. RYSBRACK Fecit et Donavit.*
Provenance. Vertue, III, p. 132: '[1746 Octob. added later] Mr. Rysbrack has finisht his bass relief for the founding hospital representing charity a woman embraceing of children—several others the boys coyling a cord or ship and anchor & the Girls. husWifrey and rural imployments milking the Cows &c. the whole block of marble about 5 or 6 foot long—and the sculpture finely finisht and executed is for a present his own donation to the Hospital—. . . .'

Literature. Webb, 1954, pp. 131–2, 193, 196, 204, illus. Fig. 63. 1965 catalogue (78).

The signed terracotta model for the fireplace and relief was bought by Sir Edward Littleton in 1759 and set up at Teddlesley Hall; Teddlesley Hall sale, March 1953; now Victoria and Albert Museum (here Plate 22). A related terracotta statuette of the figure of Charity with three naked boys, signed and dated 1745, 22 ins. high, was in collection of Mrs. Albert Beveridge, 1954, on loan to Art Association of Indianapolis, Indiana, and is now in the Herron Museum of Art, Indianapolis (Webb, 1954, Fig. 62; here Plate 23). The mantelpiece in which the Hospital's relief is set is inscribed *I. DEVALL Fecit et Donavit* (see below, No. 110).

104. SIEVER, Robert William (1794–1865)
Thomas Coram. Plaster statuette, painted brown, 13¾ ins. high.
Incised on reverse *SIEVER. SCULP.T 1833.*

Approximately in the pose of Hogarth's portrait (No. 40). Another statuette of the same pattern but five years later is by Morris Lievesley (see above, No. 100). The Hospital possesses a third plaster of the same pattern. The rather damaged Siever is the prime original. He is usually referred to as

Sievier but the name Siever is quite clearly incised on the reverse.

105. SIEVER, Robert William (1794–1865)
Sir William Curtis. Plaster statuette, painted brown, 14 ins. high, including base.
Literature. 1965 catalogue (111).
Sir William Curtis, Bt. (1782–1847); Lord Mayor of London, elected 9 November 1795; Vice-President of the Hospital, 1823–47. Seated with a document inscribed 'A Bill for the improvement of the City of London'. After Sir Thomas Lawrence.

106. STEVENSON, David Watson (1842–1904)
The Foundling. White marble bust, 24¼ ins. high, including base.
Incised on the back of the shoulders *D. W. STEVENSON. Sc. EDIN^R 1871.*
Presented by E. W. Wadeson, 1871.

107. TOMLINSON, R. (b. 1779; fl. 1806–10)
William Beckwith. White marble bust, 25 ins. high including socle, on dark painted wood pedestal (Plate 87).
Incised on the gown, bottom right *R. TOMLINSON SCULPSIT A.D. 1807,* and on the socle *W^m BECKWITH ESQ. AET. SUAE 83.*
Literature. Nichols and Wray, 1935, illus. opp. p. 293. 1965 catalogue (32).
Tomlinson exhibited R.A. 1808 (861) a 'Bust of W. Beckwith Esq., Barrister-at-law'. A portrait said to be of Beckwith and attributed to N. Hone is catalogued above, No. 43.

108. UNIDENTIFIED
Aeneas carrying Anchises out of Troy with Ascanius following. White plaster relief (tondo).
Literature. 1965 catalogue (53).

D. SCULPTURE UNTRACED IN THE COLLECTION

(a) FILLANS, James (1808–1852)
Gen. Comm. under 9 March 1850: 'Mr. Fillans, a sculptor, had presented to the Hospital a Bust of Professor Wilson, of Edinburgh.' Fillans returned from London to Glasgow in 1850 where he died two years later. Gunnis, 1953, *ad vocem,* mentions his bust of Professor Wilson (1848) as executed for the County Hall, Paisley.

E. FURNITURE, SILVER, DECORATION

109. BRITISH SCHOOL, mid-Eighteenth Century

Sidetable. Pine wood, with rectangular green Grecian marble top, supported by carved figures of a goat and two children before a tree stump (Plate 47). Presented by John Sanderson, 1745(?).

Literature. Nichols and Wray, 1935, p. 261, illus. opp. p. 263. 1965 catalogue (68). According to Webb, 1954, p. 132, this was presented in 1745 but there is no reference to this fact in the Minutes of this year. Sanderson was employed on architectural work for both the old and the new Hospital. Gen. Comm. under 15 July 1741: he is recorded as being paid for bricklayers' work £3. 19s. 2d. on the old building. On 22 July 1742 his tender for bricklaying for the new building is accepted. Gen. Comm. under 30 July 1755: 'That Mr. Sanderson do make a Bath of 16 feet long, by 10 wide. . . .'

110. DEVALL, J.

Mantelpiece (Plate 48).

Inscribed *I. DEVALL Fecit et Donavit.*

Literature. G.C.M. under 3 December 1746: 'Ordered: That the Steward do pay Mr. Devall's Men a Guinea as a Reward for their Extraordinary Trouble in the Chimney Peice put up in the Court Room, the Benefaction of the said Mr. Devall.' *Country Life*, 1920, p. 529. Nichols and Wray, 1935, p. 261.

The relief over the mantelpiece is by Rysbrack (see above, No. 103). It is generally said that Devall was responsible for the whole of the stonework of the Hospital, but no conclusive evidence to this effect has come to light in the Minutes. A 'John Duvall' is due to carry out the cornice of the new Hospital, according to Gen. Comm. under 8 December 1742. Gen. Comm. under 10 February 1748 states that Devall was employed as mason in the chapel, and again under 24 January 1750, that he was responsible for the Chapel floor, and for paving 'the Altar with Marble as Mr. Jacobsen shall direct'.

111. ELLICOTT, John (1706–72)

Two Grandfather Clocks. Longcase, walnut (Plate 67).

Both inscribed on clock face *John Ellicott London.*

Provenance. Gen. Comm. under 10 January 1750: 'Ordered/That the Secretary do write to Mr. Smith in Moorfields desiring that he would Prepare Proposals for the making of a Turret Clock in the very best manner, and be as particular therein as he can; that he first lay those Proposals before Mr. Ellicott and get them approved by him. . . .' Gen. Comm. under 28 March 1750: 'Mr. Ellicott having presented the Hospital with a Pendelum Clock'—thanks of the Committee.

Literature. Nichols and Wray, 1935, illus. one clock (with finials) opp. p. 81. 1965 catalogue (14) and (31).

John Ellicott or Ellicot made Governor 1759.

There are other longcase clocks in the Hospital. One is inscribed Ja.ˢ Foulsham Norwich on the clock face; another Rob.ᵗ Higgs London on the clock face.

112. IVES, Edward

Cartouches.

Presented by the artist.

Literature. 1965 catalogue (33, 49) lists four painted lead cartouches, and (44) a carved wood cartouche.

They are inscribed with Biblical quotations appropriate to a charitable institution, and the words *Given by Mr. Edwᵈ Ives.* They were made for the original Hospital.

113. STORR, Paul

Silver Salver.

Presented by Robert Green (Treasurer of the Hospital, 1892–1914).

Literature. 1965 catalogue (103).

The salver bears the arms of the Duke of Cambridge, seventh son of George II, for over half a century President of the Hospital. It dates from 1808.

114. WILTON, William

Ceiling of the Court Room (see Plate 21). Presented by the artist-decorator, 1745.

Literature. Gen. Comm. under 1 January 1746: 'That the Secretary do pay Mr. Wilton's Foreman One pound one shilling as a Gratuity to be distributed by the said Foreman to himself and the other Workmen employed in doing the Cieling of the Court Room, the Work and Materials being the gift of Mr. Wilton to this Hospital.' Nichols and Wray, 1935, p. 261. 1965 catalogue, p. 13.

William Wilton was the father of the sculptor Joseph Wilton. Whinney, 1964, p. 137, speaks of him as a plasterer who had made money out of papier-mâché ornament. He was employed as a plasterer and stucco-worker in the Chapel in 1749.

BIBLIOGRAPHY

In order to save space throughout the book, I have referred to manuscripts and most publications by shortened titles, as shown here in brackets after each entry. Other publications are cited in full in text and catalogue. Not quite all the following publications are cited in the text.

MS. MATERIAL

1739 onwards — General Court Minutes. MS. Volumes, Thomas Coram Foundation for Children. Continuously from 20 November 1739 (first meeting). (G.C.M.)

1739 onwards — Minutes of General Committee. MS. Volumes, Thomas Coram Foundation for Children. Continuously from 29 November 1739 (first meeting). (Gen. Comm.)

1748 onwards — Sub-Committee Minutes, Thomas Coram Foundation for Children. Various MSS. dealing with Foundling Hospital affairs, letters, etc. Continuously from 21 December 1748. Deposited at County Hall, London. (Sub-Committee)

1698–1743 — Minutes of the Virtuosi of St. Luke, 1698–1743. B.M. Add. MS. 39167. (Virtuosi of St. Luke MS.)

1961–2 — Draft Catalogue prepared by *Mr. John Kerslake* of the National Portrait Gallery . . . typescripts deposited at N.P.G. and Thomas Coram Foundation for Children. (Kerslake)

1968 — Hubert Langley. 'The Music'. MS. in possession of Thomas Coram Foundation for Children, written shortly before his death in 1968. (Langley, 1968)

PRINTED SOURCES

1746 — *Gentleman's Magazine*, 1746, XVI, p. 383. (*Gentleman's Magazine*, 1746)

1759 — *Sacred Musick, Composed by the late George Frederick Handel, Esq.; And Performed at the Chapel of the Hospital, for the Maintenance and Education of Exposed and Deserted Young Children on Thursday, the 24th May, 1759* . . . (Handel, 1759)

1766 — John Gwynn, *London and Westminster Improved*, London, 1766. (Gwynn, 1766)

1775 — Robert Strange, *An Inquiry into the Rise and Establishment of the Royal Academy of Arts* . . . , London, 1775. (Strange, 1775)

1782 — [J. Nichols], *Biographical Anecdotes of William Hogarth* . . . , second ed., London, 1782. (Nichols, 1782)

1783 James Barry, *An Account of a Series of Pictures in the Great Room of the Society of Arts, Manufacturers, and Commerce*, London, 1783. (Barry, 1783)

1791–8 John Ireland, *Hogarth Illustrated*, 2nd ed., 3 vols., 1791–8. (Ireland, 1791–8)

1808 Edward Edwards, *Anecdotes of Painters . . .* , London, 1808. (Edwards, 1808)

1840 P. W. Richardson, 'Pictures in the Foundling Hospital, London', *Art Union*, July 1840. (*Art Union*, 1840)

1845 John Pye, *Patronage of British Art*, 1845. (Pye, 1845)

1847 John Brownlow, *Memoranda or Chronicles of the Foundling Hospital*, 1847. (Brownlow, 1847)

1857 *Art Journal*, January 1857. (*Art Journal*, 1857)

1858 John Brownlow, *The History and the Design of the Foundling Hospital*, London, 1858. (Brownlow, 1858)

1890 George Clinch, *Marylebone and St. Pancras—their History, Celebrities, Buildings, and Institutions*, London, 1890. (Clinch, 1890)

1920 'The Foundling Hospital. A Site for the London University', *Country Life*, 16 October 1920, pp. 502 ff.; 23 October 1920, pp. 534 ff. (*Country Life*, 1920)

1921 Paul Jamot, 'Watteau Portraitiste . . .', *Gazette des Beaux-Arts*, November 1921, pp. 257 ff. (Jamot, 1921)

1926 C. H. Collins Baker, 'Nebot and Boitard: Notes on two early Topographical Painters', *The Connoisseur*, May 1926, pp. 3–6. (Collins Baker, 1926)

1928 William T. Whitley, *Artists and their Friends in England 1700–1799*, 2 vols. London, 1928. (Whitley, 1928)

1928 Katherine A. Esdaile, *The Life and Works of Louis François Roubiliac*, London, 1928. (Esdaile, 1928)

1934–55 *Vertue Note Books*, Vol. III; XXIInd Vol. of *Walpole Society*, O.U.P. 1934. Vol. VI; XXXth vol. of *Walpole Society*, O.U.P., 1955. (Vertue, followed by Vol. and page reference)

1935 R. H. Nichols and F. A. Wray, *The History of the Foundling Hospital*, London, 1935. (Nichols and Wray, 1935)

1942 *Country Life*, 27 March 1942. (*Country Life*, 1942)

1947 F. Antal, 'Hogarth and his Borrowings', *Art Bulletin*, March 1947, pp. 36 ff. (Antal, 1947)

1948 A. P. Oppé, *The Drawings of William Hogarth*, London, 1948. (Oppé, 1948)

1949 R. B. Beckett, *Hogarth*, London, 1949. (Beckett, 1949)

1952 Alastair Smart, *The Life and Art of Allan Ramsay*, London, 1952. (Smart, 1952)

1953 Ellis Waterhouse, *Painting in Britain 1530 to 1790*, London, 1953. (Waterhouse, 1953)

1953 W. G. Constable, *Richard Wilson*, London, 1953. (Constable, 1953)

1953 Lawrence Gowing, 'Hogarth, Hayman, and the Vauxhall Decorations', *The Burlington Magazine*, January 1953, pp. 4 ff. (Gowing, 1953)

1953 R. Gunnis, *Dictionary of British Sculptors, 1660–1831*, 1953. (Gunnis, 1953)

1954 Derek Hudson and Kenneth W. Luckhurst, *The Royal Society of Arts, 1754–1954*, London, 1954. (Hudson/Luckhurst, 1954)

1954 M. I. Webb, *Michael Rysbrack, Sculptor*, London, 1954. (Webb, 1954)

1954 H. M. Colvin, *Biographical Dictionary of English Architects, 1600–1840*, London, 1954. (Colvin, 1954)

1954 H. A. Hammelmann, 'The Art of Francis Hayman', *Country Life*, 14 October 1954, pp. 1258–9. (Hammelmann, 1954)

1955 O. E. Deutsch, *Handel, A Documentary Biography*, London, 1955. (Deutsch, 1955)

1955 *William Hogarth, The Analysis of Beauty . . .*, ed. Joseph Burke, Oxford, 1955. (Burke, 1955)

1957 Margaret Whinney and Oliver Millar, *English Art 1625–1714*, Oxford, 1957. (Whinney/Millar, 1957)

1958 E. K. Waterhouse, *Gainsborough*, London, 1958. (Waterhouse, 1958)

1959 *Allen Memorial Art Museum Bulletin*, XVI, No. 2, Oberlin College, Winter 1959. (Oberlin Bulletin, 1959)

1962 Frederick Antal, *Hogarth and his Place in European Art*, London, 1962. (Antal, 1962)

1964 Margaret Whinney, *Sculpture in Britain 1530–1830*, London, 1964. (Whinney, 1964)

1965 *Hogarth's Graphic Works*. First Complete Edition compiled and with a commentary by Ronald Paulson, 2 vols. New Haven and London, 1965. (Paulson, 1965)

1965 *The Thomas Coram Foundation for Children. Catalogue of Pictures, Works of Art and Historical Documents and Relics On View at 40 Brunswick Square, London, W.C.1.*, London, 1965. (1965 catalogue)

1965 Ellis Kirkham Waterhouse, *Three Decades of British Art 1740–1770*, Philadelphia, 1965. (Waterhouse, 1965)

1966 'Charles Brooking', exhibition catalogue, Aldeburgh and Bristol, 1966. (Brooking catalogue, 1966)

1966 Jules David Prown, *John Singleton Copley*, Cambridge (Mass.), 1966. (Prown, 1966)

1966 John Kerslake, 'Roubiliac's "Handel": a terracotta restored', *The Burlington Magazine*, September 1966, p. 475. (Kerslake, 1966)

1966 'The Thomas Coram Foundation for Children', *The Burlington Magazine*, September 1966, pp. 447–8. (Burl. Mag., 1966)

1967 Ronald Paulson, 'New Light on Hogarth's Graphic Works', *The Burlington Magazine*, May 1967, pp. 281 ff. (Paulson, 1967)

1968 Michael Kitson, 'Hogarth's "Apology for Painters"', *Walpole Society*, Vol. XLI, 1968, pp. 46 ff. (Kitson, 1968)

1970 Elizabeth Einberg, Catalogue of the exhibition 'George Lambert 1700–1765', the Iveagh Bequest, Kenwood, 1970. (Einberg, 1970)

1971 Clovis Whitfield, 'William Hogarth–Paul Before Felix–Lincoln's Inn', pamphlet written for Lincoln's Inn, republished with changes in *The Burlington Magazine*, 1971, pp. 210–4. (Whitfield, 1971)

Note. Miscellaneous documents concerning the Foundling Hospital are to be found in Swiss Cottage Local History files, Heal Collection, C6/38–69, 70–97, but nothing of any interest about the art collections. For the benefit of students working on the subject, it should also be emphasized that the Sub-Committee Minutes deposited at County Hall (see above, under MS. Material) contains virtually nothing of artistic interest.

INDEX

Note: Only the text is indexed. It has not been considered necessary to index the catalogue, where works of art appear alphabetically under artists and craftsmen within categories.

Alexander (metal-worker), 12 n.2
Amyand, George, 48
Anderson, Mrs. Walter (Sophia), 50

Bedford, Duke of, 3
Bellamy, E., 7 n.14
Bernard, Thomas, 43–4, 51 n.1
Boitard, L. P., 13 n.6
Bouverie, Sir Jacob, 15, 16 n.13
Brooking, Charles, 17, 32–3, 34 n.2, 38
Brownlow, Emma, 42, 44, 50
Brunelleschi, Filippo, 14
Burton, Philip, 51

Calder Marshall, W., 1 n.2
Campi, Giulio, 50–1
Carracci, Antonio, 53
Carter, Thomas, 20–1
Casali, Andrea, 30, 42–3
Chambers, William, 37
Collingwood, Thomas, 4 n.8, 33
Conca, Sebastiano, 42 n.16
Copley, John Singleton, 52–3
Coram, Thomas, biog. 2, 8; association with F.H., 3 ff., 55; submits seal of F.H., 6; friendship with Hogarth, 4–5; portraits by Hogarth, 1, 6, 8–10, 17, 29–31, 34, 48; by Nebot, 1–3, 7, 53; by Siever, 1 n.2; by others, 1 n.2, 14
Correggio, 43
Cotes, Francis, 10, 32

Dalton, Richard, 32
Dance, Nathaniel, 50
Devall, John, 17, 21, 25, 39, 41
Dowbiggen, Lancelot, 12 n.2
Drevet (engraver), 9

Ellicott, John, 32
Elliot, General (later Lord Heathfield), 52
Ellis (painter), 22–3
Emerson, Thomas, 29

Folkes, Martin, 7 n.16
Fourdrinier (engraver), 13 n.4, 15 n.12, 16

Gainsborough, Thomas, 22, 25, 28, 31, 38
Géricault, Théodore, 53
Giulio Romano, 51
Gravelot, Hubert, 22–3
Gregory, Sir Roger, 52
Greuze, Jean Baptiste, 27
Grey, Robert, 48
Gwynn (architect), 37

Handel, George Frederick, association with F.H., 7 n.13, 45 ff.; presentations to F.H., 41, 46, 48, 55; organizer of musical performances, 21, 38, 40, 45 ff.; illness and death, 47–8; bust by Roubiliac, 29, 48–9, 52
Harding, Francis, 17, 25
Haydon, Samuel James Bouverie, 50
Hayman, Francis, work for Vauxhall Gardens, 24; St. Martin's Lane Academy, 22, 25, 35, 37; association with F.H., 20, 36; *Finding of Moses*, 25–6, 42; mentioned, 38
Haytley, Edward, 20, 25, 28
Highmore, Joseph, association with F.H., 20, 37; in Cheron and Vanderbank's Academy, 22, 25; *Emerson*, 21, 26, 29, 52; *Hagar and Ishmael*, 25–6; mentioned, 9–10, 16, 38
Hoare, Prince, 51
Hobbema, Meindert, 33
Hogarth, Jane, 4, 7 n.14
Hogarth, William, portraits of *Coram*, 1, 6, 8–10, 17, 29–31, 34, 48 52; *Martin Folkes*, 7 n.16; *Bishop Hoadley*, 9 n.21; *Jacobsen*, 15–16; *Moses before Pharaoh's Daughter*, 25–27, 43; *Paul before Felix*, 26 n.18; 27; *Pool of Bethesda, Good Samaritan*, 5, 33; *March to Finchley*, 30–1; *The Foundlings*, 6; shield of F.H., 6–7; arms of F.H., 7, 46; *Anecdotes of an Artist*, 9–10; friendships with Coram, 1, 6, 8–10, 17, 29–31, 34, 48, 52; and Lambert, 33; work for Vauxhall

Hogarth (*cont.*)
 Gardens, 24; at St. Martin's Lane Academy, 22, 35, 37; association with F.H., 2, 4 ff., 20, 24–5, 31, 34, 38, 42, 55; support of other charitable institutions, 5; mentioned, 38, 45
Holden, Luther, 50
Hone, Nathaniel, 37
Horne (Surveyor of F.H. Chapel), 39
Hudson, Thomas, association with F.H., 20; *Jacobsen*, 13 n.4, 16, 29, 34; *Milner*, 29–30, 34; *Handel*, 29 n.25; mentioned, 10, 38

Jacobsen, Theodore, association with F.H., 3, 15, 20; building of F.H., 11 ff.; building of Chapel, 39 ff.; demolition of F.H., 52–3; biog., 15; portraits by Hogarth, 15–16; and Hudson, 13 n.4, 16, 29, 34
James (architect), 11

Keene (pulpit maker), 41
Kelly, Sir Gerard Festus, 51
Kennington, Thomas-Benjamin, 51
Kent, William, 22
King, Emma, see Brownlow
Kneller, Sir Godfrey, 9, 26

La Cave, 6
Lambert, George, 20, 28, 32–3, 37–8
Langford, Abraham, 32
Langley, Hubert, 49
La Tour, Maurice Quentin de, 9 n.21
Lee, Rev. Timothy, 37
Lievesley, Morris, 44
Littleton, Sir Edward, 18
Lovett, Thomas and John, 12 n.2

Macclesfield, Earl of, 32
Macklin, Charles, 43–4
Macmillan, W., 1 n.2
Martin, Sir Alec, 53
Mead, Dr. Richard, biog., 29; association with F.H., 2–3; comments on Rysbrack, 18 n.24
Mercier, Philip, 23
Meyer, Jeremiah, 37
Millais, Sir John Everett, 50
Milner, John, 12
Monamy, Peter, 20–1, 24, 33, 34 n.2
Monnington, Sir Thomas, 54
Morse, Dr. Jonathan, 41, 46
Moser, George Michael, 20–3, 37

Nebot, B., 1–3, 7, 53

Nesbit, Dr. Robert, 3
Newton, Francis Milner, 36–7

Paine (architect), 37
Parker, Thomas, 41
Parr, N. (engraver), 13 n.6, 21 n.2
Philpot, Stephen, 47
Pine, John, 20–1, 46
Pine, Robert Edge, 35, 37
Pine (Bluemantle Pursuivant of Arms), 7 n.13
Pollock, Sir Frederick, 48
Poussin, Nicolas, 27

Ramsay, Allan, association with F.H., 20; *Mead*, 26, 29–31, 34, 48, 52; mentioned, 10, 38
Raphael, 51–2
Reynolds, Sir Joshua, association with St. Martin's Lane Academy, 35, 36 n.11, 37; and with F.H., 32–3, 55; *Earl of Dartmouth* 33–4; mentioned, 10
Richardson, Sir Albert, 54
Rigaud, Hyacinthe, 9–10, 14
Roberts, K. (engraver), 13 n.5
Robinson, Jeremiah, 13 n.5
Roubiliac, Louis Francis, in St. Martin's Lane Academy, 22, 37; *Handel*, 29, 48–9, 52; mentioned, 23
Rysbrack, John Michael, association with F.H., 17, 20, 23, 32, 37; *Sir John Sutton*, 16; *Charity*, 17–18, 25; mentioned, 38

Sagrestani, Giovanni Camillo, 51
Salisbury, Earl of, 11
Sampson (architect), 11
Sandby, Paul, 35, 37
Sanders, John, 33, 40–1
Sanderson, John, 17
Sargent, G. R., 40 n.8
Scheemakers, 16 n.16
Scott, Samuel, 20–1
Shackleton, John, 32, 34, 50
Sharp, William, 53
Siever, Robert William, 1 n.2
Smith, John Christopher, 47–8
Spier, William, 12 n.2
Sullivan, Luke, 27

Taylor, Robert, 20–1
Taylor White, 6, 17, 32–3, 37
Thornhill, Sir James, 9, 14, 38
Thorp, John B., 14 n.8

Titian, 43
Tomlinson, R., 50
Trevisani, Francesco, 42 n.16
Tyers, Jonathan, 48
Tyler (architect), 27

Vanderbank, John, 22
Van Der Heyden, Jan, 28
Van Dyck, Sir Anthony, 9, 52
Van Haecken, Joseph, 30
Verrio, Antonio, 9
Vien, Joseph Marie, 27 n.21

Wale, Samuel, 20, 21 n.2, 25, 28, 37
Wales, Prince and Princess of, 45
West, Benjamin, 42 ff., 50, 51 n.1

Wheeler, Sir Charles, 54
White, James, 53
Wilkes, John, 36
Wills, James, in St. Martin's Lane Academy, 22, 25; association with F.H., 20; abandons painting, 26; *Little Children brought to Christ*, 25–6, 50
Wilson, Benjamin, 32, 34
Wilson, Richard, in St. Martin's Lane Academy, 22, 37; association with F.H., 20; *Foundling Hospital*, 13, 25, 28; *St. George's Hospital*, 25, 28
Wilton, Joseph, 17, 37
Wilton, William, 17, 39
Wragg (metal-worker), 42

Yeo, Richard, 7, 37

Zincke, Paul Christian, 15, 20, 22–3

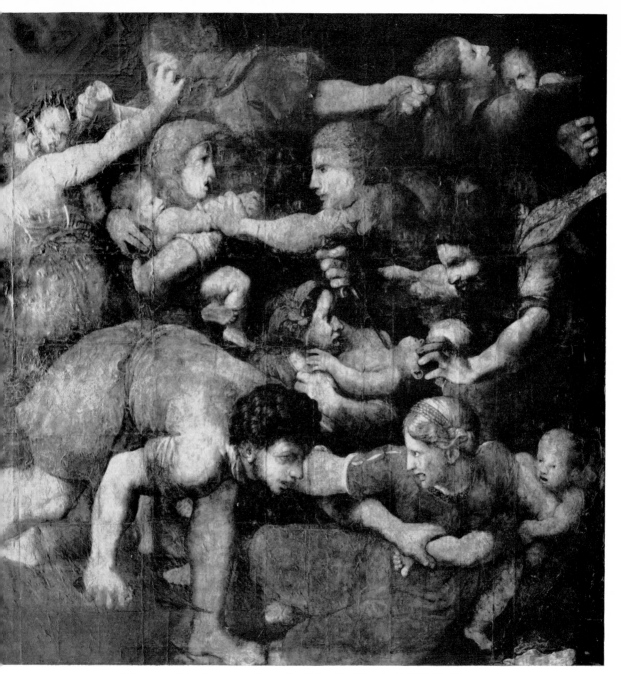

37. *Massacre of the Innocents,* from the School of Raphael (?Giulio Romano)

(a)

(b)

(c)

38. *Bacchanalian Procession*, by Giulio Campi (one drawing divided into three)

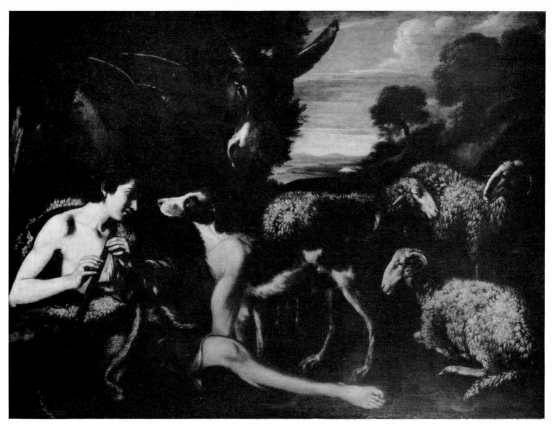

39. *A Piping Shepherd Boy*. Italian School, Seventeenth Century

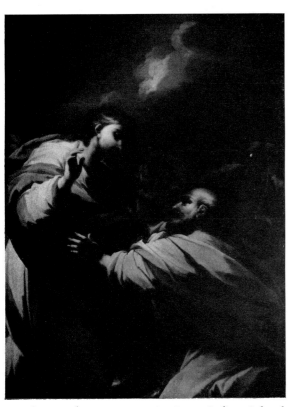

40. *Our Lord appearing to St. Peter*. Italian School
after 1700 (?Tuscan)

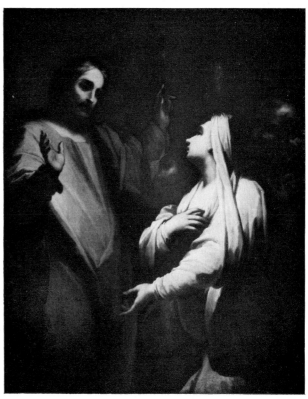

41. *Woman taken in Adultery*, by Giovanni Camillo
Sagrestani

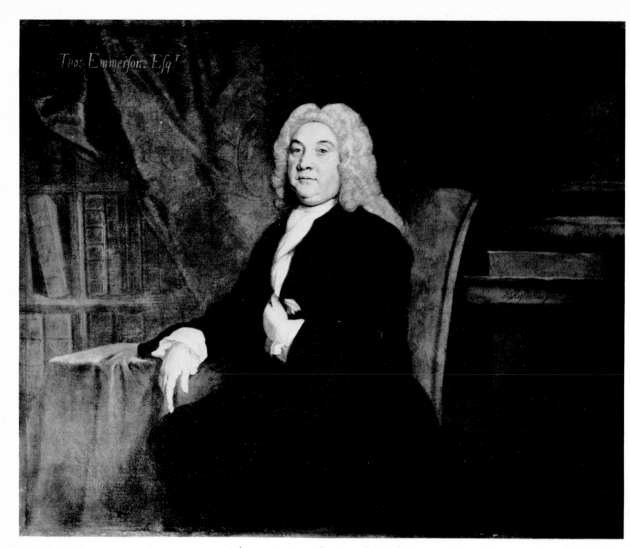

42. *Thomas Emerson*, by Joseph Highmore

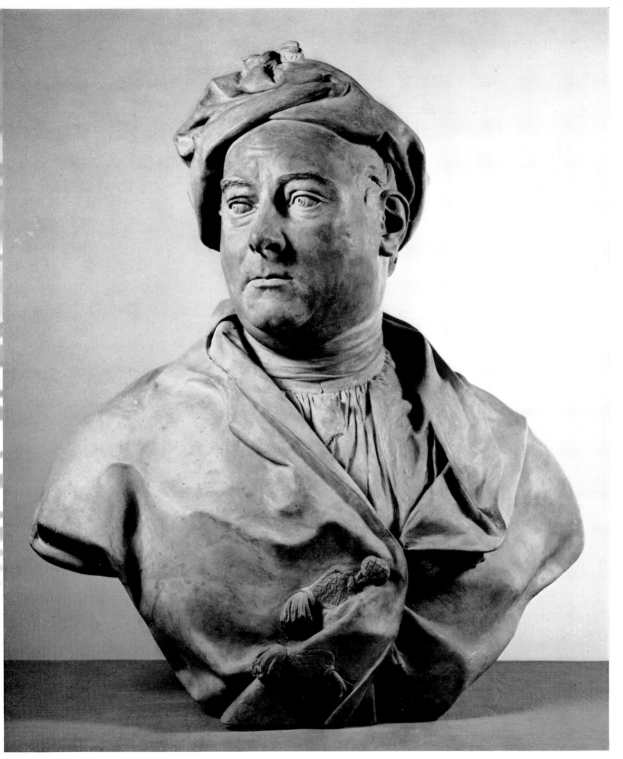

43. *George Frederick Handel*, by Louis Francis Roubiliac

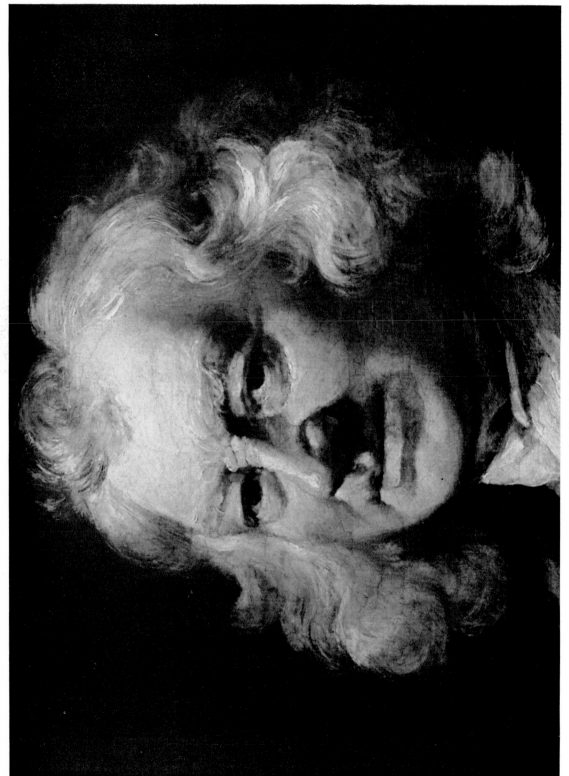

44. Detail of head of Hogarth's *Coram*

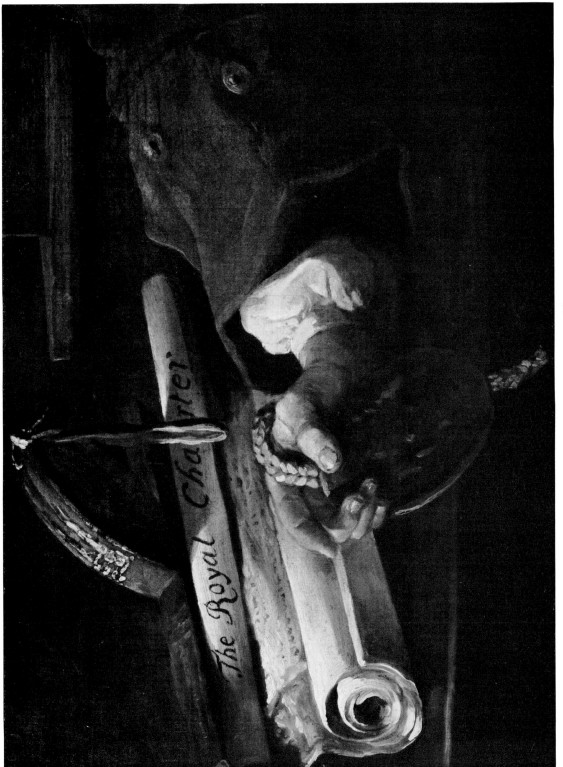

45. Detail of right hand of Hogarth's *Coram*

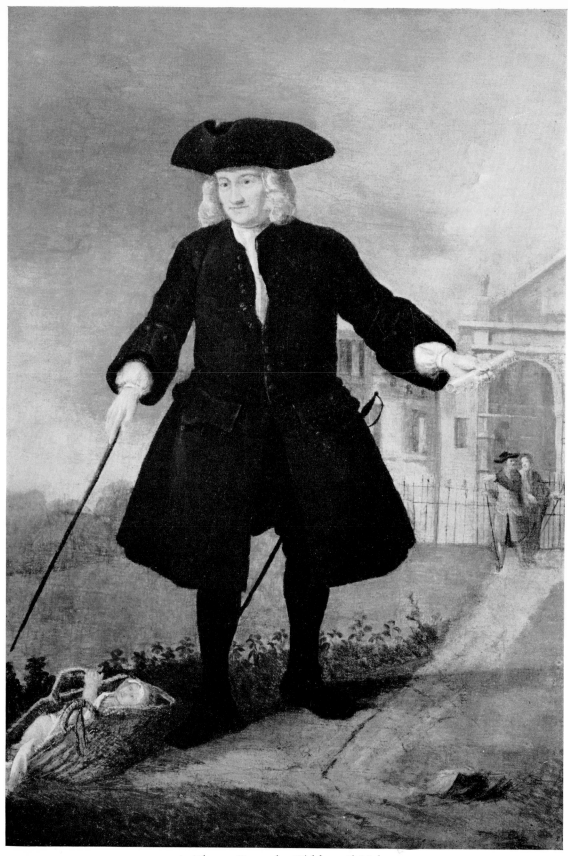

46. *Thomas Coram*, by B(althazar?) Nebot

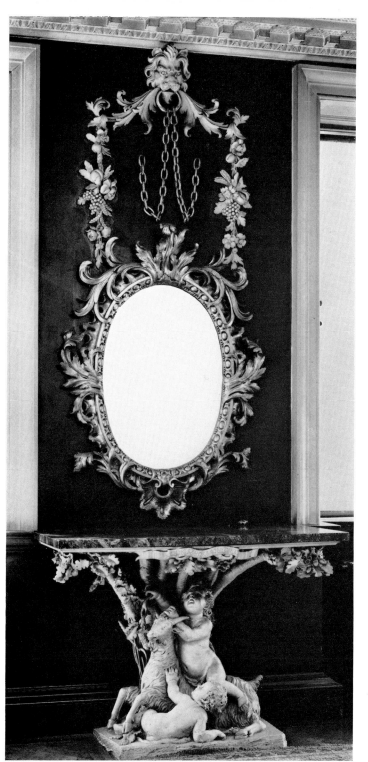

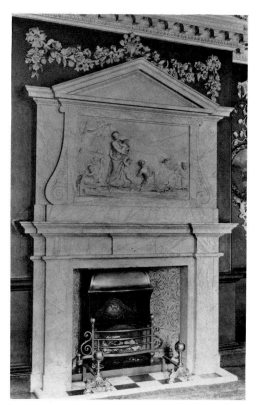

48. *Mantelpiece* in Court Room, by John Devall. *c.* 1745

47. *Sidetable*. Pine wood, with rectangular green Grecian marble top, supported by carved figures of a goat and two children before a tree stump. Mirror above. British School, *c.* 1740

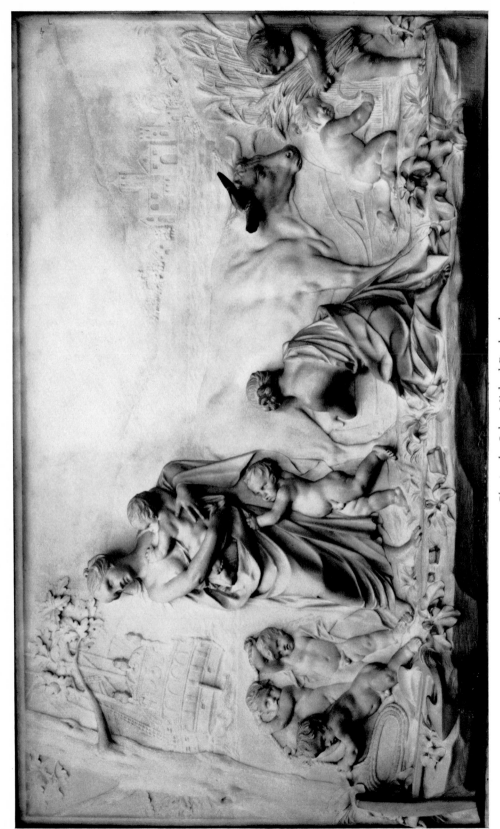

49. *Charity*, by John Michael Rysbrack

50. *Hagar and Ishmael*, by Joseph Highmore

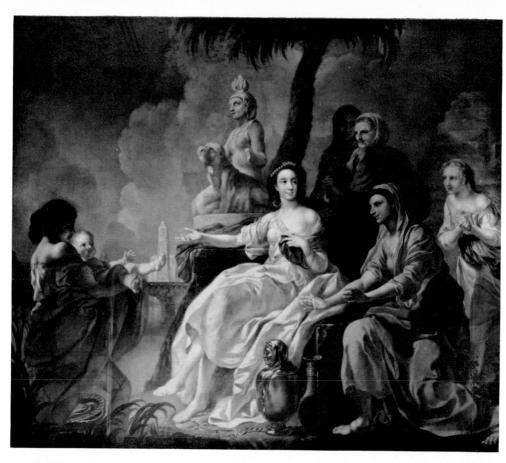

51

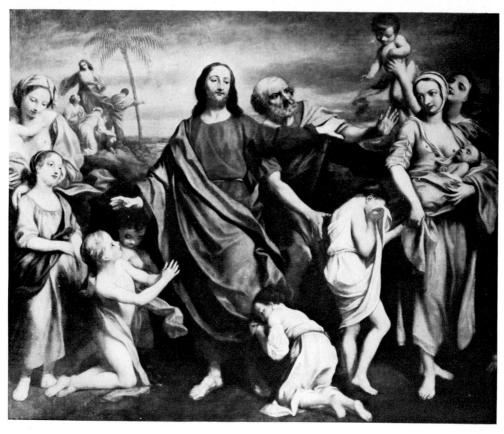

52

53. *Moses brought before Pharaoh's Daughter*, by William Hogarth

(*above left*) *The Finding of the Infant Moses in the Bullrushes*, by Francis Hayman

(*left*) *Little Children brought to Christ*, by James Wills

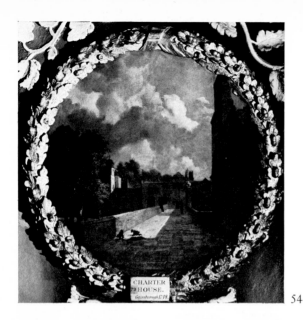

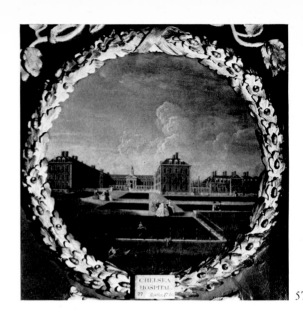

54

57

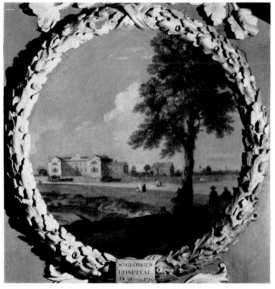

55

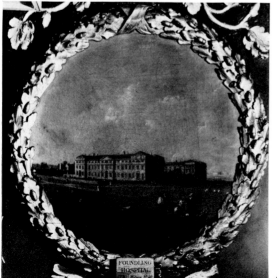

56

54. *The Charterhouse*, by Thomas Gainsborough
55. *St. George's Hospital*, by Richard Wilson
56. *The Foundling Hospital*, by Richard Wilson
57. *Chelsea Hospital*, by Edward Haytley

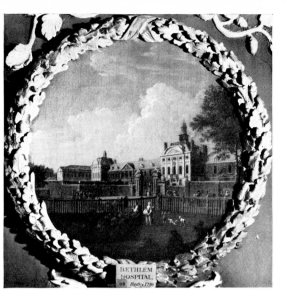

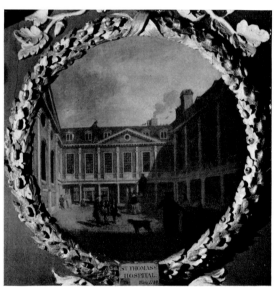

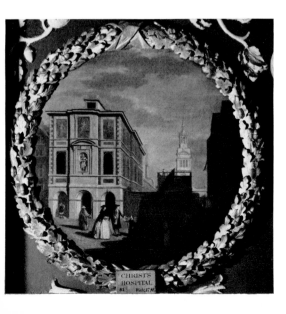

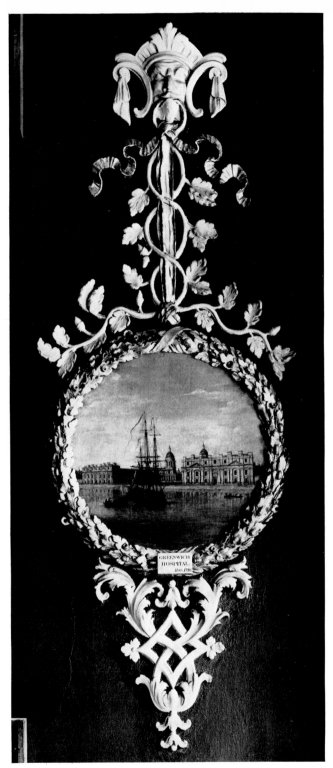

61. *Greenwich Hospital*, by Samuel Wale. With oakleaf and acorn frame

58. *Bethlem Hospital*, by Edward Haytley
59. *St. Thomas's Hospital*, by Samuel Wale
60. *Christ's Hospital*, by Samuel Wale

62. *Dr. Richard Mead,* by Allan Ramsay

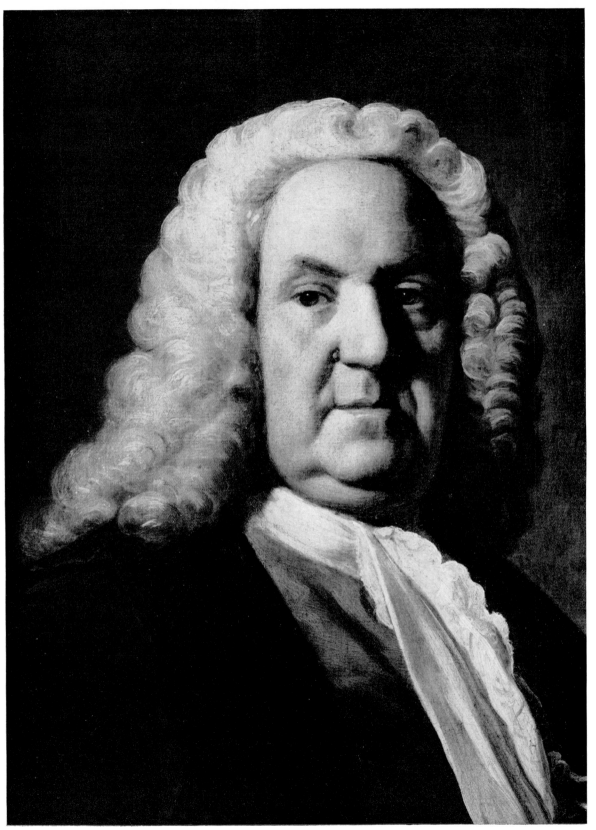

63. Detail of head of Ramsay's *Mead*

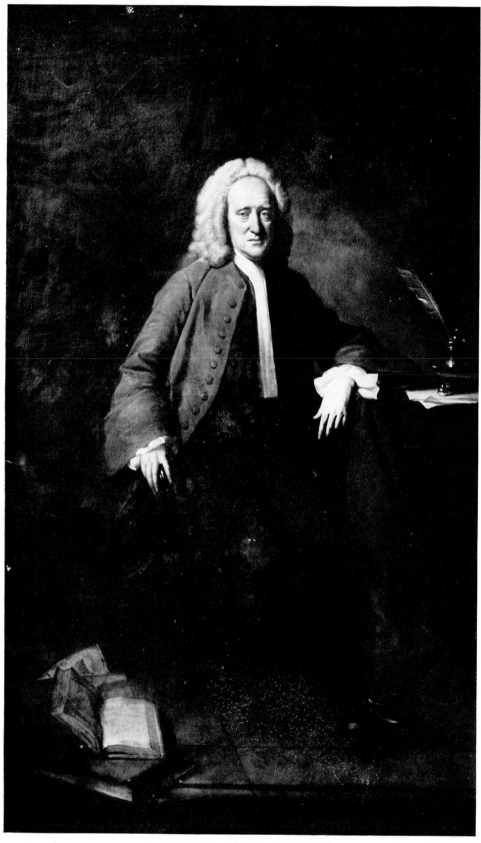

64. *John Milner*, by Thomas Hudson

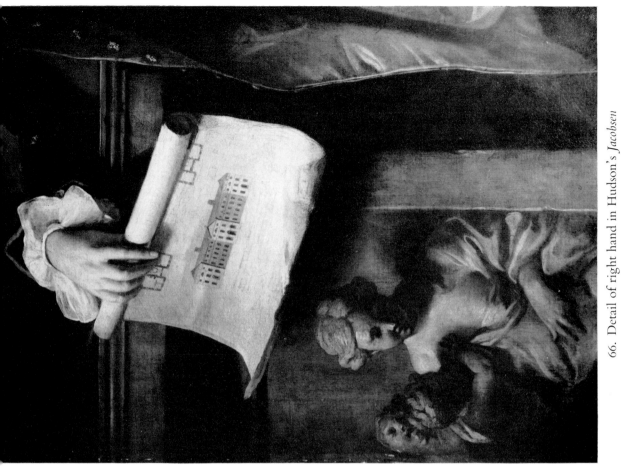

66. Detail of right hand in Hudson's *Jacobsen*

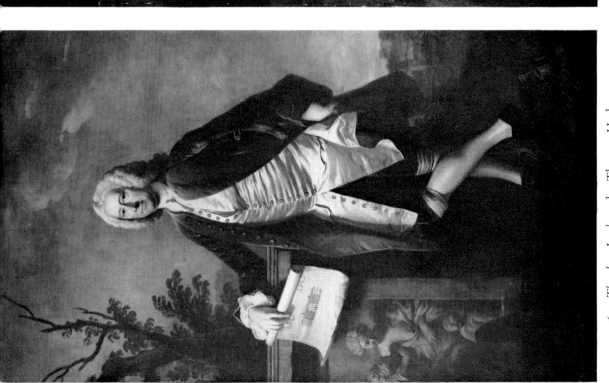

65. *Theodore Jacobsen*, by Thomas Hudson

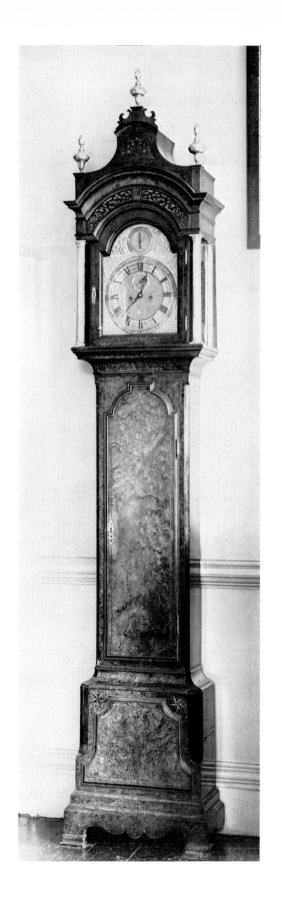

68. *Caracalla*. British School, before 1754

69. *Marcus Aurelius*. British School, before 1754

67. Walnut longcase *Clock*, by John Ellicott

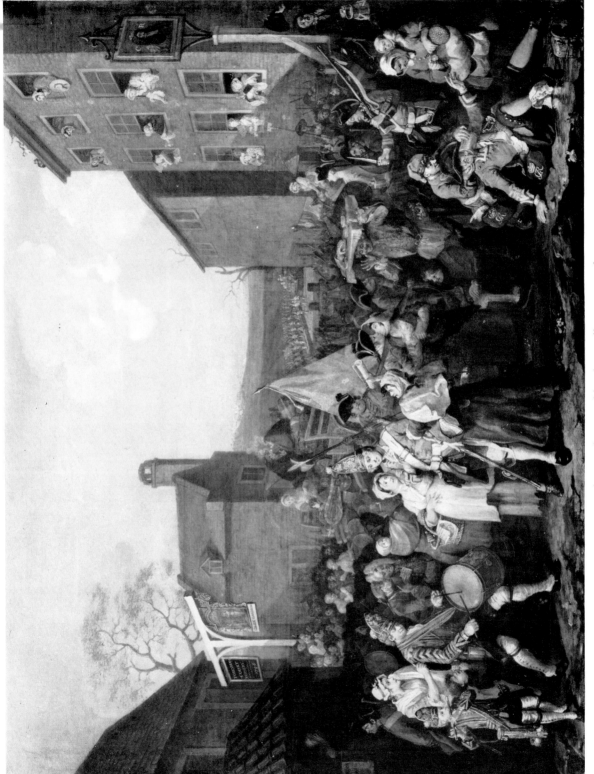

70. *The March to Finchley, by William Hogarth*

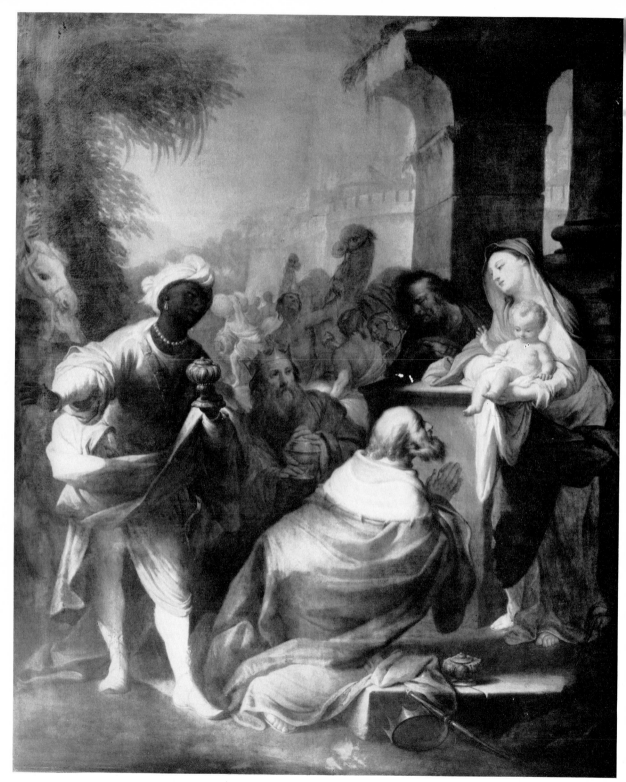

71. *Adoration of the Magi*, by Andrea Casali

72. Hogarth's Lambeth-Delft Punch-bowl

73. Keyboard of eighteenth-century Organ, said to be the one presented to the Hospital by Handel

74. *A Flagship before the wind under easy sail, with a cutter, a ketch, and other vessels, by* Charles Brooking

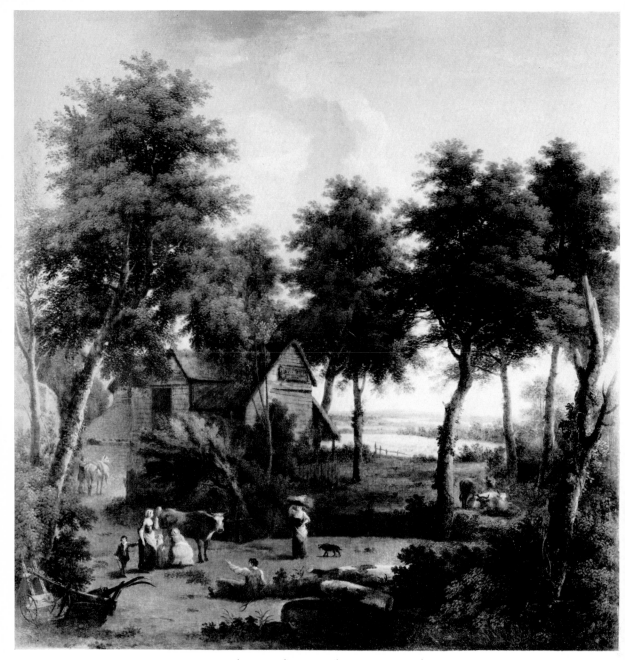

75. *Landscape with Figures*, by George Lambert

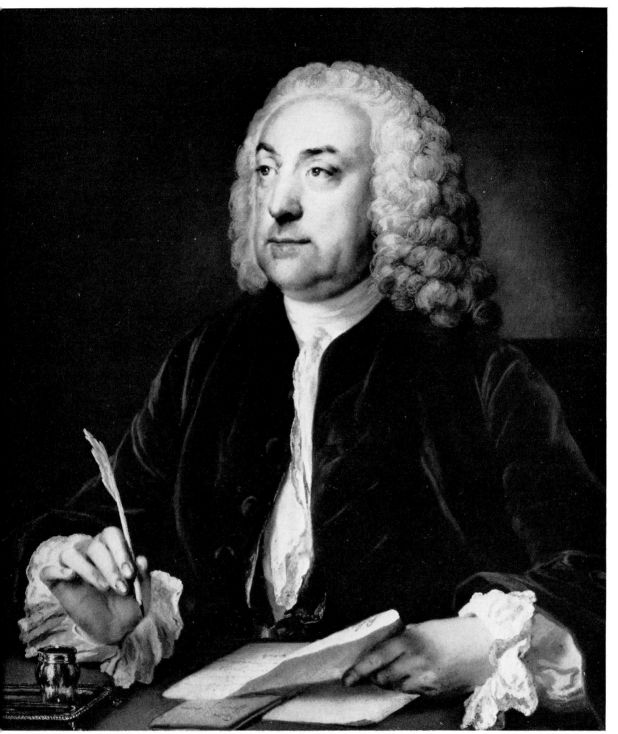

76. *Taylor White*, by Francis Cotes

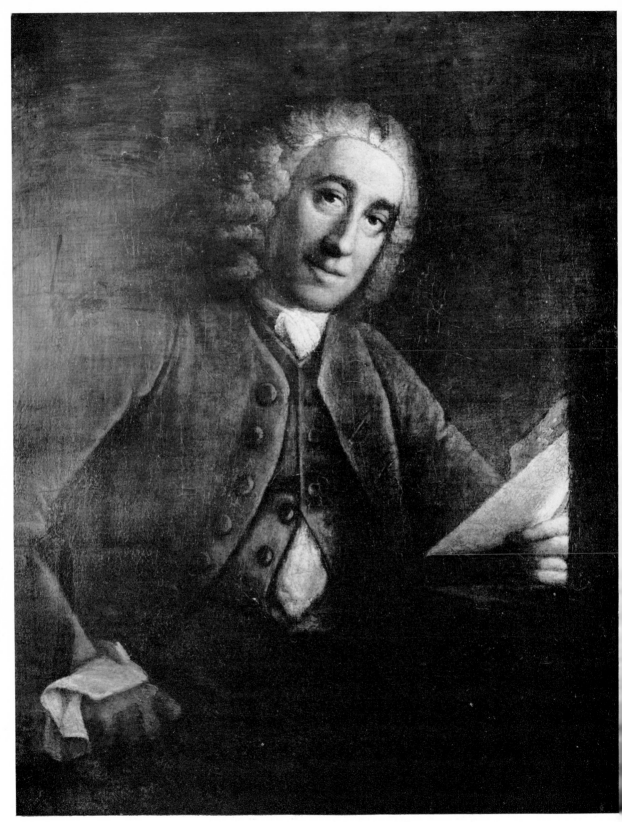

77. *Francis Fauquier*, by Benjamin Wilson

79. *George II*, by John Shackleton

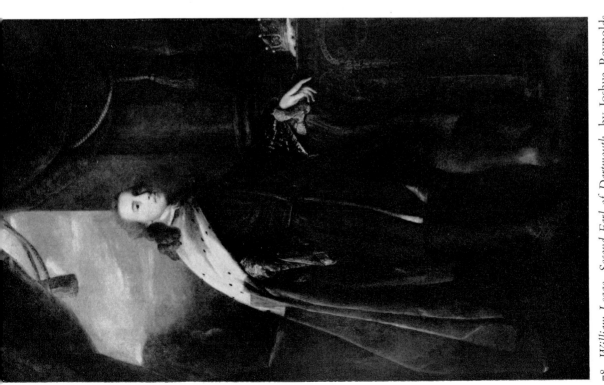

78. *William Legge, Second Earl of Dartmouth*, by Joshua Reynolds

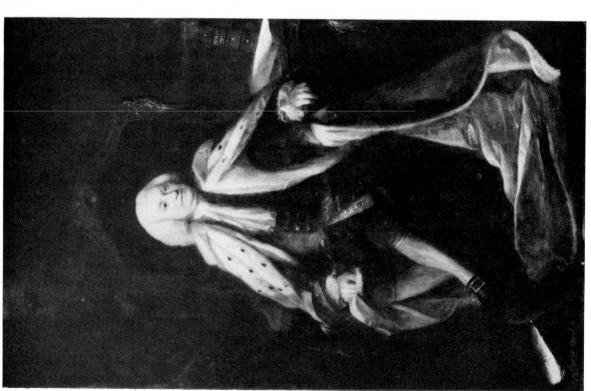

81. *Lord Chief Justice Wilmot*, by Nathaniel Dance

80. *Earl of Macclesfield*, by Benjamin Wilson

82. ?*William Beckwith*,
 by Nathaniel Hone

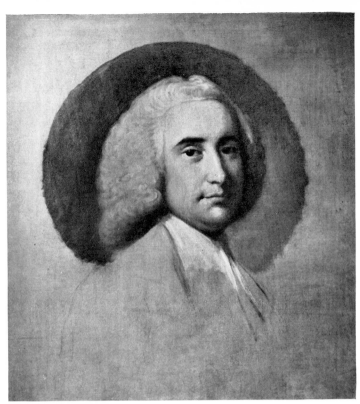

83. *The Press Gang*,
 attributed to John Collet

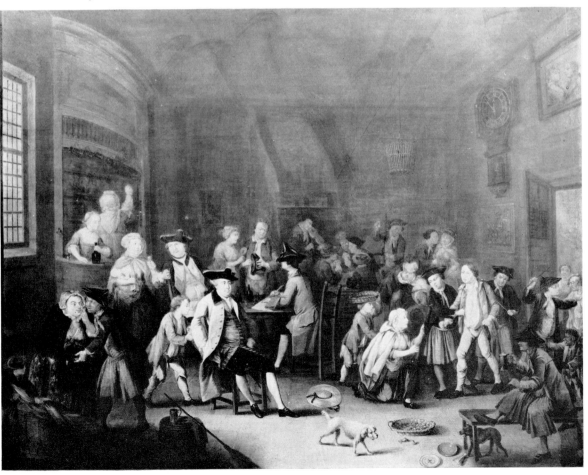

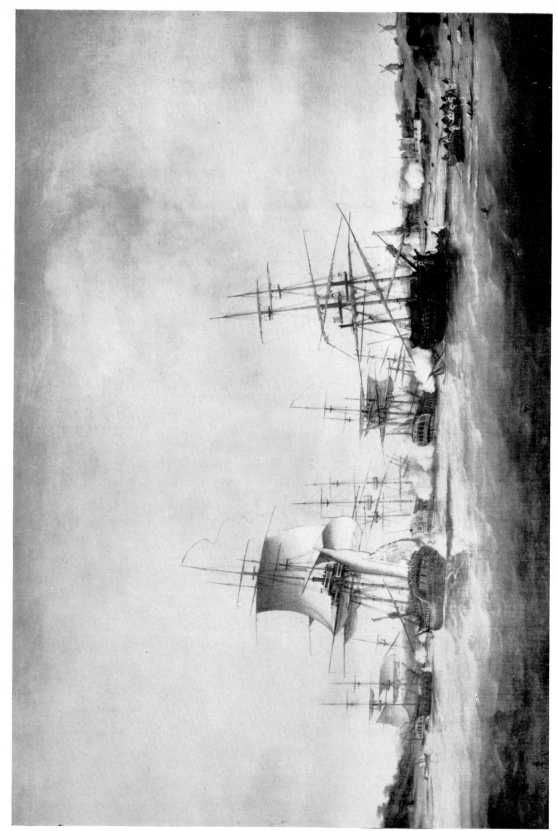

84. *Action off the Coast of France, 13 May 1779*, by Thomas Luny

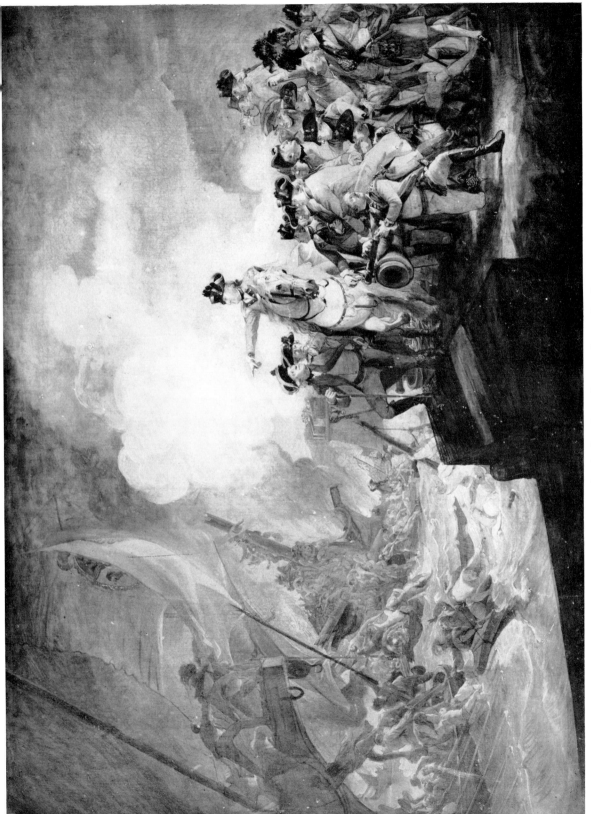

85. *Siege of Gibraltar*, by John Singleton Copley

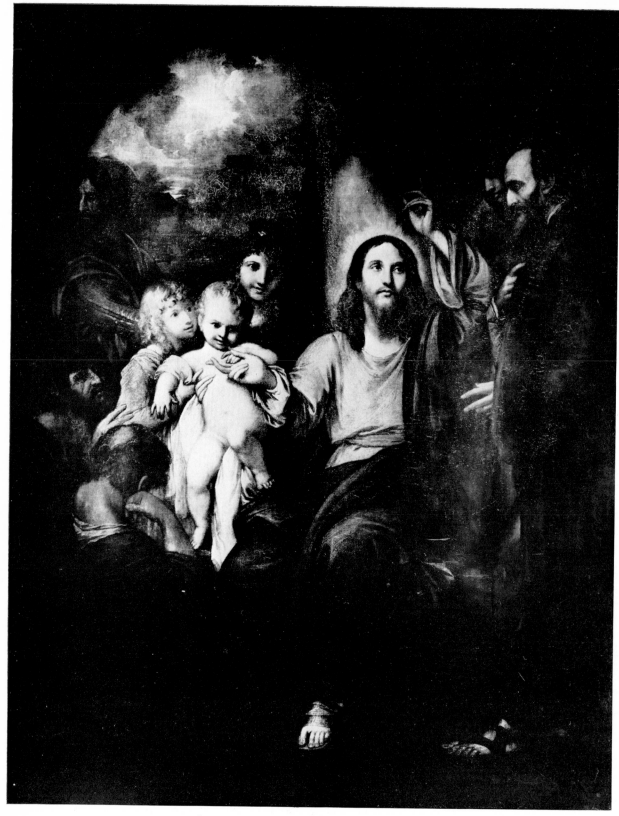

86. *Christ presenting a Little Child*, by Benjamin West

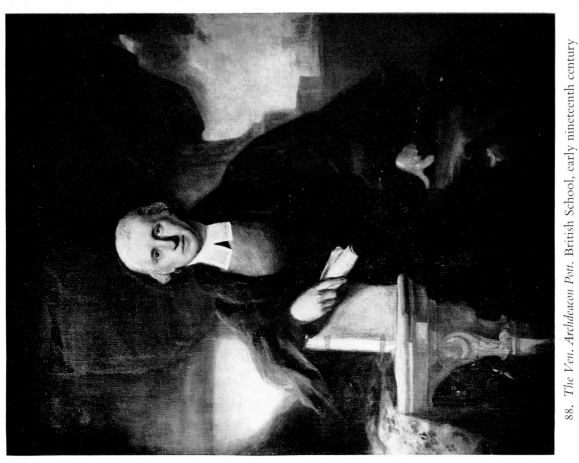

88. *The Ven. Archdeacon Pott.* British School, early nineteenth century

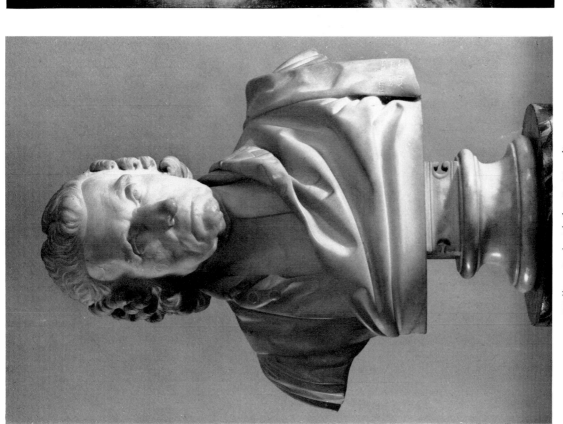

87. *William Beckwith,* by R. Tomlinson

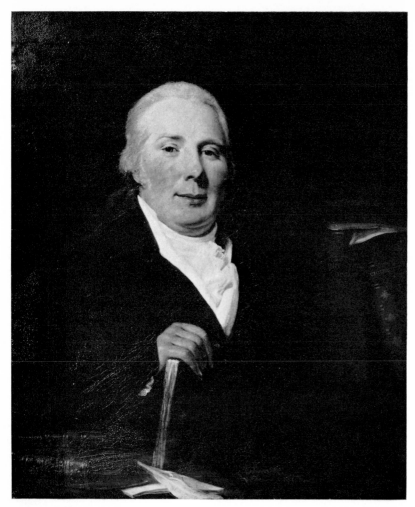

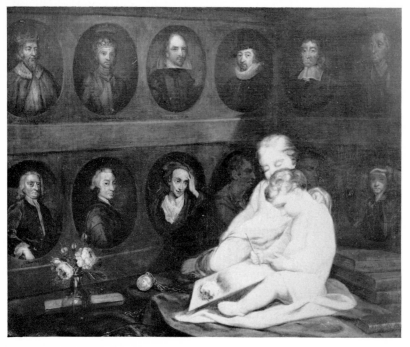

89. *Christopher Stanger*,
 attributed to George Watson

90. *The Worthies of England*,
 by James Northcote

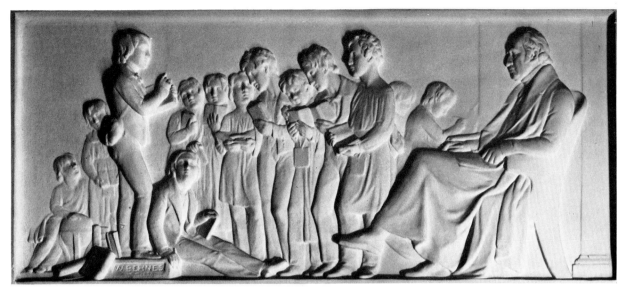

91. *Relief from Monument to Dr. Bell,* by William Behnes

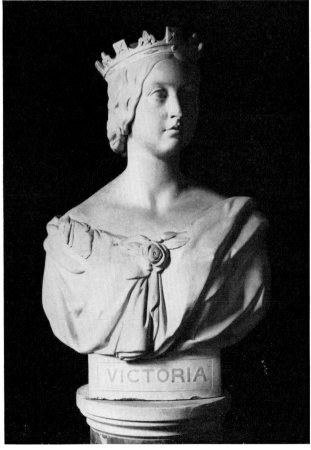

92. *Rev. J. W. Greadhall,* by Samuel Bouverie Haydon

93. *Queen Victoria,* by Joseph Durham

95. *The Christening*, by Mrs. Emma King

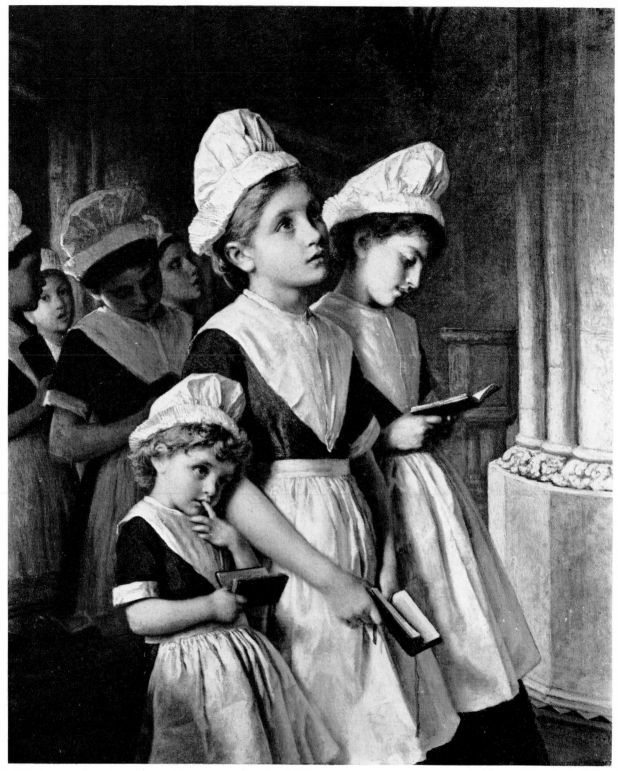

96. *Foundling Girls in the Chapel*, by Mrs. (Walter) Sophia Anderson

98. *The Pinch of Poverty*, by Thomas Benjamin Kennington

97. *A Foundling Girl at Christmas Dinner*, by Mrs. Emma King

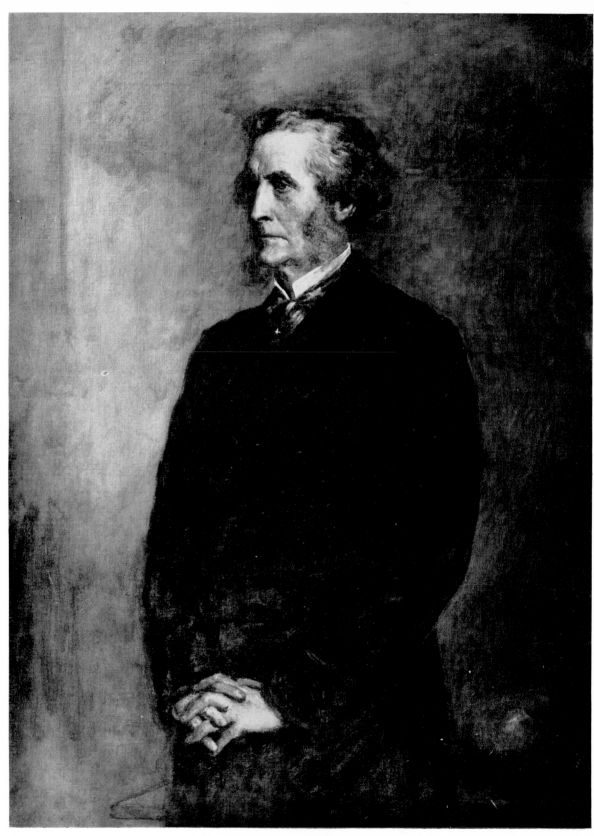

99. *Luther Holden*, by Sir John Everett Millais